HOLLYWOOD MOVIE STILLS

ART AND TECHNIQUE IN THE GOLDEN AGE OF THE STUDIOS

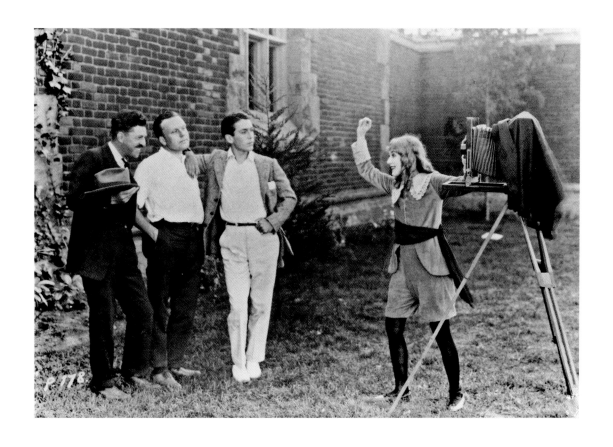

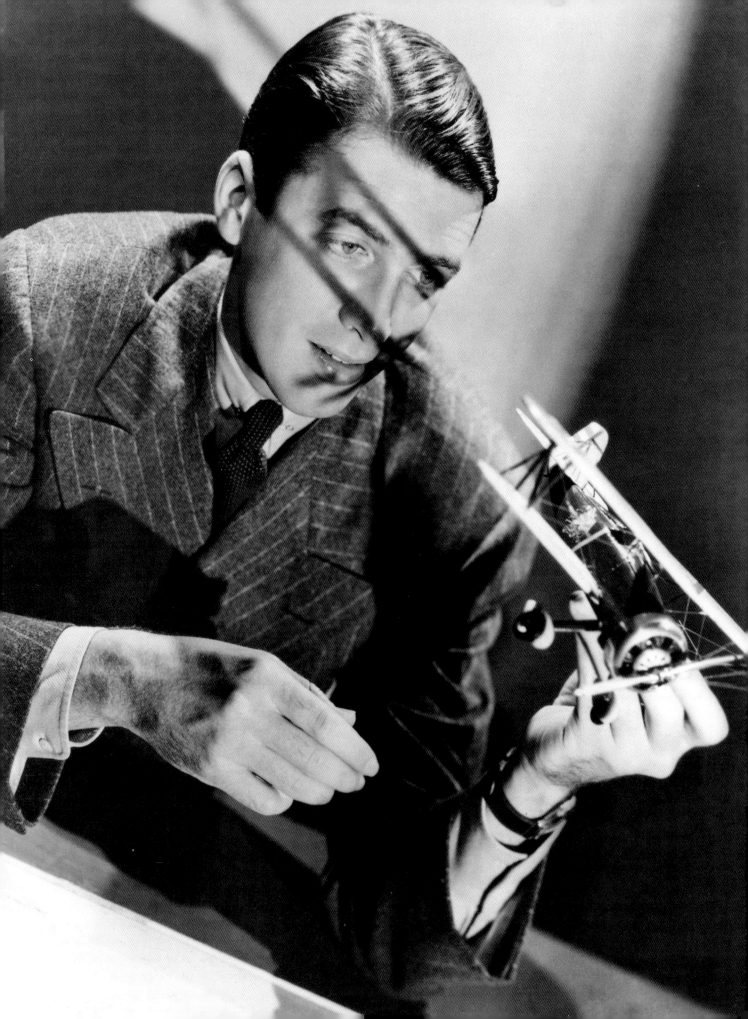

HOLLYWOOD MOVIE STILLS

ART AND TECHNIQUE IN THE GOLDEN AGE OF THE STUDIOS

JOEL W. FINLER

TITAN BOOKS

This book is affectionately dedicated to Ben and Barbara.

ACKNOWLEDGEMENTS

Special thanks to Elizabeth-Ann Colville, Kevin Brownlow, Richard Chatten, Neil Hornick and stills photographer David Farrell, also to Sid and Donald Hay, photographer Eric Cross, Julian Fox, Edith Falk, and the Jerusalem Cinematheque, Michelle Snapes and the BFI/National Film Archive Stills Department, and to my editors Timothy Auger, Marcus Hearn, Richard Reynolds and Adam Newell.

I would also like to thank eight leading Hollywood studios without whom this book would not have been possible: Sony/Columbia Pictures, Fox/20th Century-Fox, Loew's Inc./ MGM and Turner Entertainment, Paramount Pictures, RKO Radio, United Artists, MCA/Universal Pictures and Warner Bros./Time-Warner.

Hollywood Movie Stills
ISBN: 9781781161937

Published by
Titan Books
A division of Titan Publishing Group Ltd.
144 Southwark St.
London
SE1 0UP

First Titan edition: June 2012
10 9 8 7 6 5 4 3 2 1

Hollywood Movie Stills copyright © 1995, 2008, 2012 by Joel W. Finler.
All rights reserved.

Did you enjoy this book? We love to hear from our readers. Please e-mail us at: **readerfeedback@titanemail.com** or write to Reader Feedback at the above address.

To receive advance information, news, competitions, and exclusive offers online, please sign up for the Titan newsletter on our website: **www.titanbooks.com**

A CIP catalogue record for this title is available from the British Library.

Printed in China by C & C Offset Printing Co., Ltd.

Page 1:
Don't be misled by this amusing photo of Mary Pickford in her Little Lord Fauntleroy costume in 1921 playing the role of stills photographer on the set. As the film's producer and co-owner/co-founder of the distributing company, United Artists, she was the boss. (She aims the large, 8x10 plate camera at three leading members of her production team, left to right: co-director Alfred E. Green, cameraman Charles Rosher and her brother, Jack Pickford, who was also the film's other co-director.)

Previous page:
There are always a few surprises among the mass of star portraits which poured out of the studios in the 1930s, such as this unexpected shot of a young Jimmy Stewart, probably taken at MGM where he was under contract. The lighting is unusual, with a strong spot on Stewart's hands and the model airplane he is holding – which in turn casts a pattern of shadows across his face – while the slightly tilted composition contributes to the striking, almost three-dimensional effect. The subject is not entirely fortuitous, however, reflecting the fact that Stewart was a flying enthusiast and a qualified pilot in real life.

Facing page: Portraits and other types of photos often turn up as props in the movies themselves, and it is the job of the stills photographer to provide the required image. However, when a shot of a younger Fredric March was required for this scene in *The Best Years of Our Lives* in 1946, a suitable portrait was found from *A Star is Born*, a film he had made nine years earlier.

contents

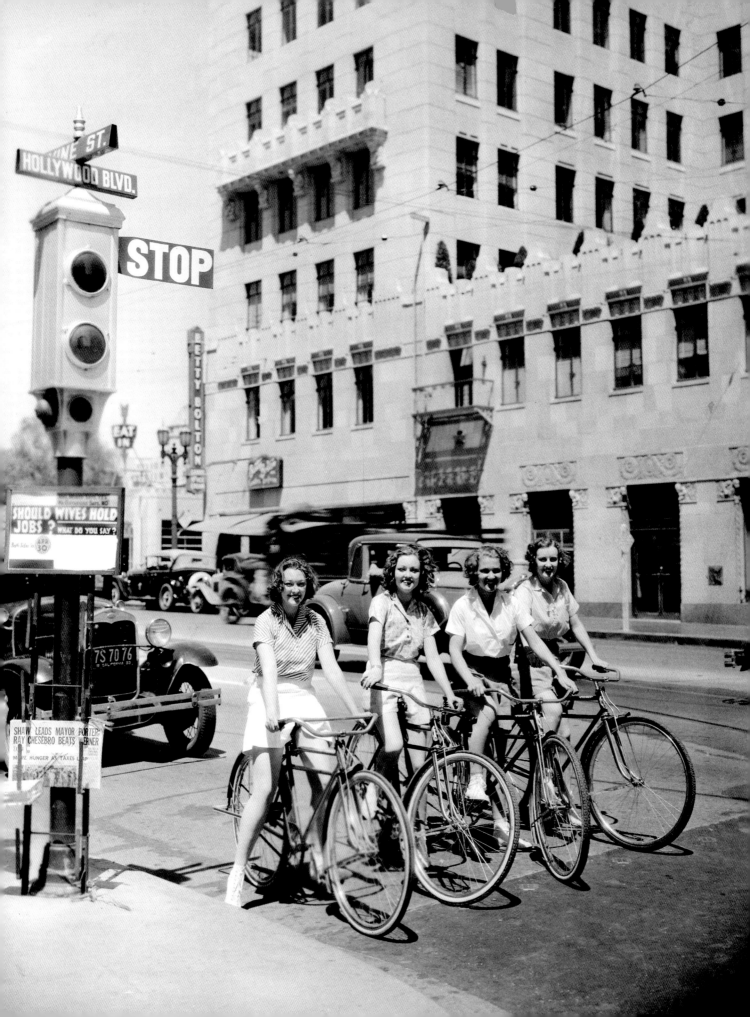

INTRODUCTION

Although the invention of photography preceded the first development of the cinema by over half a century, still photography has continued to serve the movies in many ways. Best known of all are the portraits of stars, scene stills and other photos to promote new films and players. A photographer is employed on virtually every picture and, in addition to taking the normal publicity photos, he or she is also expected to take reference shots of possible locations, of sets, costumes and other production details for use during the making of the film, as well as providing any snapshots or photographs needed for use as props in the film itself.

This book represents the first ever attempt to explore the role of the movie stills photographer in all its different guises. It is also a tribute to a much neglected profession. Loosely chronological in structure, the story begins in 1910-11, around the time that the first movie stars began to be publicized in the US and the earliest fan magazines appeared. The development of stills photography is related to the early history of Hollywood and of the cinema in general. Among the key developments in the early years were the switch from shorts to feature-length pictures, the emergence of the star system, the growth of the large studios and the changeover to sound in the late 1920s.

The main focus is on the photographers and stars – of course – and on the studio and star system which flourished especially in the 1930s. But many leading producers and directors play an important role in the story as well. Thus, the important names here are not only Theda Bara, Gloria Swanson, Garbo, Dietrich and Marilyn Monroe, but D. W. Griffith, C. B. DeMille, Josef von Sternberg, Alfred Hitchcock, Michael Powell and Erich von Stroheim. Then too there are the leading photographers themselves, including Bob Coburn, John Engstead, Laszlo Willinger and Clarence Sinclair Bull in Hollywood and such celebrated English photographers as Cecil Beaton and Cornel Lucas. Also included are remarkable contributions from the large number of unknown photographers employed by the film companies.

During recent years there has been a great revival of interest in the work of the portrait photographers, especially those who worked in the studio photo galleries in the 1930s and created some of the most memorable star images of the era – of Garbo, Dietrich and Crawford, of Gable, Cooper and Cary Grant. In contrast, the work of the unit stills photographers continues to be relatively neglected, especially since

they are generally associated with the scene stills taken on the set, capturing the key set-ups in the film more or less as seen on the screen and making use of the same lighting and compositions. (These shots are used most often to publicize the movies when they are released.)

Yet there is much more to movie stills photography than these two, most familiar types of photos would suggest. This book celebrates the remarkable range and diversity of the black-and-white photos which poured out of the film companies in great numbers during the peak years of Hollywood, from the 1920s through the 1950s. Thus, the portrait photographers and heads of the studio stills departments, who were adept at photographing the top stars, might also be responsible for the fashion shots and poster art which was required for publicity. And they might also produce photo collages or trick shots or take photos at the stars' homes, allowing them to get away from the studio portrait gallery from time to time.

At the same time, the unit photographers, who took their scene stills on the film set, would also turn out a wide selection of production shots (showing the director, stars and entire unit at work) and other behind-the-scenes or 'candid' views of the stars during the many breaks in filming, during rehearsals or while waiting for a new camera set-up. They too would often be given assignments outside the film studio – to take photos at the stars' homes, favourite restaurants or nightspots and cover the many special events such as parties, weddings, movie premieres and awards ceremonies.

Thus, the sum total of photographs adds up to a rich portrait of the movie colony in general, and of Hollywood movie-making in particular, over a period of more than half a century.

In contrast to the idealized, timeless quality of the portraits, which were also heavily retouched, adding to their unreal qualities, the more candid, everyday photos taken by the studio photographers are also of special interest for us today. Once regarded as mere news or publicity items for promoting new films, stars and events in and around Hollywood, and considered quite ordinary at the time, these photos have acquired a great nostalgia value. They are of historical interest as part of the extensive visual record documenting the styles and fashions of the times, the streets, houses and automobiles, the restaurants, nightclubs and cinemas in that tinsel town in sunny California which claims the title of 'movie capital of the world'. In addition, for those specially interested in the development of

the cinema, many of the production shots serve as a valuable record of Hollywood film-making.

As one who has been writing about the cinema and collecting movie stills for almost forty years, I can remember first being attracted to those photographs which showed the film stars and crews at work. Generally photographed with an 8 x 10 camera, these represented a fascinating and useful reference source for the writer or historian, for they often showed important details of the movie making process, types of cameras and microphones used, camera cranes and dollies, tracks laid for 'tracking shots', even sets under construction inside the studio, on the back lot or on location. It also happens that many of the most ordinary scene stills from early films have acquired a special value as a last surviving visual record of the large number of lost or missing films and as a clue to cut, censored or lost scenes, of changed beginnings or endings or even changes of cast for the films of all eras.

Then too, there is the lighter side of movie stills photography, the many offbeat and unusual photographs, the cheesecake and 'leg shots' and other kinds of publicity poses, some intentionally amusing, but others which appear incongruous or bizarre to us today. Also large numbers of trick shots of all types, double exposed shots and photo montages. In fact, the photographers were encouraged to try just about anything that might help to sell the movies to the public.

In both the text and the accompanying photographs an attempt has been made to develop a suitably eclectic approach to the subject with reference to a wide range of players, films, studios and genres, taking account of the many changes that took place in American movie-making during the main years of black-and-white filming, from the 1910s to the 1960s.

The 1930s was the peak decade of the studio and star system, for example, while in the 1940s new styles emerged, such as *film noir* and a more natural look for the stars, along with a greater dependence on filming away from the studios, on locations in the US and abroad. These trends continued into the 1950s and were reflected in the greater variety and flexibility of stills photography as the photographers took advantage of the opportunity to make use of available light, smaller cameras and faster film. In addition, changes in the types of pictures being made, such as the 1950s boom in cheap science fiction, horror and thrillers, stimulated a lively and imaginative response from the studio stills departments.

However, by the 1960s this tradition of quality stills photography in black and white was reaching an end, with the move toward virtually 100 per cent colour filming. Many of the stills were now shot in colour, while the standards of stills photography and reproduction declined. Thus, this marks the end of our story, covering a period of about 50 years from the 1910s to the mid-1960s.

Since photography and the movies each occupy a very special place within American cultural history in the twentieth century, it is surprising that movie stills photography has been so undervalued by writers, critics and film historians alike. It is hoped that this book will contribute to a revival of interest in this fascinating and neglected subject.

INTRODUCTION TO THE NEW EDITION

The basic layout and content of the book has not been changed, but over thirty new pages of photos and captions have been added. These include an original contact sheet for *Witness for the Prosecution*, a series of stuntmen in action and movie stars as photographers and a new spread on *From Here to Eternity*. Also two memorable portrait sessions at Warner Bros. in the early 1940s: Humphrey Bogart in *High Sierra* photographed by Scotty Welbourne and Conrad Veidt in uniform for his role in *Casablanca* photographed by Jack Woods.

Most important of all, in a book devoted to the Hollywood stills photographers, this new edition includes a large selection of rare photos showing many of the leading stills men at work at the various Hollywood studios: George Hurrell (Goldwyn), Elmer Fryer and Bert Six at Warner Bros., Frank Powolny (Fox), Paul Hesse at Paramount and Fred Hendrickson at RKO Radio. A number of these were supplied by fellow collector and dealer Martin Matheter, who has been especially helpful.

There are also a few additions and corrections to the text, including a more complete version of the table on page 43 listing the leading stills photographers by studio.

Finally, the book now includes a greatly expanded bibliography. The publication of a large number of photo books in recent years reflects a nostalgic interest in Hollywood's "golden age" at the same time that such well-known photographers as Eve Arnold, Bob Willoughby and Frank Worth have been encouraged to look back on their long and productive careers. In addition there have been many new books celebrating the accomplishment of the best of the movie star photographers such as Jeff Bridges, Yul Brynner, Harold Lloyd and Dennis Hopper, in particular.

This new edition would not have been possible without the enthusiastic support of my publisher, Titan Books, and editor Adam Newell.

Joel Finler,
January 2012

Marion Davies, the long-time mistress of William Randolph Hearst, was famous for her fancy dress parties. They provided not only a chance for the stars to dress up and let their hair down, but a welcome photo opportunity too. Seen here from left to right are Gloria Swanson, Marion Davies, Constance Bennett and Jean Harlow.

Below: A quite striking use of photomontage here draws attention to the offbeat and dark treatment of western themes in this 1947 film, *Pursued*, one of the first and best of a new kind of psychological western. Robert Mitchum is the troubled hero haunted by childhood memories, while Teresa Wright gives a strong performance as the girl who both loves and hates him. A giant cut-out of her face dominates the harsh western landscape, and, in fact, the role was specially written for her by her husband, Niven Busch.

Though the stills camera often occupies its own place on the film set, it is rarely seen in photos since it is generally used to take the still photos. This candid shot of director Alfred Hitchcock – apparently caught dozing during a break in filming *The Lady Vanishes* in 1938 with star Margaret Lockwood and his daughter Patricia – also shows the stills camera standing, unnoticed, on its tripod in the background with the focusing screen partly covered. Note too the identifying number 'LL-180' which provides a clue to the film's original working title, *Lost Lady*.

CHAPTER ONE
THE EARLY YEARS

The story of movie stills photography really begins around 1910-1911 when a number of exciting new developments were taking place in the US, stimulated by an increase in movie going. The fledgling American film industry had first emerged as a diverse collection of small companies struggling to grow and prosper in the early 1900s. And in 1908 the leading producers headed by Edison, Vitagraph and Biograph joined together to consolidate their position by forming the Motion Pictures Patent Company. With its ownership and control over key patents on movie cameras and projection equipment this powerful trust dominated the production and exhibition of films for a number of years and in 1910 established the General Film Company to distribute all pictures from the member companies to licensed movie theatres.

Still photographs had often been taken on the set for films made prior to 1910, and as early as 1907 both

Edison and Vitagraph were using stills, as opposed to frame enlargements, to publicize their pictures. But suddenly, in 1910-11, there was a greater demand for stills than ever before for use on posters and to be reproduced in newspapers and magazines as movie audiences continued to grow rapidly. The posters supplied by General Film, for example, had a stock border incorporating the logo of the production company with a blank area in the middle, which was filled with a black-and-white scene still featuring a particularly exciting or dramatic moment in the story, along with the title and a short synopsis or caption. Stills also began appearing regularly in newspapers and the new breed of movie magazines. The trade magazine, *The Moving Picture World* was soon followed in 1911 by *The Motion Picture Story Magazine*, the first fan magazine promoted by J. Stuart Blackton of the Vitagraph Co., while *Photoplay* began in 1912.

Whereas scene stills taken on the set generally differ from portraits, sometimes a photo can work as both, such as this striking example on the facing page. The well-known photographer, James Abbe, was hired to take both types of photos on *Way Down East* and this one may well have been by him, while actress Lillian Gish was sensitive to the value of quality photographs and was a willing subject. Most remarkable here is the almost tactile quality, capturing the textures of her beautiful white wedding dress, very much of the period.

A typical example of the way in which stills were used on posters in the mid-1910s. A portrait of the innocent young heroine played by Lucille Lee Stewart, sister of the actress Anita Stewart and wife of the film's director, Ralph Ince, is contrasted with an especially dramatic scene still from this 1916 film showing other members of the cast.

ALBERT E. SMITH
Presents
"THE NINETY AND NINE"
BY RAMSAY MORRIS
A David Smith Production
VITAGRAPH

Here:

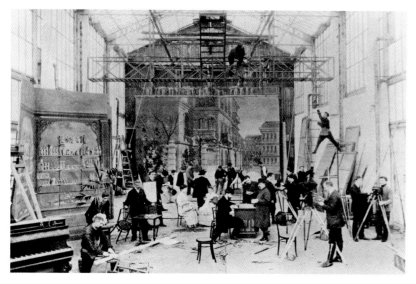

These photos of early film studios taken around 1906-8 actually predate the regular taking of stills on the films themselves. The top picture is of the French Pathé studios in Vincennes, while the other shows filming in progress at the Edison studio in New York. Since many of the early film pioneers were originally involved with photography too, it is not surprising that they wished to have photographers present to make a record of the activities at their film studios. A still photographer can actually be seen at the far right in the top photo, with his camera mounted on its tripod. We see here how simply films were made in the early days, with the use of elaborate painted backdrops as in the theatre, overhead lights and scaffolding. The camera is even mounted on a primitive 'dolly', with wheels allowing it to move.

The year 1911 also saw an increase in the number of multi-reel films, mainly two or three reelers, contrary to the Trust's preference for a standard, one-reel format. And this coincided with the beginnings of the movie star system. Whereas films had previously been released with no reference to the names of the players, it soon became apparent that audiences were especially attracted to particular stars and not only wished to have them identified, but were also eager to acquire portrait photos of their favourites.

A special phenomenon of these early years was the use of postcard photos produced by the film companies themselves as a means of promoting their stars. Thus, *The Motion Picture Story Magazine* of April 1912

included a full page advertising 'Souvenir Postal Cards of Vitagraph Players' for sale at only 25 cents a dozen or 60 cents for the entire set of 33, including Florence Turner, Maurice Costello, Norma Talmadge, John Bunny, Ralph Ince and even (no. 31) Jean, the Vitagraph dog. (Amusingly enough, Miss Talmadge was probably the only star who started out in movies by posing for the song slide photos which illustrated the song numbers, projected on the screen during the interval between picture shows in the early nickelodeons.)

However, it was the smaller independents, such as Carl Laemmle's IMP Company, which were most enterprising in taking advantage of the new trend toward producing and publicizing longer pictures featuring the leading stars of the day. Laemmle had been one of the first to recognize the value of stars and specially hired both Florence Lawrence and Mary Pickford, though they had first been discovered by Biograph and had both featured as the company's 'Biograph Girl'. Similarly, Adolph Zukor began his long producing career with the idea of presenting feature length versions of popular plays starring his 'Famous Players', while D.W. Griffith, the leading director at Biograph, left the company in order to make longer pictures, unhampered by the dictates of the Trust, taking his leading stars and technical personnel with him.

Various refinements in movie techniques around this time, especially in editing, cinematography and the use of close-ups, contributed to a greater appreciation of the role played by the stars on the screen. And movie acting developed apace. Clearly, it required a special kind of skill to sustain a feature-

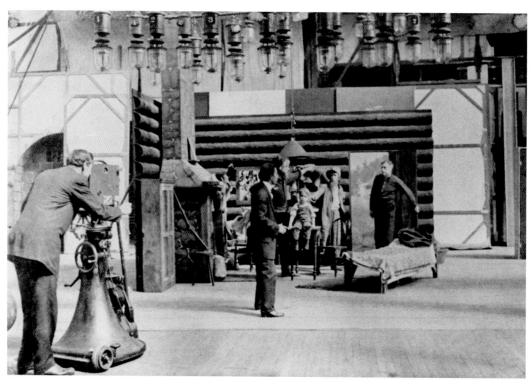

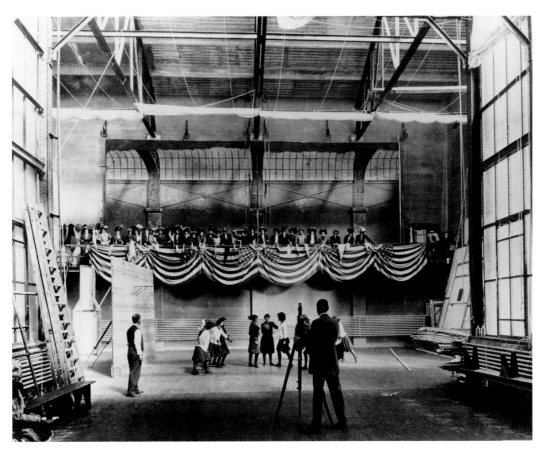

length performance on screen – as Zukor learned to his cost: it was not so easy to turn established (and ageing) stage actors into movie stars. In addition, the trend toward longer films meant that more attention was devoted to every aspect of a production, from the preplanning, casting and scripting to the use of more varied and elaborate sets, costumes and locations. And this also meant that more staff were taken on with specialized skills in each department, including stills photography. But even with the move into feature films, which provided greater opportunities for shooting stills, along with increased demands for publicity material once the completed picture was released, the still photography on most pictures continued to be a bit unpredictable and haphazard at best. The stills were but one of the many responsibilities of the camera crew, and since they did not appear in the film itself, they were regarded as a relatively low priority item, generally shot only after the filming of important scenes were completed... if the director so wished and if the actors could be prevailed upon to hold their places.

The use of frame enlargements was a cheap, but unsatisfactory alternative. The tiny 35mm frames looked grainy and lost their sharpness when blown up, while still photos could be specially posed to capture stars and key scenes in each film. And large numbers of publicity stills could be easily printed up from the photo negatives.

Many of the leading cameramen, such as Billy Bitzer, on the Griffith films, or Alvin Wyckoff (for DeMille), took the stills themselves, with the still camera positioned on its tripod next to the camera whenever a photo was to be taken. In the case of director Maurice Tourneur, the stills photography was left in the capable hands of his second cameraman, Charles Van Enger, who graduated to lighting cameraman himself in the 1920s. As he later recalled of his early years, 'I used to do all the stills for Tourneur. I was the second cameraman, the assistant cameraman, the still man. I was the actor – I'd put on make-up and act, and when Clarence Brown went away I used to have to direct, photograph and act a lot of the second unit stuff... Boy, I did everything.'

Bitzer and Wyckoff even continued to do their own stills for a short period after the change over to features. For example, when a young Karl Brown applied for a job as a stills photographer with Griffith late in 1913, Bitzer brusquely brushed him off with the comment that 'I take all the stills... and do all my own photographic work.'

Brown was, in fact, one of many young photographers who had been able to break into films around this time, through their interest in still photography, for the industry was growing rapidly and there were many new opportunities. He had his first big break on *The Spoilers* earlier that same year. In this Western drama from the Selig Company, an

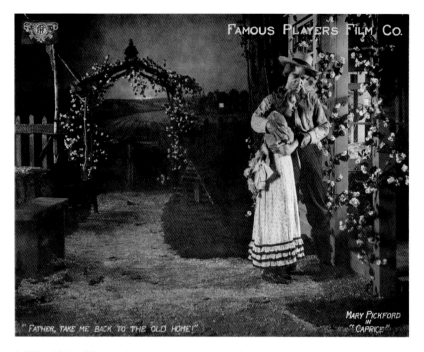

FAMOUS PLAYERS FILM CO.

"FATHER, TAKE ME BACK TO THE OLD HOME!"

MARY PICKFORD IN "CAPRICE"

A 1913 publicity still for an early Mary Pickford feature, *Caprice*, demonstrates the style favoured around this time: in addition to the star and title, the photo has been embellished with a line of dialogue from the film (like a silent inter-title) along with the name and logo of the film company. Very Victorian in style and sentiment, the lighting from 'offstage right' highlights the two characters in a theatrical manner and is meant to distract us from the cheap-looking set and painted backdrop in the background.

attempt was made to capture the authentic feel of a tough frontier town. And since the other photographers were reluctant to brave this rough and dirty location, with its muddy main street where some key scenes were set, including the big fight climax, young Karl got the job. As he recalled,

> I didn't mind a little mud... It was a glorious experience, wading out in all that lovely mud and bossing everybody around...When I called 'Still!' they froze in place until I said 'Okay' and released them from their immobility. The fight between William Farnum and Tom Santschi could not be stopped for stills or anything else. But I had a fine Goerz lens with a Compur shutter that could shoot at one three-hundredths of a second, so I shot them in action. It worked. The stills were good enough to use, and any little smearing of the action seemed to enhance the fury of that most furious of fights.

Taken on as Bitzer's assistant, Brown was assigned to look after the valuable cameras, especially out on location. One of his jobs was to unpack the stills camera, then carefully repack it each time after a still photo was taken. For, if it was left standing beside the movie camera, someone was sure to pass too close to one of the tripod legs and down it would go.

Not long after Brown was first hired, Griffith's activities as producer and director at Triangle meant an increase in the number of stills being made and printed. Thus, the talented James G. Woodbury was brought in and put in charge and 'a department was created to do nothing but process still pictures of all kinds.' By the time of the filming of *Intolerance* in 1915, Woodbury was a fixture on the Griffith lot. A

giant camera tower with an elevator or lift was constructed for filming the spectacle of the Belshazzar's feast sequence on the massive Babylon set designed by Walter Hall. According to Brown, when he, Bitzer and Griffith were filming from the top of the elevator, Woodbury was positioned on the level just below them with his 8 x 10 stills camera and tripod creating one of the most memorable still images of the early silent cinema. (Since, apparently, no photo was ever taken of this camera tower, possibly on purpose, for many years there was some speculation as to whether this shot had been accomplished from a balloon or a moving platform.)

On this same production Brown was encouraged by Woodbury in his experiments with one of the stills man's favourite techniques, called 'dodging'. He found that it could be adapted, laboriously, for use in the film itself, creating a special light area around the face of Christ in the Biblical scenes – an unusual example here of how the techniques of still photography could be adapted for use in filming. And some of these same shots were also given the simulated texture of having been printed on canvas, like an old painting – yet another trick used in still photography.

Madison Lacy was another young photographer who got his start working for Woodbury in 1917. In a virtual rerun of the Karl Brown experience, the young enthusiast had caught the eye of Billy Bitzer at the Griffith studio: 'Anybody who's crazy enough to haul around a camera that heavy ought to be paid for it,' he told me. In his interviews with John Kobal and his own book (Leg Art: *60 Years of Hollywood Cheesecake*) Lacy has described what it was like to be a still man in those days:

> When I first started out, you handled slates, loaded cameras, timed the shots, fero-tagged the fero-tag tin, dried the prints, loaded, made copies. We had to develop our own prints... You also had to do your own retouching. Anything at all that had to be done, you did... We would fuss around our still lab, developing and printing, making copies and loading film holders. Then someone from the set would call us, and we'd go down and take a still picture. We'd grab a couple of glass plates and take the picture on orthochromatic film, a slow process that demanded at least a full second of exposure, freezing the actors in mid-action poses...

(After only a year or two with Griffith, Lacy moved on to work as a camera assistant and stills photographer for Hal Roach and Harold Lloyd.)

That same year (1917) the twenty-two year old Clarence Sinclair Bull arrived in Hollywood from his tiny Western home town of Sun River, Montana. He got his first job as assistant cameraman at the new Metro studio, then joined producer Thomas Ince and Triangle in Culver City in 1918. And when that

studio was taken over by Goldwyn a year or so later, Bull stayed on.

Among the many other young photographers who first became involved in films around this time were James Wong Howe, who was just eighteen when hired by DeMille (in 1917) and served for a number of years as assistant to cameraman Alvin Wyckoff. Robert Coburn started as a camera assistant at Sherwood Productions and other small Hollywood studios in 1917-18, while Donald Biddle Keyes began as a camera assistant at the Ince-Triangle studio, then joined Lasky-Paramount after World War I. Older and slightly later arrivals of note included Karl Struss, hired by Cecil B. DeMille to photograph his young star, Gloria Swanson, on the set of *Male and Female* in 1919 and Hendrik Sartov who was specially employed by D.W. Griffith to do close-ups of Lillian Gish in *Broken Blossoms* (1919). Undoubtedly there were many others, too, but unfortunately the information on the early careers of the photographers is sketchy and incomplete.

What all these men have in common is that they got their start in Hollywood at a time when that tiny village northwest of Los Angeles was growing incredibly fast. From the end of 1913 when both D.W. Griffith and C.B. DeMille arrived and began producing all their pictures there, up to the early 1920s, there was a steady increase in the number of new movie companies and studios. Within just a few years it had been transformed from a picturesque, rural farming community and residential area of attractive homes, crisscrossed by a few simple, mainly dirt roads, with a population of under 10,000, into the main centre of movie-making in the US (and in the world). The population had grown to 35,000 by 1919 and would reach 130,000 in 1925, while the name 'Hollywood' would come to be widely adopted as the shorthand term for the American industry itself.

It is, of course, appropriate that the beginnings of what was to become the strong tradition of Hollywood movie stills photography can be traced back to this period, for the stills men themselves have played an essential role over the years in creating that view of Hollywood, or 'Tinseltown', as a very special kind of place. Karl Brown's book, *Adventures with D.W. Griffith*, for example, accurately captures the pioneering spirit of the early film-makers, characterized by their special flair for invention and improvisation, coping successfully with the many unexpected problems they encountered in bringing their ideas alive on the movie screen or in their still photographs.

In fact, this period was characterized by rapid changes in all aspects of the film making process. The trend toward greater specialization in the various filmic crafts meant that the camera assistants, in particular, were soon faced with two quite different choices for their future careers. On the one hand, a promotion to lighting cameramen, the most obvious choice, meant an involvement with and responsibility

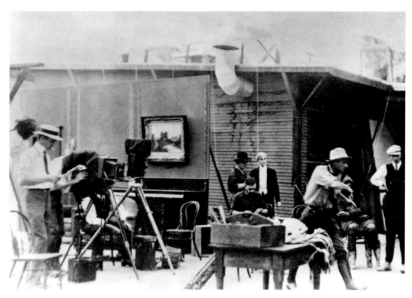

for the shooting of the picture second only to that of the director. But, on the other hand, specializing in stills photography would mean playing a more marginal role in the production itself. Of course, the stills man would be asked to contribute in various ways. Even before the beginning of shooting, his photos of possible locations, costumes and sets were used in planning the production, and he would be expected to take shots of all the main scenes and stars. But otherwise his brief was often a quite general one with a large degree of freedom to capture different aspects of the movie in his still photos. It was important to record the most dramatic, entertaining or glamorous moments which could be used most effectively in promoting or publicizing the completed film, along with candid, behind-the-scenes shots of the director, stars and/or crew at work or between scenes.

The choice of a career as a stills photographer naturally appealed to those who saw it as a virtually freelance, creative activity without the tremendous responsibility and pressures of the lighting cameraman. Among the early group of camera assistants, Karl Brown, Charles Van Enger, and James Wong Howe, along with Sartov and Struss, all graduated to chief cameraman and went on to excel in this field, whereas Madison Lacy, Clarence Sinclair Bull and Robert Coburn returned to their first love, portrait or stills photography, and had long, distinguished careers as Hollywood stills photographers.

As Karl Brown noted, the various types of movie stills were now more in demand than ever before:

Production stills for lobby displays and for publicity illustrations, portrait stills for distribution to the emerging class of movie fans who were writing in for pictures of their favourites, enlargements for lobby displays, blowups from 35mm frames for the set dressers,

A rare early photo of a stills cameraman at work. Director Cecil B. DeMille on the right, in white hat, shirt sleeves and riding boots, is seen rehearsing his actors on the open air set of *The Squaw Man*, his very first feature, filmed at the 'Lasky Barn' in Hollywood in early 1914. The unknown photographer who has taken this truly behind-the-scenes shot has ignored the main action, which is going on out of frame to the right where the actors, in costume, are rehearsing. Other actors and technicians lounge in the background, watching the rehearsal, but at the same time we see the stills photographer taking a shot, probably cameraman Alfred Gandolfi. And for his convenience the stills camera is positioned right beside the cine camera.

According to the biography of Clarence Sinclair Bull (*The Man Who Shot Garbo*), one of his early assignments was the stills work on the Maurice Tourneur production of *Treasure Island* in 1919. This unusual photo shows how the stills man could be accommodated during the shooting, given his own space to set up camera and tripod. This may be Bull with his camera in the background. Director Tourneur in glasses and hat is instructing the actors in the next scene to be filmed. Alternatively, it may actually have been Bull who took this photo!

and even action stills made with small, high-speed cameras to catch out various stars in unconventional, off-scene, candid-camera shots.

However, from quite early on there were two distinctly different types of photos most often associated with the movies. The scene or production stills, generally horizontal or 'landscape' format, were made on the set while the film was in production. In contrast, the portraits (vertical or 'portrait' format) were taken in a separate, portrait studio by a private photographer unconnected with the movie companies.

The art of portrait photography had made great strides during the early years of the century, but had generally been ignored by the newly developing movie industry. However, a few leading producer-directors, such as D.W. Griffith, DeMille and Tourneur, can be credited with trying to improve the quality of movie photography during the 1910s, if not earlier. Technical historian Barry Salt has drawn attention, for example, to the influence of portrait photography on Griffith's films as early as 1909-10, particularly with regard to the regular use of back-lighting of his actors and actresses. (In fact, as he states 'the technique of reflector fill-light had been standard in studio portrait photography for about a decade.') Billy Bitzer was credited with applying this device to film, and over the next few years it was widely adopted for location filming by many other cameramen.

By 1914 Griffith's own publicity releases claimed that he achieved effects in his films 'hitherto attained only in "still" photography.' Of particular interest here is the special care which Griffith took with the close-ups of his female stars. But clearly he was never too concerned about whether they matched exactly with the shots which came before or after, for he often varied the action in each new take of a scene. As Salt has pointed out in his book, *Film Style and Technology*, 'Griffith's interest would seem to have been less in continuity, and more in the dramatic effects he could achieve, in particular by eliciting (the best possible) performance from his actors'.

Thus, it is not surprising to find that when Griffith saw the portrait photos of Lillian Gish taken by photographer Hendrik Sartov for *Hearts of the World* (1918), he was sufficiently impressed to hire the photographer in order to find out if he could achieve the same, soft focus effects on film. The results, based on a system of lens diffusion for shooting close-ups, can be seen most clearly in *Broken Blossoms* (1919) along with *Way Down East* which followed in 1920 and was Griffith's last big hit. These two films had a great impact on the look of Hollywood pictures of the 1920s – Griffith's last important influence on the American cinema. The three leading cameramen exponents of this soft focus style were Sartov, Charles Rosher and Karl Struss. As was the case with Sartov, Struss soon became part of the camera crew and graduated to lighting cameraman within a year, then went on to become one of the leading figures in Hollywood; he even patented his own soft focus lens and was the first winner of the Oscar for cinematography (with Rosher) for *Sunrise* (1927).)

By the mid-1910s there was a growing recognition of the importance of still portrait photography, of how it could be used to benefit the film industry and

even to launch the career of new stars. This became most apparent after Fox's remarkable success with Theda Bara. The studio had provided her with an elaborate, fictitious biography to go with her new name, an anagram of 'Arab Death'. But most important of all, Fox had hired the photographers Underwood & Underwood to take a revealing series of portraits of her featuring mysterious or exotic looking poses with a variety of props such as skulls, cross bones and crystal balls, wearing Arab or Oriental looking jewelry, and made up with heavy eye shadow, with her hair falling freely in a suitably uninhibited style: the incarnation of a new type of movie 'Vamp', unlike anything ever seen on the screen before.

Prior to the 1920s the stars were responsible for arranging their own portrait sessions with private photographers. Thus, it was Lillian Gish who is credited with discovering Sartov and introducing him to Griffith. Similarly, the young James Wong Howe drew on his skills as a photographer to advance his movie career and was especially successful with the youthful Paramount star, Mary Miles Minter. While working as a camera assistant, he had continued to take still photographs of the stars as a useful sideline. In Miss Minter's case he made use of a black velvet frame around the camera in order to darken, and thus give a greater expressive quality to, her pale blue eyes. She was so impressed that she asked him to be her personal cameraman on her next feature films, thus launching him on his long and distinguished career. And when Mary Pickford's mother was approached by a young, unknown actor named Rudolph Valentino asking for her advice on how to break into pictures, she insisted that 'the first thing you must do is get the very finest photographs of yourself and spend plenty of money on them...' (Apparently, Mary Pickford would spend as much as $50,000 a year on photos, while the Gish sisters regularly budgeted about $10,000 per annum each.)

Undoubtedly the most famous incident ever to take place at a photographic studio was experienced by comedian Harold Lloyd in 1919. At a small movie company such as Hal Roach's Rolin, there was no resident photographer during these early years, so an appointment was arranged for Lloyd to have his photos taken at the Witzel studio in downtown Los Angeles. And here it was, on a Sunday afternoon in August that Lloyd had the terrible accident which almost killed him. The idea was that he would pose for the stills camera with a papier maché prop bomb which was painted black and had a long-delayed action fuse. But somehow a real explosive bomb became mixed up with the harmless prop ones. Harold jokingly lit the fuse, but the long delay as the photographer prepared to take the shot meant that the fuse had burned all the way down. As Lloyd himself later recalled, 'I dropped the hand holding the bomb and was saying that we must insert a new fuse when the thing exploded.' If he had not dropped his hand

at that moment, it is likely that he would have been killed instantly. The explosion tore a hole in the ceiling and broke all the windows. Harold's face was covered in blood and he lost two fingers on his right hand, but fortunately made a complete recovery and was able to resume his career not long after, developing into one of the most popular and successful stars of the 1920s.

Most of the leading portrait photographers, such as Apeda, Mishkin or Underwood & Underwood, were located in New York or in Los Angeles where companies such as Witzel, Hoover and Nelson Evans benefited from the rapid growth of the movie industry. Perhaps most remarkable of all is Evans, about whom very little is known. He did work for Mack Sennett for a time, and his legacy includes a wide range of portraits taken both in and out of doors (taking advantage of the mild climate) which inspired the book *Hollywood: The Years of Innocence*.

It is significant that all of Evans's photos were taken before 1921, for by this date the private photographers were beginning to lose many of their movie star clients. The growth of the Hollywood studios during the early 1920s had led to the upgrading of many departments, including previously neglected areas such as costume design, special effects, make-up and, of course, stills photography. From now on the film companies not only employed the stills men on the films but also began to hire their own portrait photographers too. A specially designed, small-scale photographic studio or 'gallery' would be constructed on the lot for portrait sessions with all the company's stars. Although some of the stars were initially reluctant to give up their favourite private photographers, at least the new portrait sessions, arranged by the studio, were free. And it did not take long for the stars to be convinced of the quality of the

A familiar type of production still shows leading members of the cast and crew assembled onset for a group photo. Here director Rex Ingram (left) on the Paris set of *The Four Horsemen of the Apocalypse* (1921) addresses cameraman John Seitz, lead actress Alice Terry and scriptwriter June Mathis, seated on the floor in front of Rudolph Valentino in his French officer's uniform.

This photo shows Stroheim editing *Foolish Wives* in 1922, one of his many remarkable feature films which were badly cut and censored.

characteristic of silent film acting. However, the world of the silent cinema appears very strange and distant from us today, far removed in styles of dress and deportment, as well as in decor and settings, and photographed, prior to 1926, on the less sensitive orthochromatic film stock. Thus, the true quality of the silents is difficult for us to judge fairly, also given the fact that only a tiny fraction of the vast numbers of silent films have survived in good quality prints. Many of the most important pictures from leading stars and directors are totally lost. Ironically, the silent cinema is probably best remembered from the large numbers of still photos that remain. The many pictures which appear in books and magazines serve to remind us of films that have disappeared and of stars who are all but forgotten. In the case of Theda Bara, for example, so few of her films survive that the still photos of her assume a special significance for us today.

Of course, it is often difficult to gain more than a hint of the films themselves from the photos alone, and there is always the danger that the artificially posed stills are misleading with regard to the films which they allegedly represent. (Kevin Brownlow makes just this point in discussing the early kiddie pictures of Sidney and Chester Franklin filmed in 1915-17; as he notes, 'the cloying cuteness' of the kiddie poses in the still photos fail entirely to convey the 'witty, exuberant adventure stories' of the films themselves.)

Perhaps the special usefulness and powerful, evocative qualities of stills from the silent era can best be understood with reference to the work of a particularly brilliant director like Erich von Stroheim. In fact, there are some uncertainties regarding his early career: though he can clearly be identified playing a bit part in black face toward the end of *The Birth of a Nation* (1915), it is only with the help of a production still that his work as an assistant to D.W. Griffith on *Hearts of the World* (1918) has been confirmed. Thus, in his book *Hollywood: The Pioneers*, Kevin Brownlow describes how he removed the paint covering part of the background of a still to reveal Stroheim adjusting the uniform of a soldier extra. (Clearly, 'behind the scenes' photos of films being made are especially useful in documenting many aspects of the early silent cinema showing the techniques that were used – cameras, lighting, sets, special effects, etc. – and for identifying personnel and cast on each production.)

Stroheim first emerged as a leading star and director in 1918-19, and his work as a director was almost entirely confined to the final decade of the silent era, 1919-1929. More than any other director of the time, his career serves as an archetypal example of the changing position of the creative film-maker brought increasingly into conflict with the studio bosses of the 1920s. (Though many other leading producer-directors, such as DeMille, Griffith and Rex

studio gallery men. For they were headed by photographers of the stature of Donald Biddle Keyes and Eugene Robert Richee at Paramount, Clarence Sinclair Bull first at Goldwyn, then at MGM where he was joined by Ruth Harriet Louise in 1925, Jack and Roman Freulich at Universal, and Bert Longworth, Max Munn Autrey and Frank Powolny at Fox.

Perhaps the clearest indication of the changes taking place during these years can be seen in the experience of Max Munn Autrey. During 1922-24 he gained widespread recognition for his fine portraits of leading figures in Hollywood at the Witzel photo studio, including Fox stars Tom Mix and George O'Brien. This led to his being offered a contract by the Fox studio late in 1924 (or early in 1925). He then left Witzel and spent the next eight years as a leading photographer at Fox, taking portraits of their leading stars including Janet Gaynor, Spencer Tracy, Charles Farrell and Edmund Lowe.

The most important development in Hollywood in the 1920s was the growth in the studio system. Power became increasingly concentrated in a small number of giant, vertically integrated companies led by MGM, Paramount and Fox, joined by the enlarged and newly successful Warner Bros, (which took over First National in the late 1920s) and the newly formed RKO Radio, while the three 'mini-majors' of note were Universal, United Artists and Columbia.

This trend was further reinforced by the change-over to sound filming during 1928-29 when the silent era came to an unexpected end. (The many changes will be discussed in the following chapter dealing with the studio system.)

In fact, the best of the early still photographs effectively captured the special, stylized qualities

Ingram, experienced similar problems.) Unfortunately, few of Stroheim's films were released in the form he intended, and one is naturally intrigued by some of the extraordinary, unusual and erotic stills representing scenes which were cut, lost or censored from his films (see pages 34 - 37).

His first feature as director, writer and star, *Blind Husbands*, was filmed in 1919, coinciding with the formation of United Artists, while his last silent, *Queen Kelly*, produced by Gloria Swanson for the same company ground to a halt exactly ten years later. During these years he experienced a variety of production problems with companies large (MGM, Paramount), medium (Universal) and small (Goldwyn Pictures). Since not one of his features survives in a complete form today, the stills from his productions are of special interest to us as a record of films which are totally lost: *Devil's Pass Key* (1920), *The Honeymoon* (1928) (part two of *The Wedding March*); of sequences cut by the releasing studio (*Foolish Wives*, *The Wedding March*, *The Merry Widow* and especially *Greed*) and of *Queen Kelly* the feature which was only partly completed before production was halted. In addition, *Blind Husbands* and *Foolish Wives* only survive in a shortened form, while scenes were censored from a few of the films too. His special interest in satirizing the behaviour of the decadent nobility in old Europe of the pre-World War I era in such films as *The Merry Widow* and *The Wedding March* led him to include various brothel and orgy scenes considered far too daring and explicit for the time. According to Madison Lacy who worked on *The Wedding March* at Paramount, 'Stroheim shot scenes in a brothel that never have been shown on the screen, and I shot the stills.' One can only speculate from some of the more extraordinary photos on what Stroheim may have had in mind. It is just possible that some of the material was included in the European prints which frequently differed from the version shown in the US. (As a sad epilogue to his career, his only sound film, *Walking Down Broadway* [Fox, 1932] was taken away from him and partly reshot by another director before being released under a new title, *Hello Sister*.)

A leading exponent of naturalistic acting, Stroheim was also known for the richness of visual detail in his films, for his special attention to costumes, set design and backgrounds, often making use of elaborately constructed sets and carefully selected locations. One of the most sophisticated of silent film writer-directors, the subtleties in his treatment of characters, attention to quality of acting, his satirical tone in treating European subjects, ironical juxtapositions of plot and subplot, and the sheer visual impact of his films means that they stand up exceptionally well today. And these same qualities are often captured in the many remarkable stills.

Since the director is the one person who can most

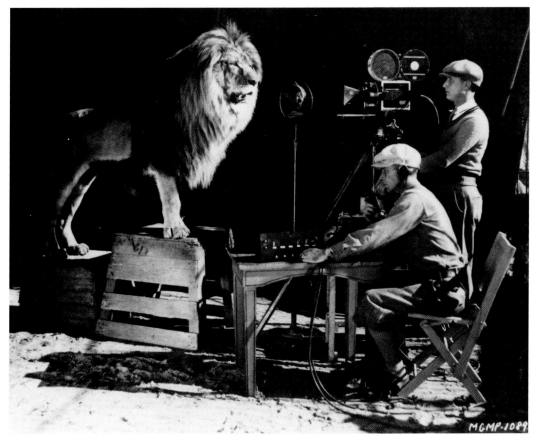

An iconic image marked the end of the silent era: filming (and recording) the roar of the MGM lion.

A mixture of stills was used by Universal to promote this 1926 thriller including all the usual ingredients: secret conspiracies, kidnapping and murder. Directed by Herbert Blaché, it starred Matt Moore, Mildred Harris and Warner Oland.

easily encourage or discourage the taking of stills during the course of a film, it is generally easy to recognize those directors with an interest in the stills, as opposed to those who make the photographer's job impossible. Clearly, Stroheim belongs in the former category. As an actor himself, often the star of his pictures and a famous personality of the silent cinema, he appears to have encouraged the shooting of many interesting photographs on his productions. These included not only the usual scene stills, but many 'behind the scenes' shots, too. It is a sad irony that, without realizing it at the time, he was ensuring that some aspects of his remarkable productions would survive, at least in still form. In all too many cases, the stills are all we have left.

From the stills representing the lost second part of *The Wedding March*, for example, one is struck by the marked contrast between the rough, snowy Alpine settings, the schloss, hunting lodge and peasant characters with the stylized urban setting of Imperial

Vienna of the first part. But most striking of all is the example of Stroheim's masterpiece, *Greed* (1924). Originally completed in an approximately nine hour version, to be shown in two parts, less than one-third was retained in the prints released by MGM. Yet, surprisingly enough, much of the reduction was concentrated in subplots and the long prologue sequence introducing the various characters.

On this, his most highly valued and personal production, filmed entirely on location in and around San Francisco and Death Valley, Stroheim took great care to ensure that the stills photographer, Warren Lynch, was on hand to record every scene as it was being filmed. By comparing the surviving reels of the film with the stills versions of the same scenes, we can see how well the photographer succeeded. Matching the large numbers of additional stills to Stroheim's shooting script, one can only wonder at the remarkable extent to which Lynch appears to have captured the special flavour of the scenes which are lost. It is a clear indication of the nature of Stroheim's achievement, as well as the power of still photography, that not only on the screen, but in the stills too, one has the feeling of an entire milieu brought to life. Rather than actors playing their roles on a film set, it is as if fully rounded characters exist within a real world, captured by the camera. (In my 1967 book on Stroheim I tried to show how one could gain a fuller understanding of the complete *Greed* through re-reading the original novel *McTeague* by Frank Norris and matching Stroheim's shooting script with the large number of stills). A recent attempt to produce a more 'complete' version of *Greed* on video using stills to fill in some but not all of the missing sequences was a dismal failure, as it totally destroyed the flow of the existing footage while adding little. Archivist Herman Weinberg is best remembered for his attempts to reconstruct the complete versions of both *Greed* and *The Wedding March* in photo book form, though one has to turn to Fay Wray's autobiography to discover that the stills man on this latter was William Fraker. (This was not the well-known photographer and cameraman, William A. Fraker, but probably his father who was also a stills photographer.)

Note, too, that *Greed* serves as an early example of a practice that would become standardized in Hollywood during the studio era, whereby the responsibility for the stills photography would be divided between the 'unit stills man' – working closely with director, cast and crew while the film was in production – and the generally better known (and better paid) portrait photographer, who would take the more artistically posed portraits of the leading stars in the studio's photographic gallery. This latter function on *Greed* was handled by the head of the Goldwyn Company's stills department, Clarence Sinclair Bull, who would become a leading photographer at MGM for many years and whose name figures prominently in the chapter which follows.

Charlie Chaplin, seen here with Fatty Arbuckle in *The Rounders*, quickly became the leading star at Keystone shortly after he arrived at the studio. These stills from his only year at the studio – 1914 – are typical of the publicity material for his early comedy shorts – mainly grainy enlargements from the film frame. Even after he became famous and successful there were relatively few scene stills taken on the Chaplin shorts. The cast would be specially posed for one or two scene stills, as illustrated on the following page for *Getting Acquainted*. But otherwise the publicists would make do with the kind of grainy frame enlargements seen here.

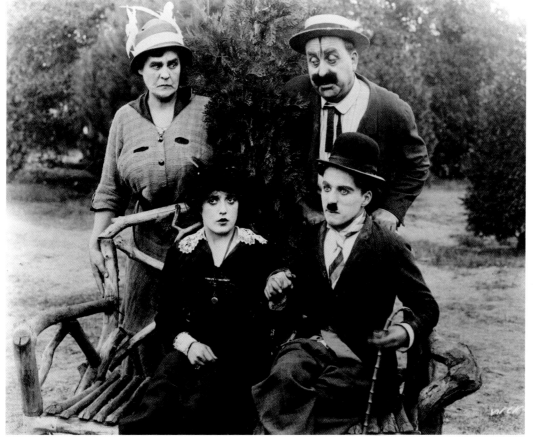

Above: Chaplin and Valentino were but two of the many stars whose portrait postcards were distributed by the early film companies as part of their publicity. Chaplin's importance to Essanay is reflected in the fact that he is No.1 in the company's 1915 series of postcards, but by the following year he had already moved on to Mutual.

Top left: Although Chaplin played the familiar tramp character in his early films, he occasionally varied his appearance, as in *Mabel at the Wheel*, his first two-reeler. Chaplin is seen here with top hat, frock coat and goatee in a scene with Harry McCoy and Mabel Normand.

Left: This obviously posed still from *Getting Acquainted* is loosely based on the sequence when Charlie's wife, played by Phyllis Allen (above left), and Mack Swain catch him flirting with Swain's wife (Mabel Normand). Essentially a group portrait within the park setting where the film was shot, the still is pin sharp, in contrast to the usual frame enlargements.

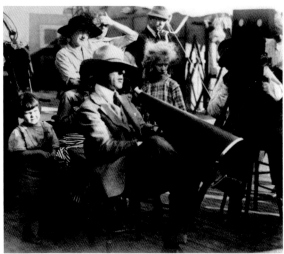

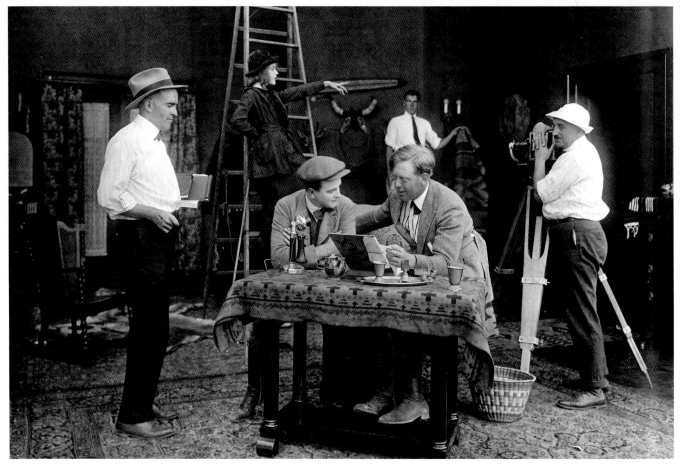

Many production shots were taken on film sets during the mid and late 1910s, providing us with a valuable record of the era.

Top left: In this photo Mary Pickford is visited on the set of her latest feature, *Pollyanna* (1919) by her friends Douglas Fairbanks and Charlie Chaplin. One could never guess from this shot that these were three of the most famous producer-stars in the cinema who had just formed their own distribution company, United Artists, with director D.W. Griffith.

Above: A more typical production still of the period – director (Robert Z. Leonard), stars (Mae Murray and Wheeler Oakman) and technicians all carefully posed on the set of this 1917 production at the Universal studio.

Top right: By the time that this picture was taken, on the set of *Intolerance* in late 1915 or early 1916, cameraman Billy Bitzer and his assistant, Karl Brown (far right), were fully occupied with the filming and the job of stills photography had been taken over as a full time job by James Woodbury.

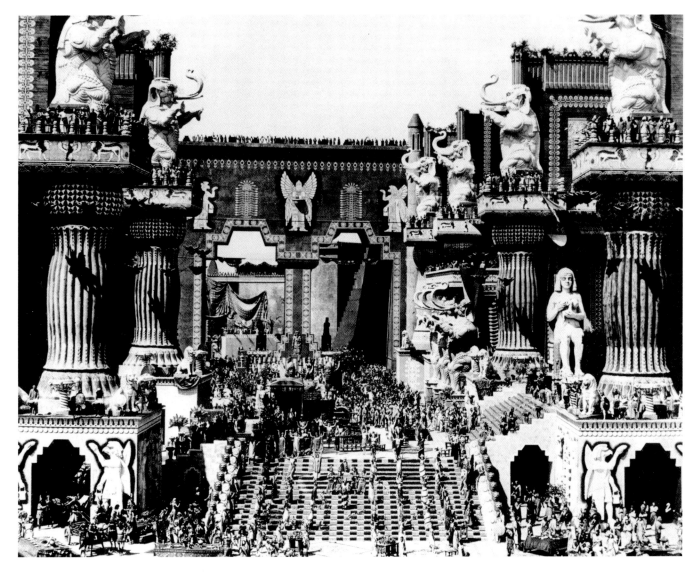

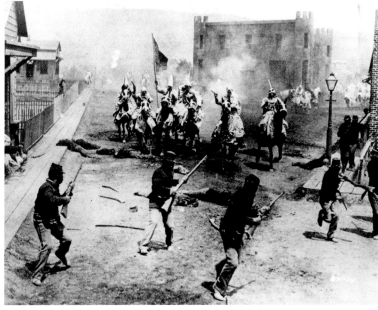

D. W. Griffith was one of the first producer-directors to appreciate the value of quality stills. This image from *Intolerance* (1916) (above) is justly famous for its sheer scope and spectacle, capturing the cast of thousands and sumptuous sets. In contrast, the still from *The Birth of a Nation* (1915) (left) captures the immediacy of this action scene obviously staged for the camera, the composition neatly framed by the diagonals of the street and buildings. Reflecting the racist qualities of the second half of the film, the 'good' Klansmen, all in white, are lit up in the centre, outlined by puffs of smoke, while the black soldiers, partly in shadow, flee in the foreground and out of shot to the right.

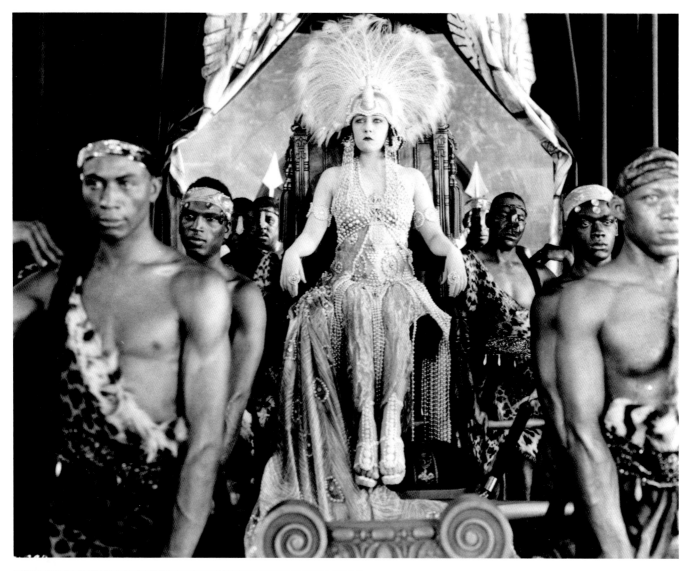

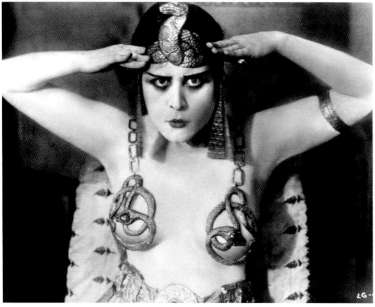

Two memorable, exotic images of the early silent cinema. Gloria Swanson is shown above (probably photographed by Karl Struss). Struss was hired by DeMille for the first time to take still photos on the set of *Male and Female* (1919). The spectacular costumes for the Babylon flash-back sequences were designed by Mitchell Leisen who was also working in films for the first time.

Theda Bara is shown in a characteristic pose as *Cleopatra* (1917), perhaps the best known of her many costume roles around this time which included Carmen, Salome and Madame DuBarry. Movie stills photography was coming into its own in the late 1910s and played an important role in the rapid rise to stardom of both these actresses. The Witzel studio was hired by Fox to photograph Bara in her costume roles in 1917-18.

Opposite page:
This unusual and striking soft-focus portrait of Theda Bara was one of a series taken by the New York photographers Underwood & Underwood to launch her career at Fox in 1915. The use of heavy eye shadow and the wild mane of dark hair contrasts with the very white, bare flesh, while a few pieces of jewellery complete the overall effect.

A striking example here of how a simple production still could also be a remarkable photograph. The film-makers, clustered around the camera, form a neatly balanced composition, lit by the arc lights in the centre of the dark film set. The young Garbo appears radiant, glowing, in marked contrast to co-star Lars Hansen, with director Clarence Brown just behind her and cameraman William Daniels in shirtsleeves behind the camera. The film is *Flesh and the Devil*, filmed at MGM in 1926.

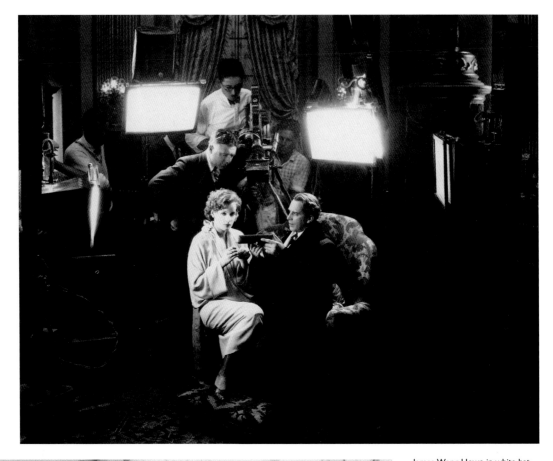

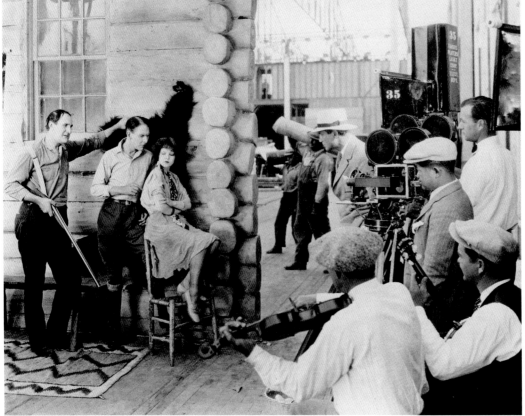

James Wong Howe in white hat and striped jacket filming *Mantrap* in 1926. He too had used his mastery of still photography to further his career. Packed full of detail, this still shows how simply a shot could be accomplished in the silent days. The stars on the left are Ernest Torrence, Percy Marmont and Clara Bow, directed by Victor Fleming (centre), while musicians help to set the mood for the actors and cover up the noises going on in the background. (The last film to be shot on the old Paramount lot, the prop men can actually be seen in the process of moving to the new studio in the background.)

Such was the power of silent film acting that an accomplished actress like Lillian Gish was a natural subject for the stills camera. This photo (opposite) of Miss Gish as Lucy, the tragic heroine of Griffith's *Broken Blossoms* (1919), set in the Limehouse section of London's East End, serves as both a scene still and a touchingly evocative portrait.

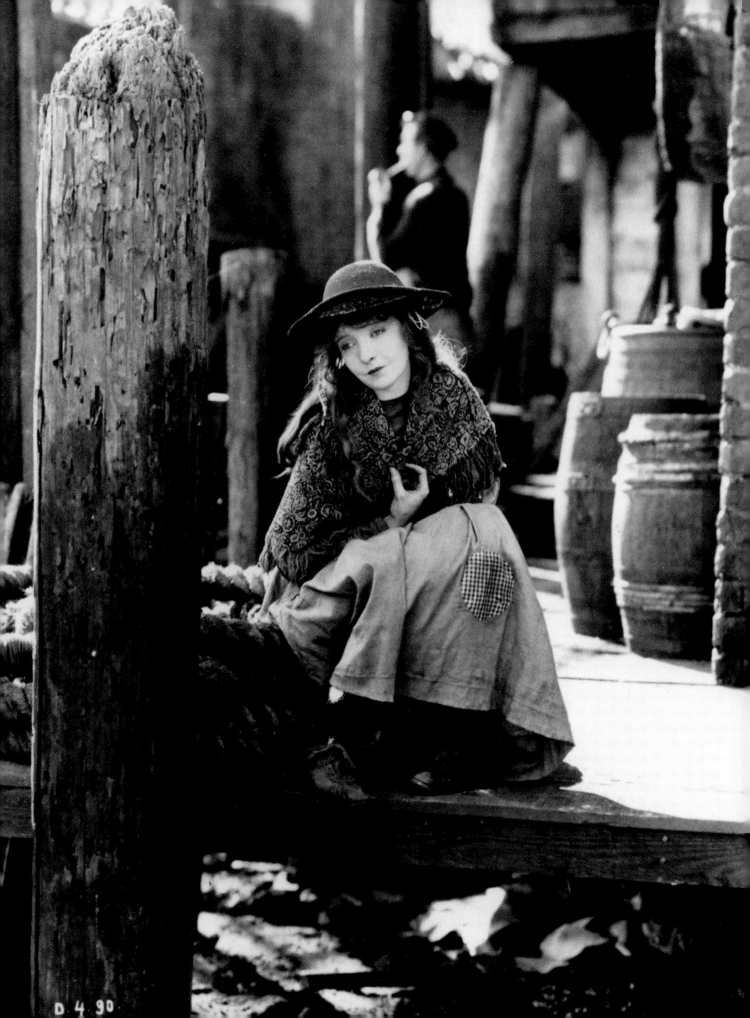

A variety of amusing and revealing behind-the-scenes views taken by stills photographers in and around Hollywood in the 1920s.

Top left: Buster Keaton strikes a characteristically serious pose for the photographer and appears to be signalling for a left turn, on location at Lake Tahoe, California – where he directed and starred in *Our Hospitality* for Metro in 1923.

Top right: An unusual shot of Mary Pickford catches her just emerging from her portable dressing room during the filming of *Dorothy Vernon of Haddon Hall* in 1924, one of her few grown-up roles during the years when she was making the transition from playing little girls on the screen.

Travelling circuses in the US regularly make their winter headquarters in California or Florida, providing an opportunity for making movies during the off season. This picture captures the period flavour of shooting cheap animal comedies at Universal City in the 1920s.

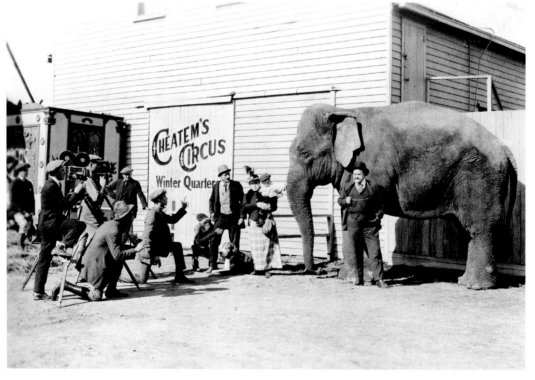

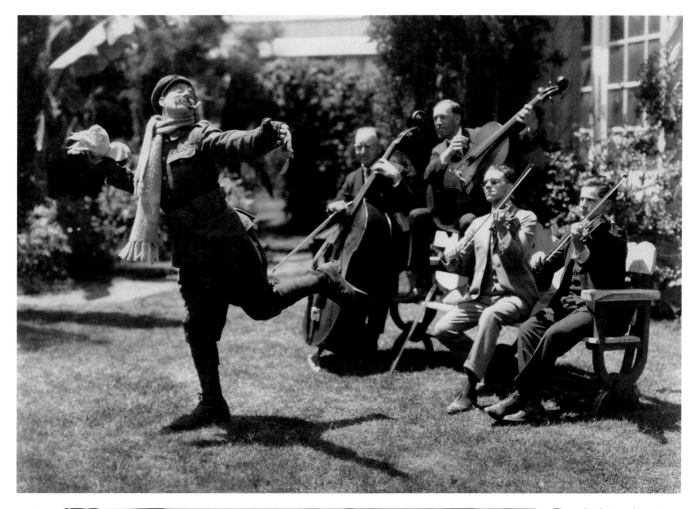

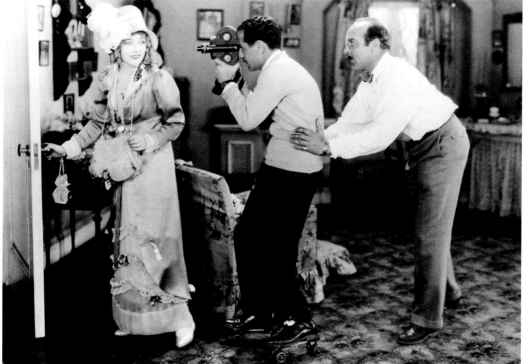

The studio photographers were on call to take a variety of shots of their stars for publicity. Syd Chaplin, the comedy star and older brother of Charlie, is seen here cavorting to the sound of director Mickey Neilan's resident string quartet during a break in filming *The Rendezvous* on the Goldwyn lot in 1923.

Quality Street, an MGM production of 1927, was noteworthy for an ingenious use of the moving camera, both handheld shots and filming from a moving crane. Here director Sidney Franklin aims his new Bell & Howell Eyemo camera, specifically designed for hand filming, at star Marion Davies, while mounted on roller skates to achieve a smooth movement and guided by the assistant director Hugh Boswell. Of course this shot may have been staged specially for the stills camera, but it is quite charming nonetheless.

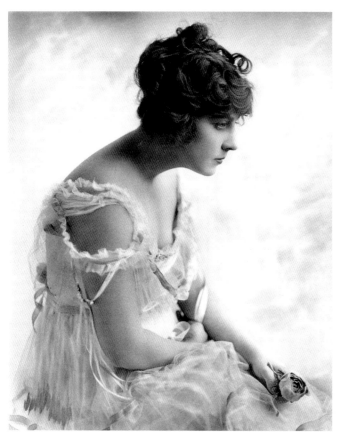

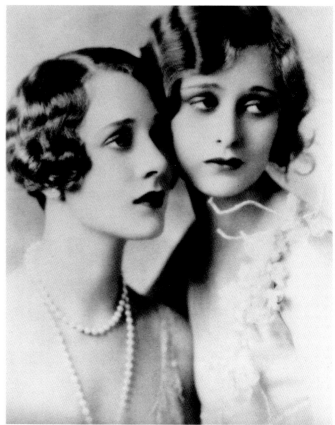

These early portraits present a 'traditional' view of feminine beauty on the screen, making use of soft focus and lighting effects, with props and costumes carefully selected to contribute to the overall effect, especially soft, fluffy or lacey white dresses open at the neck, the occasional, tasteful item of jewellery such as a single strand of pearls, and flowers or blossoms as the favourite props.
Top left: Dorothy Dalton photographed by the Witzel studio in Los Angeles around 1917.
Top right: the actress sisters Helene and Dolores Costello, daughters of matinee idol and movie star Maurice Costello.
Right: a portrait of 'America's Sweetheart', Mary Pickford, made at the Hartsook studio in the late 1910s, one of a vast number of photos of her taken around this time.

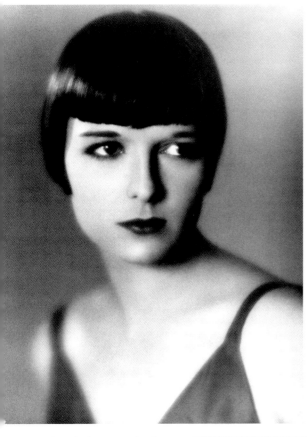

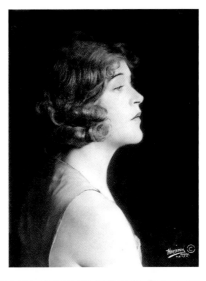

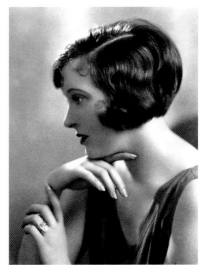

In marked contrast to the photos on the previous page, a sharper and more modern style of portrait photography emerged in the 1920s, as demonstrated most clearly by this late 1920s shot of Louise Brooks (top left) with her familiar bobbed-hair style, disdaining the use of any additional props or jewellery, and wearing a simple low cut dress. Similarly, a surprisingly modern-looking profile shot of Mae Murray (by Hartsook) taken in the late 1910s and later retouched for publication (top centre). However, the 1920s portraits of Clara Bow, (right), and Corinne Griffith, (top right) – this latter by Irving Chidnoff in New York – combine the modern look with a use of back lighting to create a softer overall effect. Finally, the much-photographed Gloria Swanson (below right) in a typically simple but effectively modern fashion pose of 1926. (Note that the original photographer credit on these early portraits can often be found in the lower right hand corner of the picture.)

A small and representative selection of stills from the tremendous number of important silent and early sound films which have been lost forever. The photos, of course, take on an added significance for they give us some idea of what we are missing. In the case of Lon Chaney, for example – the master of make-up and disguises who was fond of totally transforming his appearance in each new film (above) – at least the stills preserve for us the extraordinary mask-like make-up he adopted for his role in *London After Midnight* in 1927. Similarly, no prints appear to survive of Josef von Sternberg's late silent film, *The Dragnet*, starring William Powell and Evelyn Brent (right). W.C. Fields (top right) is best remembered today as the raspy voiced sourpuss of 1930s comedies. But this amusing still from one of his many lost silents, *The Potters* (filmed in 1926), reminds us that Fields had a substantial career in the silents, too, especially at Paramount in the late 1920s.

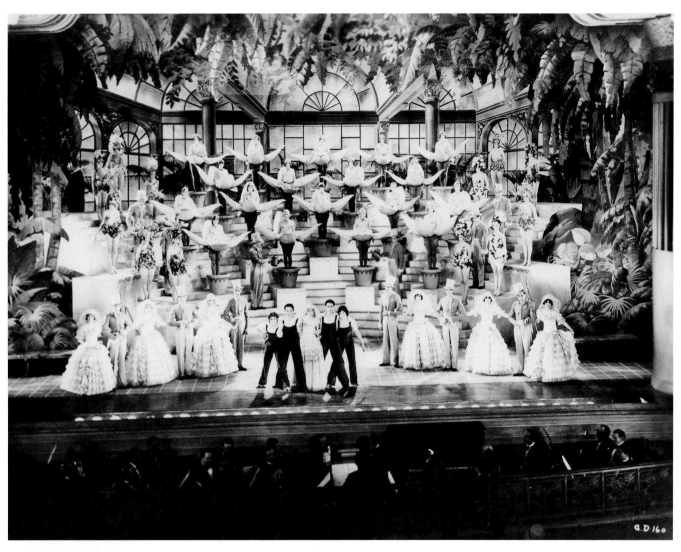

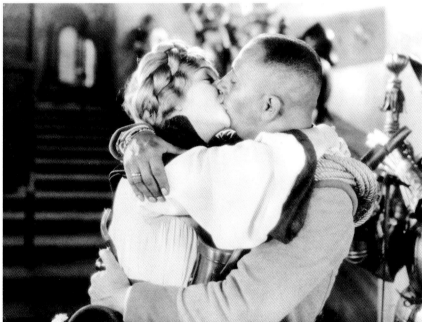

The hit song 'Tiptoe through the Tulips', written by Al Dubin and Joe Berke, was given a spectacular treatment by Warner Bros, in *Gold Diggers of Broadway*, one of a number of early sound musicals filmed in the new, two-colour Technicolor. One can only imagine what this lavish production number originally looked like. Although the film was a big box office hit, all we have to remember it today, unfortunately, are the many black-and-white stills and a single reel of the movie which has been painstakingly restored. Although most of Erich von Stroheim's films as a director have been cut, partly lost or destroyed and heavily censored, only two are lost entirely – *The Devil's Pass Key* (1920) and this late silent, *The Honeymoon* – Part II of *The Wedding March* (1928). Stroheim himself and ZaSu Pitts, were the stars. The film was last seen at the Paris Cinémathèque in the 1950s before this last known print was destroyed in a fire.

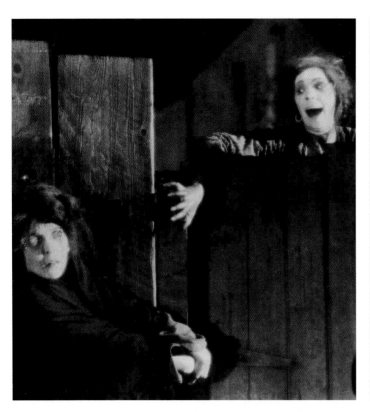

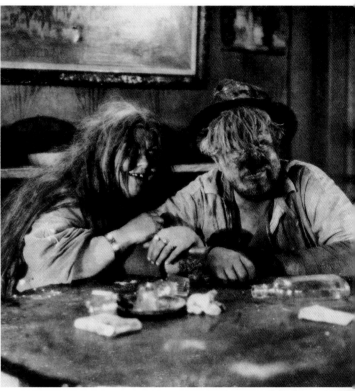

Coming from one of the great masterpieces of the cinema, even in its severely cut form, the many stills from the missing sequences of *Greed*, filmed by von Stroheim in 1923, are so evocative that they give us a strong sense of what has been lost. The cut version is missing most of the prologue, including McTeague's drunkard father (top right), also most of the fantasy sequences and subplots including Maria (Dale Fuller) who returns to haunt the dreams of Trina (ZaSu Pitts) after she is brutally murdered (top left). A scene still at the Sieppe house (right) is packed full of detail and includes all the main characters in characteristic poses; reflecting von Stroheim's strengths as a director, the scene comes remarkably to life in this shot.

Opposite page:
The final reels of the picture were shot in Death Valley under the most difficult conditions. The heavily tanned director is seen here (top left) under the protective umbrella with cameraman Ben Reynolds, directing Gibson Gowland, whose hair has been bleached white by the sun (top right). Earlier in the film Gowland is seen with Jean Hersholt on the San Francisco boardwalk by the sea in another missing scene (below).

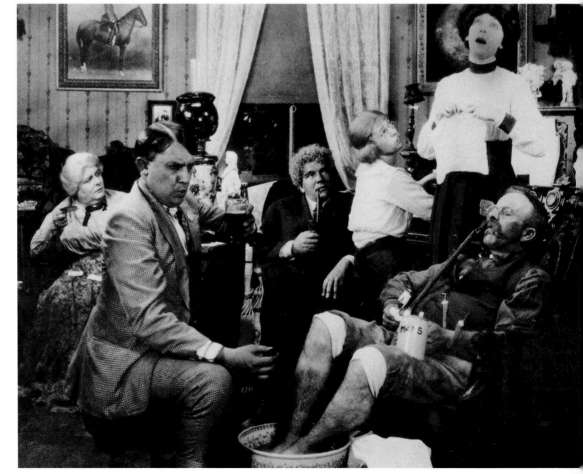

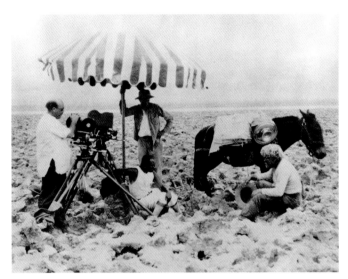

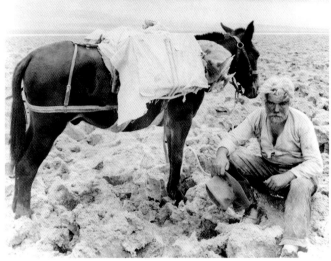

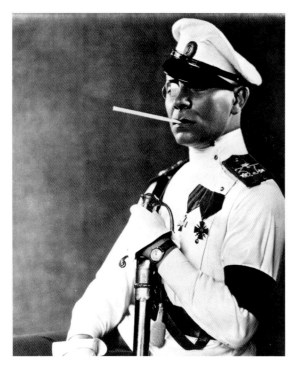

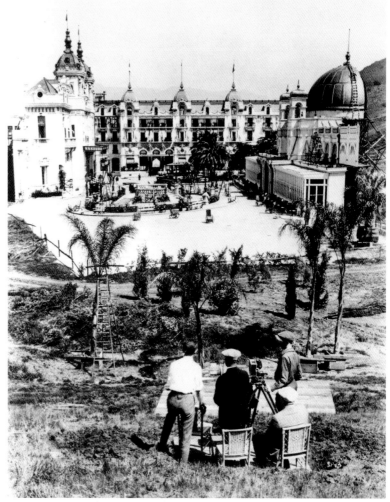

The stills above and right are from Stroheim's remarkable third feature, *Foolish Wives*, filmed for Universal in 1920-21. Above is the archetypal image of Stroheim himself, impeccably dressed in his spotless white officer's uniform – complete with monocle and long cigarette holder – playing the villainous lead character, Count Karamzin. The stunning production shot shows Stroheim in white cap with his assistants planning the

Monte Carlo sequences. (Stroheim himself also collaborated with Richard Day in designing the impressive outdoor set.)

(Below) As both actor and director, Stroheim's face was familiar to movie-goers in the 1920s. Here he examines a publicity photo at MGM in 1925 around the time that he was directing *The Merry Widow* (below right).

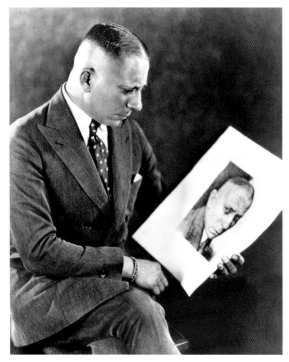

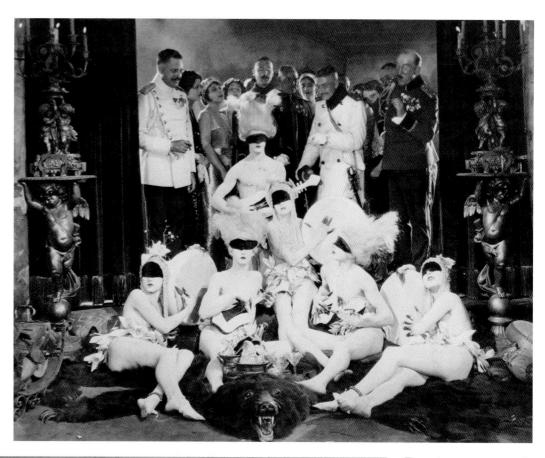

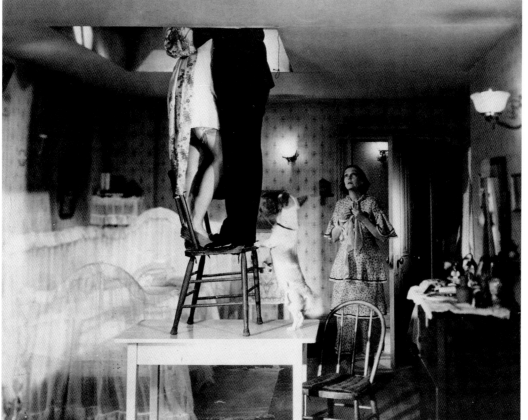

The erotic content was extremely important in many of Stroheim's films and is best illustrated with this pair of stills from his personal reworking of *The Merry Widow* in 1925 (above and opposite below right). He introduced many characteristic touches into the light and frothy original story, in order to make it an altogether darker and more complex work. Some of these scenes were, of course, cut from the final version of the film, either by the censors or by the horrified studio bosses at MGM. Thus, the stills serve to remind us, in a small way, of what we are missing. Finally (left) an evocative and sexy photo from Stroheim's last production as a director, *Walking Down Broadway* (1932) starring ZaSu Pitts. A remarkable still which neatly captures the feel of the scene and is packed full of interesting detail, like Stroheim's films. However, the scene does not play quite like this in the final version of the film.

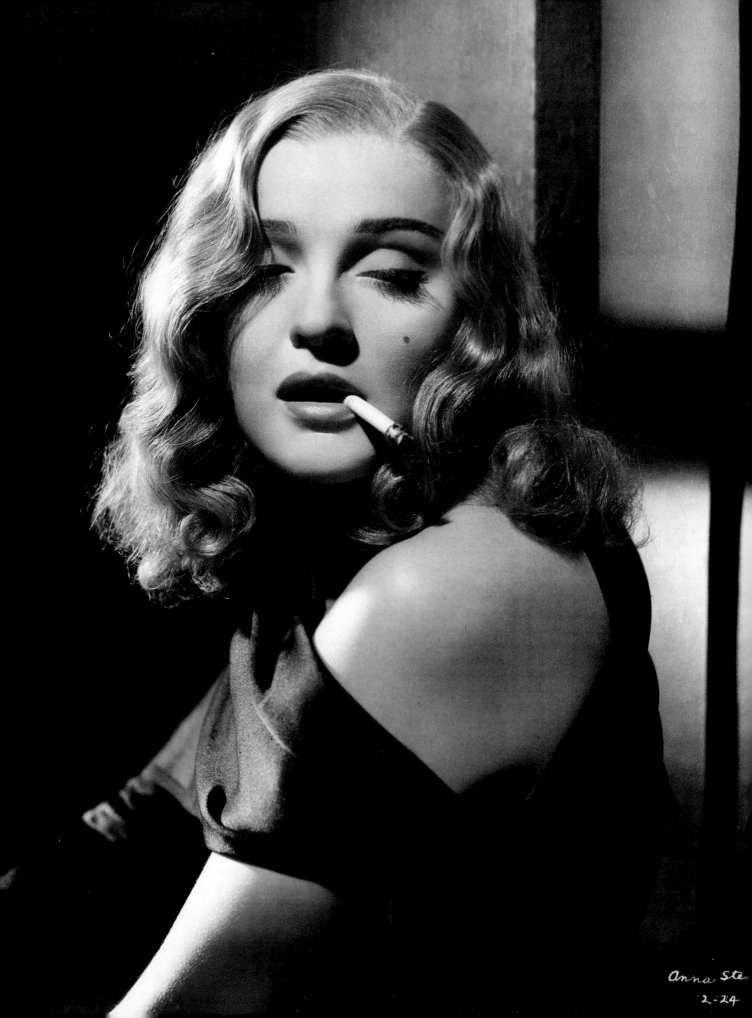

CHAPTER TWO
HOLLYWOOD STARS AND PORTRAITS

The portrait and stills photographers fulfilled an essential role during the peak years of the studio era which lasted from the late 1920s to the early 1940s, for this was the period when the star system flourished. The studios especially depended on the photographers, who played a major role in first grooming and developing potential new star prospects, then in creating their special image and helping to maintain their popularity once they had been established on the screen. At the same time the studios were turning out large numbers of films, averaging 40-50 features a year along with shorts, documentaries and cartoons. Thus, they employed a full time staff of photographers to take scene stills for each of the features and a wide range of other types of photographs behind-the-scenes to help in publicizing the studio and its films as well as the stars and other leading studio personnel.

This period was characterized by centralized control over the movie-making process. Each of the large studios was a veritable movie factory, organized for maximum efficiency and divided into a large number of specialized departments ranging from camera and art departments to special effects, wardrobe, make-up and, of course, stills photography, which was closely affiliated with, or under the control of, publicity. The department heads were often important figures in the industry, wielding a great deal of power behind the scenes. A figure such as Cedric Gibbons, who headed the MGM art department for thirty years, exercized a greater influence on the typically glossy and stylish look of the studio's pictures than any other single individual, including the studio bosses. Similarly, the matching style of the MGM still photographs was the responsibility of Clarence Sinclair Bull who headed the stills department for over thirty years and was Garbo's favourite photographer.

During the 1930s in particular, the studios devoted much of their time and energy to discovering new stars and exploiting them in appropriate star vehicles. Promising newcomers were carefully schooled for stardom and could be given on-screen experience as they worked their way up from bit roles to supporting roles and then leads. But before they had even appeared on screen for the first time, and even prior to their screen test, they would be photographed by the

stills man, as part of the typical routine of developing a particular image for the player which could then be tested on the public. After the make-up and hairdressing departments had done their bit and the appropriate costumes had been selected from wardrobe, an appointment would be made for a photo session with the stills photographer, who would endeavour to capture the new image on film in the most flattering manner possible. A variety of suitable portraits would then be selected to be sent to newspapers and fan magazines and the new star was on his or her way (see pages 48 - 51).

As part of the standard buildup, the studios would devote much time and effort to developing an attractive and appealing public image for their stars, and were then prepared to work hard to popularize and sustain this image over many years. However, many of the stars naturally resented the exceptional degree of control which the studio maintained over their lives and appearance. The studios invariably tried to fit the newcomers into a preconceived and conventional idea of beauty and glamour based on the stars who happened to be popular at the time. In the 1930s, for example, there were innumerable Garbo and Dietrich look-alikes among the many actresses imported from Europe, such as Gwili Andre, Tala Birell, Anna Sten and Isa Miranda. Similarly, at the time that Bette Davis was first signed up by Warner Bros, her appearance was restyled and hair dyed blonde to imitate the look of Constance Bennett. She credits make-up expert Perc Westmore with creating her new look, but resented some of the superficial and unsuitable roles that went with it at the time in such films as *Three on a Match* (1932) and *Fashions* of 1934. And there were the inevitable fan magazine spreads pairing her with other Hollywood blondes such as Carole Lombard (see page 46).

In her autobiography, *The Lonely Life*, Miss Davis recalls her earliest memories of Hollywood and refers disparagingly to 'what they called photographic tests. They supposedly found out your good angles and your bad angles. All I wanted to do was act!'

Anyone who did not fit into a readily identifiable mould was regarded as a problem. Thus, the conventional view of newcomer James Stewart was expressed

Following in the wake of Garbo and Dietrich, many producers went looking for Continental beauties who could emulate their success. Clearly, Anna Sten fitted into the Dietrich mould. Stills such as this one played an important part in developing and publicizing her. She was given the full star treatment for over a year by producer Sam Goldwyn, including dancing, singing and English lessons, while vast numbers of photos of her were placed in newspapers and magazines and blown up on huge billboards all over Manhattan before she was launched on the American public in the role of Nana early in 1934. However, such a carefully lit and posed portrait, complete with cigarette, appears too much like a Dietrich parody – which probably sums up Anna Sten.

by portrait photographer Ted Allan. As he recalled, 'Two years after Stewart had been with the studio [MGM], we still didn't know what the hell to do with him...' They attempted to give him a more athletic and romantic image, like Robert Taylor: 'We tried photographing him outside leaning over fences, working with a shovel, with a tennis racquet... but it didn't work...' And Allan concludes his remarks by admitting that 'I wouldn't have guessed he would become a star.' Of course, Allan's assessment fails to take into account Stewart's special talents as an actor, his sensitivity and thoughtfulness and uniquely expressive voice. These comments probably reflect the attitude at MGM where there already was a long list of contract stars. And it is worth noting that Stewart got his best, early starring opportunities on loan-out to other studios – RKO for *Vivacious Lady*, Universal for *Destry Rides Again* and Columbia for *Mr Smith Goes to Washington* – rather than at his own MGM.

Although this system of developing new star talent was perfected in the early 1930s, more or less the same pattern continued to be followed during the 1940s and 1950s, too. Thus, a young Shelley Winters was horrified by the initial studio assessment of her in the early 1940s: 'The hair is too dark blonde and kinky, but we can straighten and bleach it. Forehead too low: we'll take care of that with electrolysis. Eyes slant the wrong way, eyelashes should take care of that. Nose too wide – we may have to operate... lips too thin; make-up will take care of that. Teeth crooked, caps needed. Shoulders too broad, bosom too flat', etc., etc.. And in the 1950s, over twenty years after Bette Davis, the young actress, Dina Merrill, was similarly disappointed to discover that the producers at 20th Century-Fox were more interested in how she

photographed than in whether she could act.

There was an obvious contradiction here between the attempts to force all newcomers into a pre-existing mould and the fact that an essential element in establishing oneself as a star was an individuality that was uniquely the star's own. In addition, photographer Ernest Bachrach has drawn attention to the important distinction between acting in front of the movie camera and posing for photographs:

> *It is a common misconception that screen stars are inevitably easy subjects for the portrait photographer. Not by any means... They often become painfully self-conscious and camera shy in the portrait gallery. On the set the star is completely immersed in his creative work... his mind is completely absorbed by his character- ization, direction, and so on. In the portrait gallery, on the other hand, he has nothing to think about except that he is being photographed.*

Among the men, Spencer Tracy, James Cagney and Humphrey Bogart were known as difficult subjects for the portrait photographers, while the women were generally more amenable and benefited accordingly. However, Irene Dunne was one of the actresses who did not enjoy posing and refused to discuss this aspect of her career when giving interviews. But perhaps Shirley Temple presents the most unusual example of a leading 30s star who strongly disliked posing for photographs. Rated the top box office attraction in Hollywood for four years, from 1935 when she was seven years old to 1938 when she was ten, little Shirley was more than just a movie star. Such was her fame and the appeal of her name and image that they were licensed to appear on, and help promote, a great variety of products ranging from dresses, hair ribbons and novelty soap to cutout books, sewing sets, pocket mirrors and especially Shirley Temple dolls which sold in the millions. So great was the demand for photographs of her that her studio, 20th Century-Fox, was desperate to get as many portraits taken as possible. In her autobiography, Shirley Temple Black recalled that as a young girl she had regarded the still photography sessions as especially 'gruelling':

> *Generally I tolerated the whole process, but sometimes after hours of being dressed, redressed, and posed, photography grew awfully wearisome. Others decided what I would wear, how to stand or sit, I was never consulted as to what might be a good pose... 'You've got enough already,' I blurted after one particularly onerous session. The photographer was offended... We struck a bargain. I would stop my bellyaching, but he would take only one shot for each pose... I did my best to strike the required poses, but raised one finger each time to remind him of the single-shot promise.*

Three Shirleys in one – the real Miss Temple poses with an authentic Shirley Temple doll wearing a genuine Shirley photo badge. As Hollywood's leading box office star in the mid-1930s, she was the most photographed child star ever. She was extremely photogenic and easy to photograph, in spite of the fact that she did not enjoy the frequent photo sessions at all. Of course, photos of her were in great demand, far greater demand than her studio, Fox, could ever meet. Similarly, there was a world-wide market for everything that bore the Shirley Temple image.

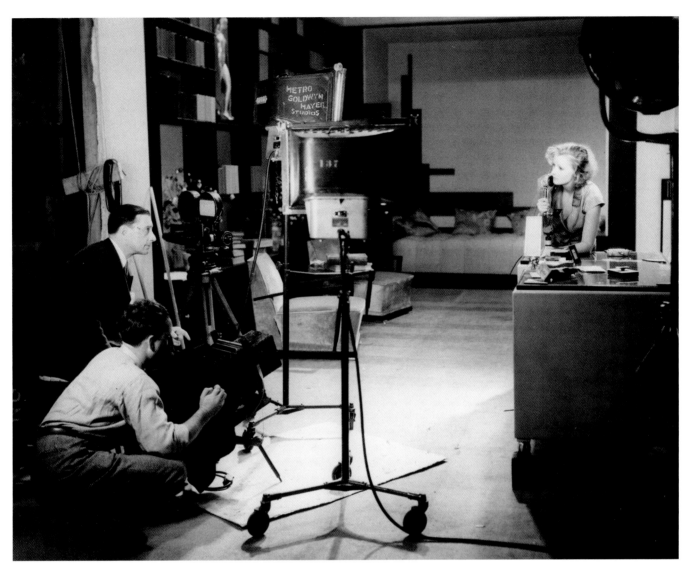

Though a few of the top men such as Gary Cooper, Cary Grant and Clark Gable were frequently photographed in the 1930s, the decade is best remembered as Hollywood's golden age of glamorous women. Such actresses as Joan Crawford and Katharine Hepburn enjoyed being photographed and made a big effort to help, rightly realizing that quality photographs were extremely useful in promoting them and their films. And, of course, many of the famous portraits are of the leading stars, yet a significant proportion of the most memorable images were of actors who are totally forgotten today. Clearly, still photographs alone never made a star.

The contract system of the period played its part here as in everything else relating to 1930s film-making, with stars and photographers (and just about everyone else) under long term contract. This made it easier for the portrait men to get to know the stars and develop a good working relationship over the years. Although all the studio players were obligated to pose for publicity photos, as part of their contract, they

could be choosy regarding the photographers they would work with, unco-operative in arranging appointments, and unpredictable as to when they would actually turn up. Among the many examples of long and close working partnerships between photographer and star were those of George Hurrell and Joan Crawford, Ernest Bachrach and Katharine Hepburn (at RKO), Frank Powolny and Loretta Young (at 20th Century-Fox), Robert Coburn Sr. and Rita Hayworth at Columbia in the 1940s, and especially Clarence Sinclair Bull and Greta Garbo at MGM.

Their relationship was a very special one since Garbo refused to do portrait sessions with anyone else after 1930. (She had previously been photo-graphed by the only woman among the top portrait photographers, Ruth Harriet Louise, who had retired from MGM in 1929.) Bull regarded her as 'the easiest of all stars to photograph. She seems to feel the emotion for each pose as part of her personality,' he wrote in his unpublished notes. 'She actually works harder when posing for portraits than she does before

A rare glimpse here of a stills session with the star Greta Garbo on the deserted set of *The Kiss*, her last silent film in 1929, with French director Jacques Feyder and her favourite MGM photographer Clarence Sinclair Bull. According to him, 'She didn't like the camera too close, so we used long lenses to get close-ups.'

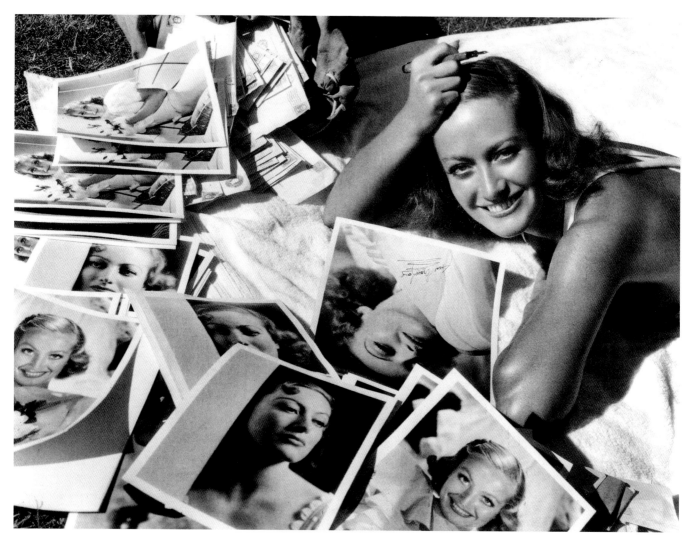

Some of the stars took their responsibility to their fans very seriously indeed. Joan Crawford claimed that she always answered her own fan mail and signed the photos, too. 'I never used a stamp... [though] I know many stars who did...' This rather modern-looking photo was taken in 1933, as one can tell from the postmark on the envelopes. Caught by the photographer in a candid moment, Crawford appears much more like the girl next door getting a tan in her garden than the more familiar star image of her, heavily made up, with special emphasis on her full lips and large eyes.

the motion picture camera... She considers the posing as part of her screen work and feels absolute concentration is necessary... She never seems to tire of posing.' In addition, Bull appreciated the fact that she was 'quick and decisive' in going through the 8 x 10 proofs of her all-too-rare sittings. All she approved were used for publicity due to the demand for photographs of her. (Since portrait sessions were related to her films, the shortage of photos was due to the fact that she appeared in only five features during 1935-41 before her retirement in 1942.) The relatively small number of new Garbo photos released during these years is in marked contrast to the vast numbers available from the other top stars.

In fact, all the leading studios employed a staff of portrait and stills photographers (see the accompanying table). Their quality and numbers generally reflected the importance of each studio's players. Thus, MGM easily tops the list, followed by Paramount and Warner Bros. Columbia, however, had relatively little interest in portrait photography prior to the early 1940s. Only when the studio began promoting its new star discoveries and especially Rita Hayworth, did it

begin to hire portrait men of the calibre of Bob Coburn, Whitey Schaefer and George Hurrell to help publicize them and their films.

It was inevitable that once the film studios had taken over the responsibility for the star portraits in the 1920s, there would be many changes. In addition, the changeover from silents to the early talkies altered the way that films were made and this had its parallel in still photography style. The 'artistic' soft focus effects of earlier years now began to look old fashioned, and a sharper, new and more modern style was born – matching the new look of the movies, many of them featuring a new generation of stars.

For established silent actresses such as Norma Shearer and Joan Crawford it was not only important to demonstrate their ability to handle dialogue, but it was also useful to update their 'image' as well. It was appropriate, for example, that George Hurrell began to take his first photos of MGM stars around this time. His earliest portraits of Norma Shearer in 1929, when she was filming her first talkies, gave her the opportunity to break with her previous 'wholesome' image: they projected a more modern and sexually

A Selective List of the Leading Stills and Portrait Photographers During the Peak Years of the Studio Era

Columbia
William Fraker (1927-34)
Irving Lippman (1933-39, 1947-56)
Robert Coburn Sr. (1940s to 1950s)
A. L. 'Whitey' Schaefer (1934-41)
Bud Fraker (1934-42)
George Hurrell (early and mid 1940s)
William Cronenweth (1940s)
Robert Coburn Jr. (1950s)

Fox/20th Century-Fox
Witzel (late 1910s)
Frank Powolny (1923-1966)
Max Munn Autrey (1925-33)
Alex Kahle (early 1930s)
Gene Kornman (1933-53)
Otto Dyer (1933 to late 1930s)
Jack Woods (late 1930s)

Metro-Goldwyn-Mayer
Clarence Sinclair Bull (1924-1961)
Ruth Harriet Louise (1925-29)
Bertram 'Buddy' Longworth (1926-29)
Homer van Pelt (late 1920s)
Virgil Apger (1930s, 1947-69)
William Cronenweth (1930s to early 1940s)
James Manatt (late 1920s to 1940s)
George Hommel (1930s)
Eric Carpenter (1933 to early 1940s, 1950s)
Ted Allan (1933-38)
Laszlo Willinger (1937-46)
Bud Graybill (late 1930s to early 1950s)

Selznick
Ted Allan (late 1930s)
Fred A. Parrish (1939 – Gone with the Wind)
Madison Lacy (1945-46)

Goldwyn
Kenneth Alexander (1925-35)
Donald Biddle Keyes (mid/late 1930s)
Robert Coburn Sr. (1935-40)
George Hurrell (early 1940s)

Republic
Roman Freulich (1945 to 1950s)
Donald Biddle Keyes (1945-54)
Mickey Marigold (1948-50)

DeMille/P.D.C.
William Herbert Mortensen (1926-30)

Paramount
Eugene Robert Richee (1921-41)
Donald Biddle Keyes (early 1920s)
Ernest Bachrach (mid-1920s at Astoria Studios)
Otto Dyar (1925-33)
George Hommel (late 1920s)
John Engstead (1930s to 1941)
Don English (1930s)
William Walling (1930s)
A. L. 'Whitey' Schaefer (1941-51)
Bud Fraker (1940s and 1950s)

RKO-Radio
Ernest Bachrach (1929 to late 1950s)

Robert Coburn Sr. (1929-35, 1938-40)
John Miehle (1930s)
Fred Hendrickson (1930s to early 1940s)
Gaston Longet (1930s to early 1950s)
Alex Kahle (1935 to early 1940s)
Emmett Schoenbaum (late 1930s)
Wallace Sewell (late 1940s)

Universal
Jack Freulich (1922-35)
Roman Freulich (1920s to early 1940s)
Buddy Longworth (early/mid 1920s)
Ray Jones (1930s to 1958)
Sherman Clark (1930s and 1940s)
Mickey Marigold (early 1930s)
William Walling (1940s and 1950s)

Warner Bros.
Elmer Fryer (1929-40)
Fred Archer (late 1920s)
Scotty Welbourne (1930s to 1945)
Bert 'Buddy' Longworth (1930s to 1945)
Bert Six (1930s and 1940s)
Madison Lacy (1930s to early 1940s)
Irving Lippman (early 1930s)
Homer van Pelt (1930s)
Mickey Marigold (1930s to early 1940s)
Mac Julien (1935 to 1946)
Martin Munkacsi ('Muky')
 (late 1930s to mid 1940s)
George Hurrell (1939-1940)
Jack Woods (1940s)
Eugene Robert Richee (1940s)
Floyd McCarty (mid 1940s to mid 1950s)

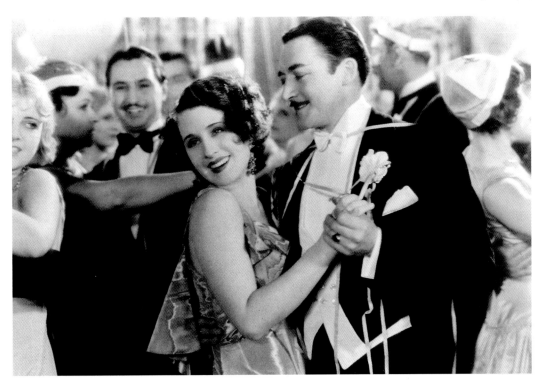

This still from *The Divorcee* captures the new, sexy look of Norma Shearer (dancing with Theodore von Eltz). Still photography played an important part in helping Shearer to change her image with the coming of sound in 1929, and thus make a smooth transition to the more modern type of roles characteristic of the early talkies. Norma Shearer maintained her position as a leading MGM star virtually up to her retirement in 1942 (with the help of her husband, Irving Thalberg, of course).

provocative quality, helping her to land the lead role in *The Divorcee* (1930) for which she won an Oscar, giving her career a new lease of life in the 1930s. Similarly, his portraits of Joan Crawford around the same time helped convince the studio bosses to take her more seriously as a dramatic actress. She was thus more easily able to break free from the frivolous, 'jazz baby' roles with which she had previously been identified.

Similarly, Phyllis Calvert has recalled her experience at Gainsborough in England in the 1940s. "I wanted to break out of 'goody' parts, and I wanted to play bad roles, too. On *Madonna of the Seven Moons* I managed to get the stills photographer to take me in two different parts, the good (girl) and the bad. And I gave them to the production manager and that's how I got the part."

In Hollywood in the early 1930s there was a new interest in shooting close-up photographs of the stars rather than the medium or full length portrait shots which had previously been regarded as the norm. By getting closer in, the photographers gained an added impact, immediacy and intimacy while achieving all that was expected of them. For example, they were required to keep the images relatively simple and easy to reproduce. A basic head shot against a plain background was most suited to the demands of the large number of newspapers and pulp magazines where the quality of reproduction was poor. More complex shots, making use of subtle lighting effects, could be used only in the better quality fan magazines and picture magazines. And though the photographers were still using a bulky 8 x 10 camera, similar to that of earlier years, by the early 1930s they were able to take advantage of newly improved and more sensitive lenses and faster film stock, all of which made their job considerably easier.

The large negatives were full of detail, yet could easily be altered by the small army of retouchers who were employed by each studio for just such a purpose. As Willinger recalled,

It used to take about three or four hours to retouch one negative. We had very good retouchers there at MGM, and we had anywhere from 300-400 [contact] sheets a day, which took some time! The average retoucher did three negatives a day.

And once the Hollywood production code began to be strictly enforced by the Hays Office, during the middle and late 1930s, it was applied to the stills as well as to the films. In fact, there was a separate advertising code which had first been adopted in 1930. But the formation of an Advertising Advisory Council, as a branch of the Hollywood Production Code Administration to more strictly enforce the provisions of the advertising code, only occurred towards the end of 1933, when there was a serious effort made for the first time to enforce all the provisions of the Code. This meant that, from this date on all publicity material, including film stills, had to be submitted to the AAC for approval. It was then the Council's job to make sure that the material conformed to so-called contemporary 'norms' of good taste.

Not surprisingly, the Council paid special attention to the publicity photos of the young women stars in particular, and a large proportion of the stills rejected were pin-up or 'leg art' shots of female players. According to Laszlo Willinger, at MGM, 'there was a whole group of retouchers who did nothing but take the shadow out of the cleave of the breasts... and you could not show the inside of the thigh'.

Not surprisingly, the photographing, processing and placing of black-and-white stills in the many local and national publications was a major studio activity in the 1930s. The general standards were remarkably high considering the vast number of photographs involved. For example, according to biographer Bob Thomas, when Joan Crawford generously invited the young actress, Gail Patrick, to attend one of her photo sessions with George Hurrell, Gail was amazed to see her posing for literally hundreds of shots while providing a running commentary on how to get the best effects with make-up and clothes. As for Carole Lombard, Paramount released over 1700 portraits of her during the years she was under contract (1930-37). Yet she was often photographed at the other studios as well, for many of her best pictures were made on loan out (*Twentieth Century* for Columbia, *My Man Godfrey* for Universal and *Nothing Sacred* for Selznick). And Scotty Welbourne claims to have taken almost 700 photos of Miss Lombard in one day when she was starring in *Fools for Scandal* at Warner Bros, in 1937.

A photo session with Scotty Welbourne in 1940 to publicize his role in *High Sierra* helped to create a tough new star image of Humphrey Bogart and relaunch his career (see pages 68 - 69).

According to film historian John Kobal, the group of six staff photographers at Paramount in 1932 averaged about 250 negatives per day, of which about one third would be usable, while, during the course of a year, the publicity department would send out almost a million still photographs. Similarly, around the same time the Warner Bros, photography department under Gene O'Brien had 30 full-time employees, including retouchers, developers, printers and lab technicians in addition to the stills photographers who averaged about 300 photographs per day. On each production photographers would generally provide the publicity department with well over 500 usable stills.

In spite of having to work with large 8 x 10 cameras, their special portrait galleries were so well equipped, and aided by numerous assistants, the portrait photographers at each studio were able to turn out a vast quantity of superb portraits. In a recently filmed interview (which appeared in the television documentary *Face Value: The Hollywood Portrait*), Bob Coburn Jr recalled his early experience as a boy watching his father at work in the gallery at Columbia:

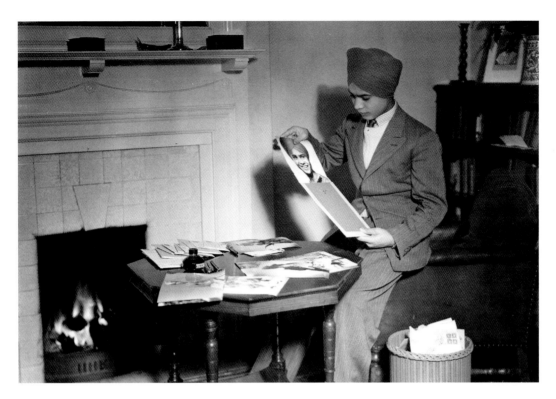

All 1930s stars were expected to devote some of their free time to answering fan letters and signing 8 x 10 photos of themselves. Here the young Sabu, still attending school at Beaconsfield, is seen with a selection of photographs taken at Alexander Korda's London Films studio at Denham. He would soon be going to Hollywood where he would star in various exotic films including *The Jungle Book* and *Arabian Nights* (1942).

I can remember, he shot practically all his portraits on 8 x 10... and he had swings and tilt on the camera, this way and that, he could almost make it sing, he was turning it so fast... He had 8x10 holders stacked up so high in just a few minutes, in half an hour... There would be a runner from the lab who would take them away and bring him more. He had an assistant handing them (the unexposed plates) to him, and he could reach behind and insert them in the camera without breaking his concentration. He didn't like to look around as he talked to the actress...

The many remarkable portraits which survive from this era have gained a special nostalgic value for us today. The best of these photos not only capture an immediately recognizable image of the star, but also achieve a generalized and universal quality which is timeless in its appeal. They are the idealized cultural icons of the Hollywood dream factory at its peak. Aiming to create a strikingly glamorous image, the photographers were masters at manipulating light and shadow to virtually 'recreate' the faces of the stars – with some assistance from the hairdressers and make-up experts and finally the retouchers. Often they were so artificially posed and lit, and so extensively retouched, that the end result bears only a slight resemblance to the true appearance of the stars themselves. (Possibly some of the more difficult subjects, who resented the portrait sessions – for all the stars were bound by their contracts to pose for publicity shots – were reacting against the predictably artificial and heavily retouched pictures which they knew would result.)

Not surprisingly, some of the leading photographers, such as Eric Carpenter and Laszlo Willinger, both of whom worked at the giant MGM studio during the peak years, were themselves quite critical of the studio methods. Carpenter, for example, was unhappy about the fact that 'at Metro, once you took the photos, they were out of your hands. You could give suggestions as to how you wanted them printed, but that was it. You were very limited by the studio's image of itself.' Similarly, Willinger, a Jewish, Hungarian-born refugee from Nazism, who arrived around the same time as Carpenter and was already an established photographer of note, was generally disappointed with his experience at MGM, the largest and most successful of the studios. 'It was an archaic system,' he recalled in 1979, and 'there were lots of rules.' In addition, 'the people who made the final selection didn't know the first thing about photographs,' while most of the stars themselves all too readily accepted the conventions of the system. 'You know, when I first showed the stars their photos, they were already touched up like mad. And I said, "This is what you look like, now let's see what we can do..." And no one, including the men, ever said, "This isn't me."'

The photographer's job was further complicated by the fact that all the leading stars had the right to approve or reject the portraits which they did not like. Even many years later it was a rare star, such as Lauren Bacall, who would make use of her veto to get rid of all the glossy and heavily retouched portraits instead. According to photographer Cornel Lucas: 'A picture for the police, Mr Lucas, a picture for the police,' was her unusual request to him.

A typical early portrait of Bette Davis shows her as a young blonde starlet given a glamorous new image by the Warner Bros. studio in the early 1930s. In spite of the artificiality of the pose, some of her special qualities as an actress shine through. The very whiteness of the slightly overexposed image means that the actress's wide intelligent eyes are especially highlighted.

In marked contrast to the photo above, here she is, a few years later as a leading Hollywood star, in an intimate portrait session with leading Warner Bros. stills man, Elmer Fryer. (He holds a remote release cable attached to the large stills camera behind him.) Her stylish hat and costume for *The Sisters* (1938) were designed by Orry-Kerry, her favourite costume designer at Warners during the 1930s. The only props are a period lamp, an elaborately decorated wooden chair and a small table covered by a white lace cloth. In this carefully arranged composition, lights and camera neatly frame the action. Miss Davis is clearly the centre of interest, one side of her face lit up, smooth as ivory. In sharp focus, she is outlined against the bare background, though a few shadows play on the wall behind her.

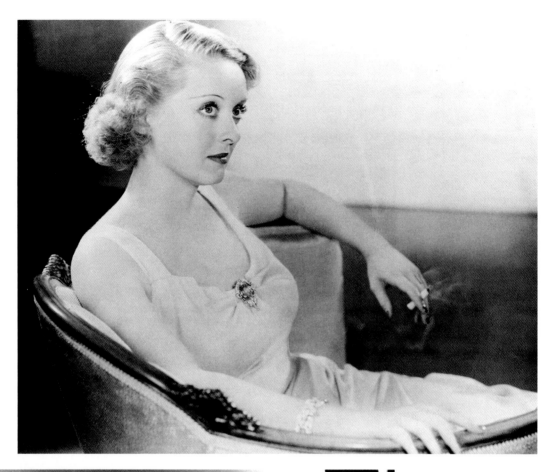

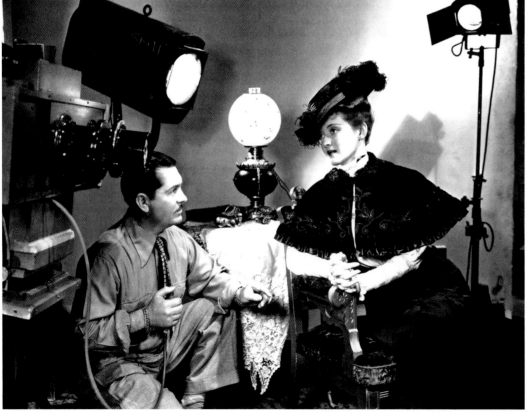

Opposite: A spotlight aiming from above lights up her hair and forehead and her slightly overexposed face is washed out of all extraneous details, aside from the pencil-thin eyebrows and slight shadows revealing high cheek bones. Outlined by the dark, high-collared dress she is wearing, Dietrich's mask-like face has an unreal, ethereal quality to it. The only bit of decoration is provided by a pair of round white (pearl?) earrings which match the ring on her finger. This is the ultimate in glamorous 1930s portraiture, the kind of photo which helped to create the legend of Marlene Dietrich as the exotic woman of mystery.

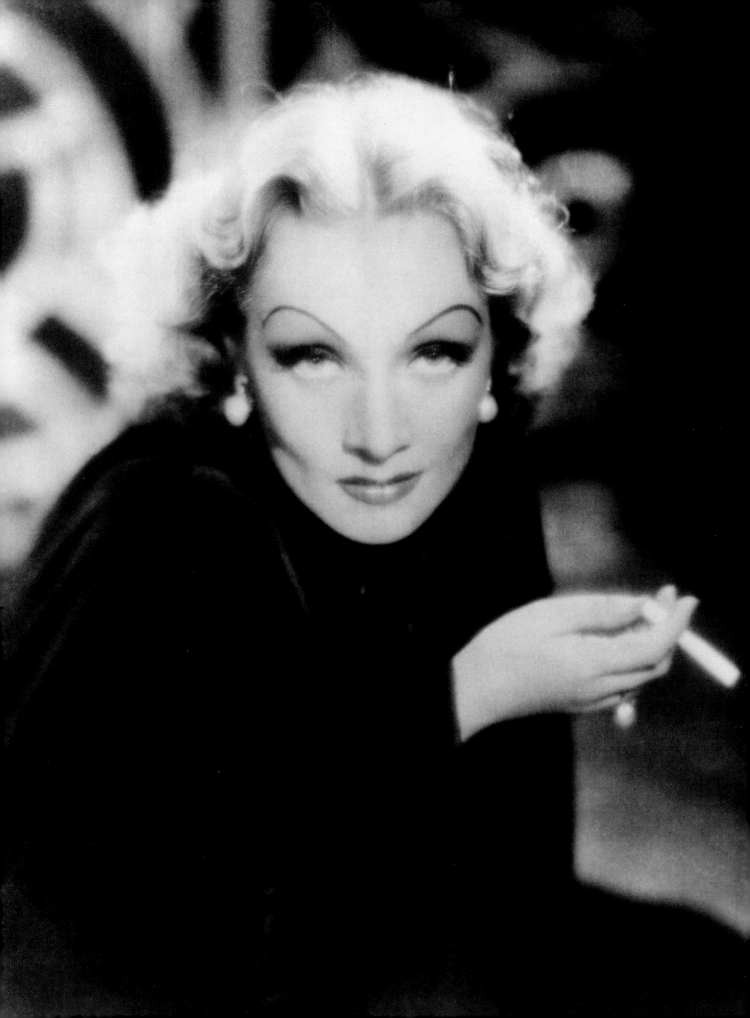

This selection of photos illuminates the role played by the stills photographers in first developing a special image for aspiring new starlets and actors during the peak studio years. For example, when the young Patricia White arrived at Warner Bros. in 1945, she was given the standard studio treatment, including the photo session shown here. The photos included the usual range of portraits, beach wear, bathing suit and lingerie poses including the kind of "leg shots" or "cheesecake" often used to publicize new starlets. As the centre of attention in the studio photo gallery, she appears all but oblivious to the activities of the technicians who surround her and the large stills camera (an 8 x 10 Deardoff) that has been rigged up to take shots from above. (Virtually forgotten today, her movie career was relatively brief; she can be spotted as an extra in a number of Warner features released in 1946-47.) This production still is accompanied by two of the many photos of her released by the studio at the time, prominently captioned, of course, with the name "Pat White".

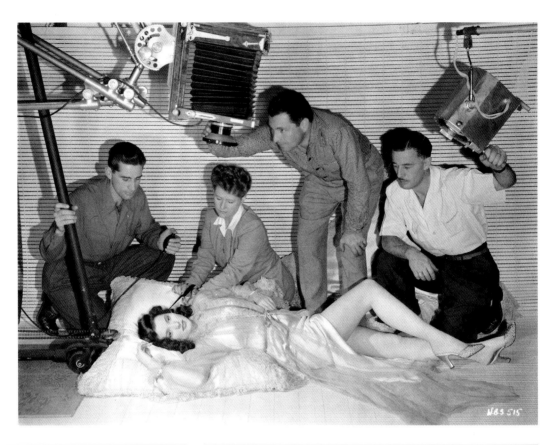

PAT WHITE — Warner Bros.-First National Pictures

PAT WHITE — Warner Bros.-First National Pictures

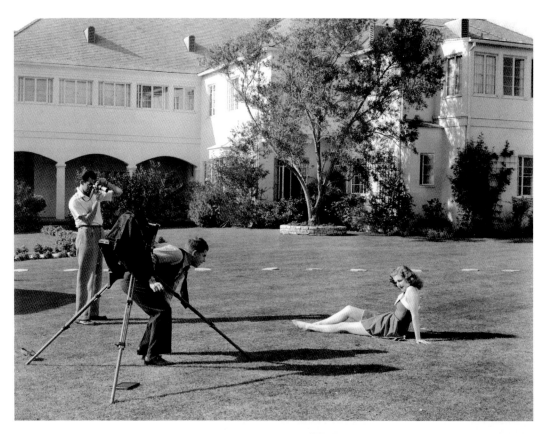

Ann Sheridan was given a similar treatment, probably in 1936 or '37 shortly after she was put under contract, seen here being photographed on the lawn outside the Warner Bros. studio building. An unusual example of three photographers in action — the large stills camera on its tripod and a second photographer with a smaller, hand-held camera (possibly a Leica), both themselves photographed by the third stills man. Miss Sheridan's subsequent career was very different from that of Pat White, for she soon developed into one of the studio's leading stars in the late 1930s and on into the 1940s.

This scene still comes from *A Star is Born* (1937), the film which gives an insider's view of the standard treatment meted out to aspiring young starlets in the 1930s. Here the make-up men go to work on Janet Gaynor, endeavouring to transform her appearance into the conventional glamorous image of that period. This image of her (without the two men) featured prominently in the 3 May 1937 issue of *Life* magazine when the film was selected as the Movie of the Week.

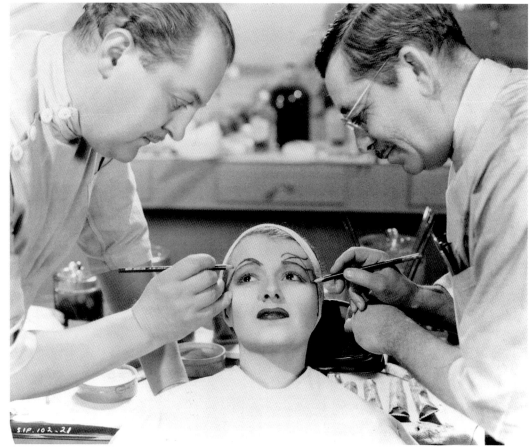

In contrast to the standard approach of artificially glamourizing new, young starlets, producer Samuel Goldwyn hired the brilliant George Hurrell to photograph Teresa Wright, his new contract star, rather differently and naturally in recognition of her qualities as a serious dramatic actress. This was around the time that she was starring in her first film, *The Little Foxes* in 1941 earning her first Oscar nomination as Best Supporting Actress; she won the following year.

Lois Maxwell and Doris Day were both at the beginning of their movie careers when they were photographed by Bert Six in the photo gallery at Warner Bros. in the late 1940s. Here he appears to be demonstrating the detailed preparation that goes into every stills session and the special care with which he treats the studio's leading ladies—arranging the lights, positioning the camera and adjusting their costumes to get everything just right for the camera. Twenty years old at the time, the Canadian born Miss Maxwell only appeared in a few films before she left the studio, moved to England in he 1950s and later made her claim to fame as Miss Moneypenny in the James Bond films.

Opposite: In marked contrast, the amazing Doris Day was a band singer who had never acted before she was thrust into her first movie role in 1948. Warner Bros.' most remarkable star discovery of the late 1940s, she soon established herself as the studio's top musical star, on into the 1950s.

A varied selection of stills photographers at work in the 1930s — on location, out of doors and in the studio portrait gallery — at three of the leading studios, RKO-Radio, Paramount and MGM.

According to film historian and screenwriter Dewitt Bodeen, "Irene Dunne persuaded make-up artist Ernie Westmore and photographer Ernest Bachrach to take a series of stills showing her as she aged from a pretty young girl to a successful gray-haired congresswoman… Monday morning the photographs and a note were on (studio head) LaBaron's desk. 'This is Irene Dunne, the girl who should play the lead in *Cimarron*.' LeBaron ordered a screen test. Irene got the part." Here she is seen on the set in costume photographed by RKO stills man Fred Hendrickson in 1930.

An unusual angled composition here shows Eleanor Powell and Robert Taylor, the stars of *The Broadway Melody of 1938*, taking part in a photo session in the studio's portrait gallery. A divergent response from the two stars – Powell laughs and looks up at the photographer who has climbed up to get this high angle perspective, while Taylor continues to look out of the corner of his eyes at the second photographer, more normally positioned below. An interesting example of two stars photographed together.

Opposite: Shortly before Paramount failed to renew her contract in 1934, Miriam Hopkins was photographed by Paul Hesse, who specialized in colour photography at a time when virtually all the films and the stills were in black-and-white. Shooting with available light, filtered through the leaves and branches above to give a natural colour effect, this photo also shows his colour camera on its tripod, his camera case and spare photographic plates, all well out of shot. Not a regular studio employee, Hesse frequently traveled to Hollywood on special assignment, employed by *Photoplay* magazine. Perhaps his colour photos even helped Miss Hopkins land the lead role as *Becky Sharp* in the first feature filmed in the new three-strip Technicolor the following year.

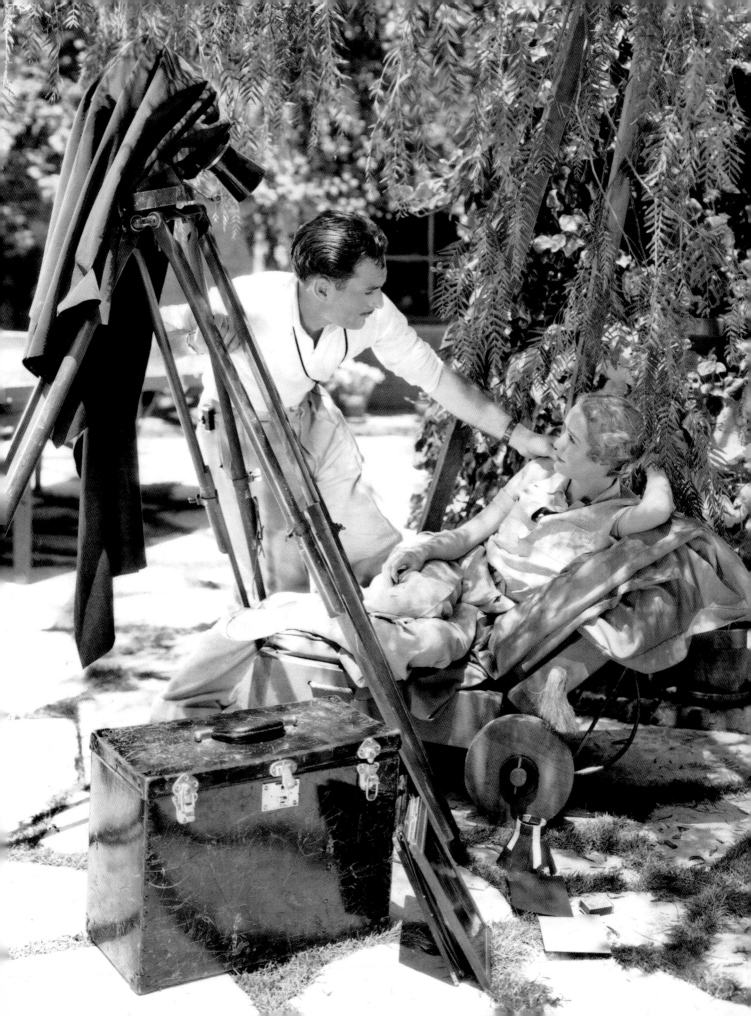

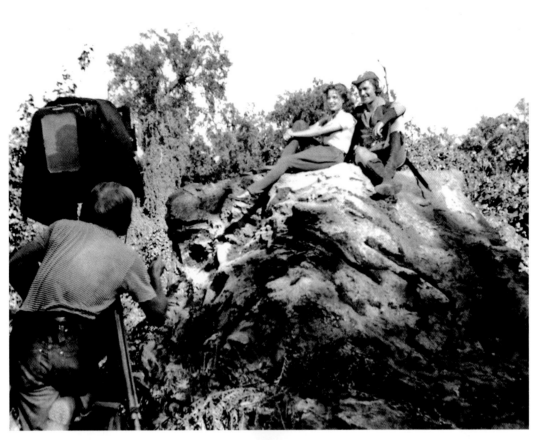

Opposite and left: One of the most popular Hollywood stars of the 1930s, Errol Flynn was cast in a number of large budget Technicolor movies at Warner Bros. toward the end of the decade including *The Adventures of Robin Hood* and *The Private Lives of Elizabeth and Essex*. Thus, it was important for the studio's stills men to provide as many high quality photos as possible for publicizing the films. While shooting *Robin Hood* on location in Chico, California in the autumn of 1937, Flynn was visited by his then wife, the actress Lili Damita. The tempestuous nature of their marriage, well known at the time, meant that photographer Mac Julien was probably pleased to be able to photograph them posing happily together.

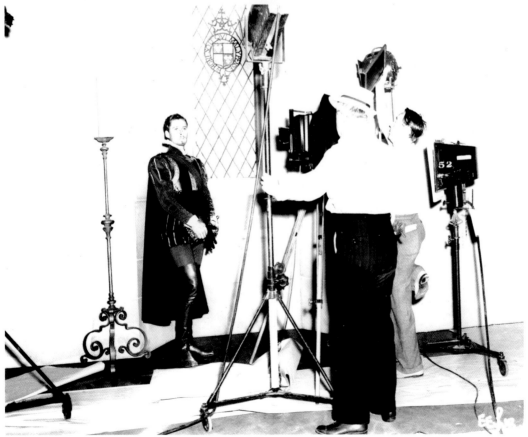

In the Warner portrait gallery a bored looking Flynn waits patiently as the photographer and his assistant arrange the lights before taking a series of photos of him in costume as the Earl of Essex.

This picture spread presents a small selection of the one hundred or so photos taken by stills man Jack Woods, an example of the kind of portrait session in the studio gallery which would normally be arranged for the stars of every major Hollywood film. The star is the brilliant German-born actor Conrad Veidt near the end of his career — he died in 1943 — wearing the uniform of his role as the Nazi officer, Major Strasser, in *Casablanca* in 1942. (Veidt was a dedicated opponent of Hitler in real life who had left Germany when the Nazis came to power.)

The immaculate white uniform, which plays down the Nazi symbolism, is only seen once when Strasser first visits Rick's café relatively early on. (He is never seen wearing the hat with its little swastika, for example.) Whereas the vast majority of Woods' photos favour the light uniform, as more flattering to Veidt — a bit of artistic license here — in the film Strasser, the nasty Nazi, is most often dressed in black.

A variety of close-ups show the actor with and without a hat, full face and in profile, his expressive face brightly lit or partly in shadow to suggest a slightly sinister quality reflecting the character he plays.

In the medium shots there is a hint of the exotic reflecting the Moroccan setting of the film with the carefully controlled background lighting and shadows suitably low-keyed and atmospheric. Arabic style screens can be seen in the background along with a few key props including a large, elaborately decorated vase and a wood inlaid chair.

The quality of these portraits, taken with a large, 8 x 10 plate camera is typical of Hollywood stills photography during the peak years.

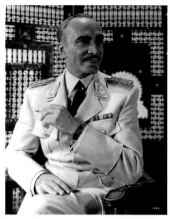
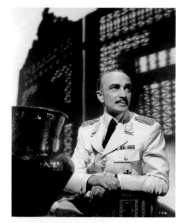

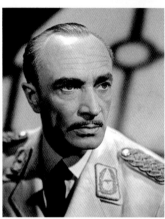

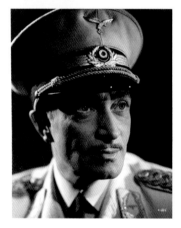

C.569

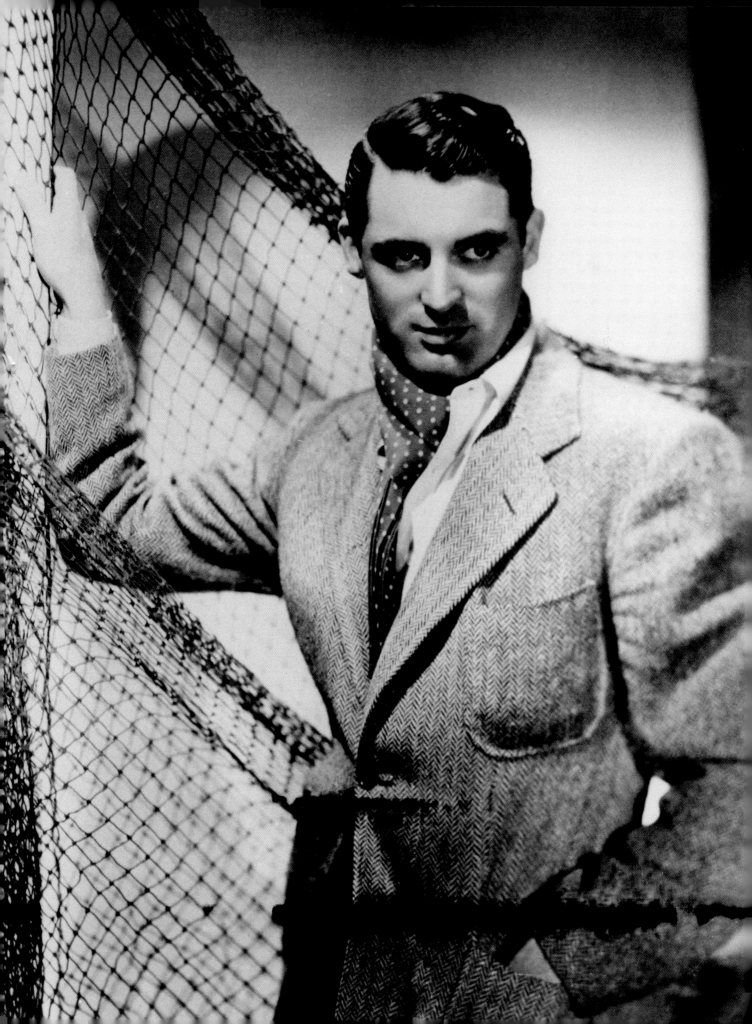

The handsome and stylish Cary Grant (opposite) was one of the favourite male subjects among the 1930s stars. But he was under-rated as an actor, and it is possible that these two sides of his career were not unrelated. A man of many talents, Grant was excellent in comedy and action roles and a natural romantic lead, as Mae West discovered quite early on.

This contrasting pair of portraits of a young Katharine Hepburn was probably taken around the time that she first arrived in Hollywood in 1932. On the far right is a daringly large head close-up which fills the frame – possibly taken by Ernest Bachrach, the leading photographer at RKO at the time – while the one on the near right is a striking example of how to frame a face within the portrait. Her face is given an ethereal, timeless quality, in keeping with the hooded cloak which looks like a costume from the Greek or early classical theatre. Apparently she took her photo sessions quite seriously: 'I photographed better than I looked,' she is quoted as saying, 'so it was easy for me... I let myself go before the camera... Once you get in front of the camera, it's not the look that's important, but how you come across...'

A very direct, head-on approach clearly works best with the irrepressible musical star Al Jolson (above). He appears just about to launch into a song, holding nothing back, in contrast to the shot of Cary Grant, for example, which hints at a mysterious, darker side to his personality.

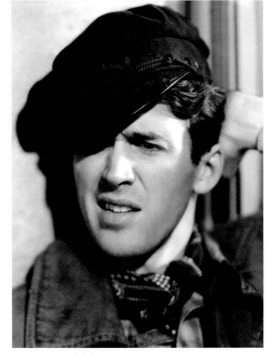

This atmospheric shot of Henry Fonda is a good example of the character portraits which were a staple of Hollywood studio photography, used for publicizing a particular film. He is in costume for his role as the frontiersman hero caught up in the American Revolutionary War in *Drums Along the Mohawk* (1939). The photo has been quite simply accomplished, with a spotlight used to highlight one side of Fonda's face; the few props include a simple wood table, candle and powder horn. However, the overall effect is quite memorable.

This striking portrait of a young Jimmy Stewart as Chico in Fox's remake of *Seventh Heaven* (1937) makes an appropriate pairing with his friend Henry Fonda. His very natural, likeable and slightly awkward pose contrasts with the serious intensity of Fonda's darker image.

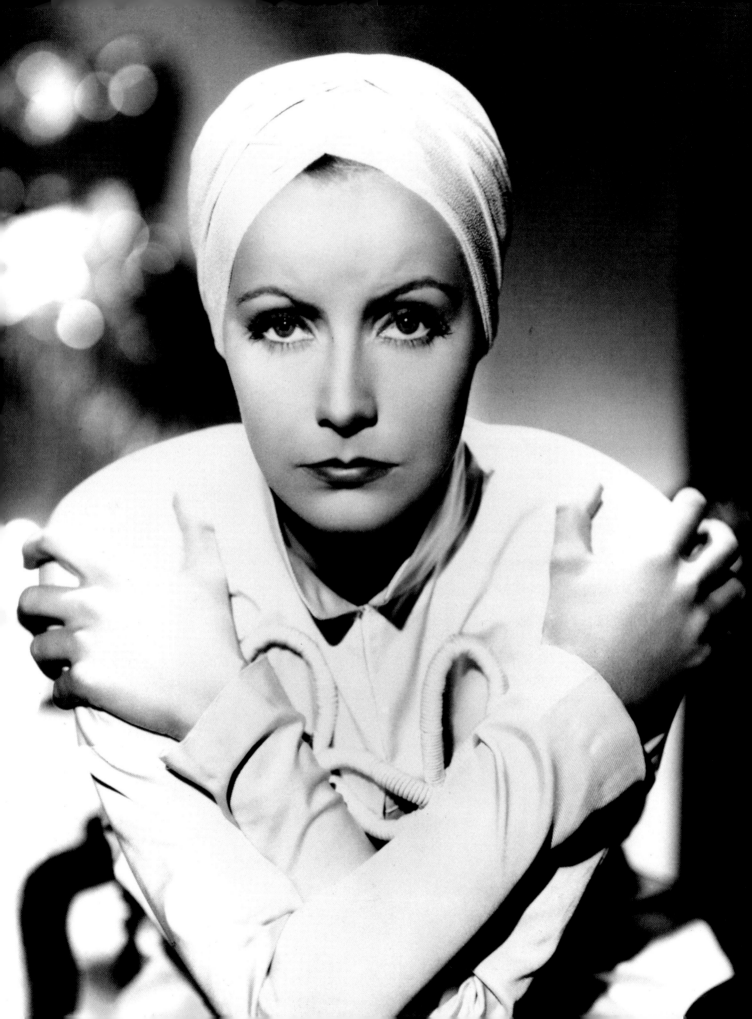

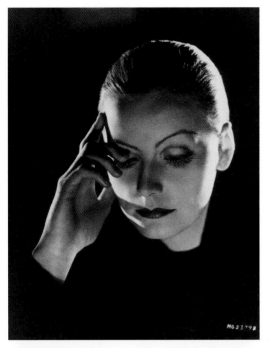

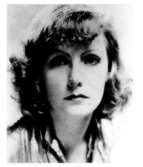

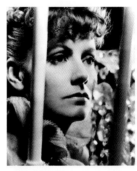

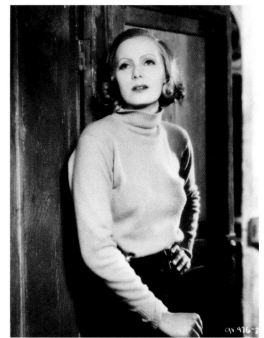

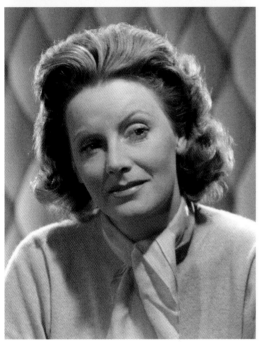

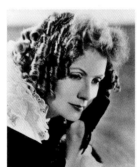

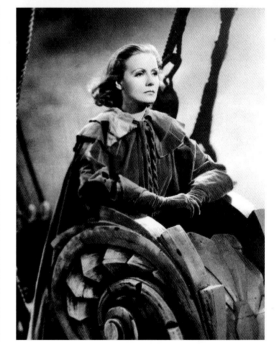

Garbo's reputation as a great beauty and film actress was reinforced by her qualities as a subject for the still camera. This varied selection of shots from her 1930s films gives some idea of the range of her roles during these peak years. Some of these were almost certainly taken by Clarence Sinclair Bull, head of the MGM stills department, who especially enjoyed working with her. 'I never had to say "hold it" or "still please", he later recalled. 'All I did was light that face and wait and

watch. Her face was the most inspirational I ever photographed. Virtually all her photographs were carefully selected and retouched, so it is especially interesting to see a rare, unretouched shot, looking more natural and relaxed (above left). There are a few lines on her forehead and under her eyes, while a tiny mole to the right of her nose was eliminated from all the 'official' prints. But, if anything, she appears even more appealing than in the retouched portraits.'

Top left: *Mata Hari* (1931).
Top right: *Anna Christie* (1930).
Centre top to bottom: an early 1930s portrait; *Anna Karenina* (1935); *Love* (as Anna Karenina, 1927); *Camille* (1936).
Below right: the final close-up of *Queen Christina* (1933).
Facing page: *The Painted Veil* (1934).

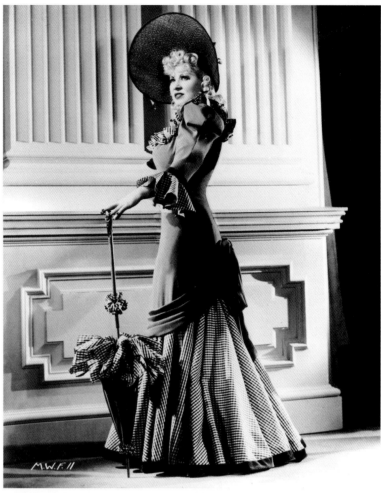

The retouching of photographs in 1930s Hollywood took many different forms: male chest hair had to be air-brushed out, as seen in this publicity photo (right) for one of the early entries in MGM's Tarzan cycle starring Johnny Weissmuller with Maureen O'Sullivan as Jane. Mae West (above right) has been made to appear especially slim and curvaceous with the help of some discreet retouching. West was often photographed against a plain background so that the retouchers

would have an easier job of subtly altering her figure. One can clearly detect the retouching of eyes, lips and eyebrows on this Fox studio portrait of starlet Irene Ware (above), taken around 1932-3 by photographer Hal Phyfe, who was even allowed to add his own credit in the lower right hand corner. All but forgotten today, Ware was signed by Fox after appearing on stage in Earl Carroll's Vanities, but her movie career fizzled out in the late 1930s.

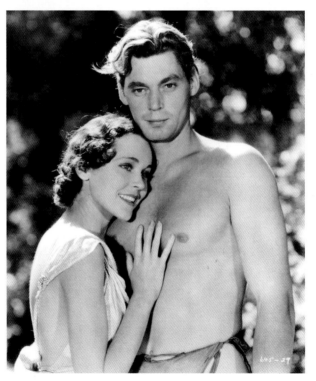

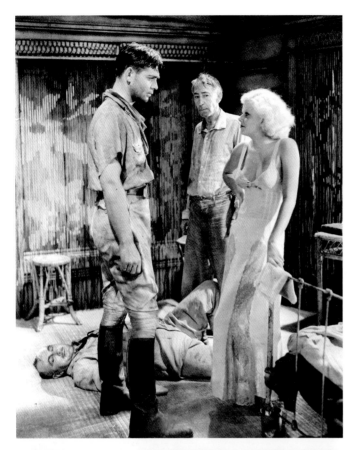

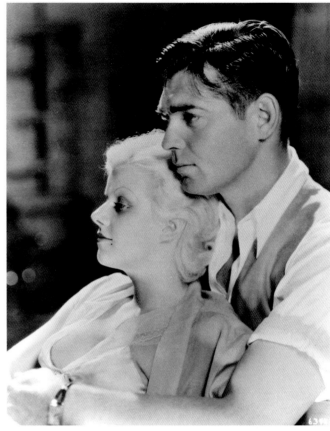

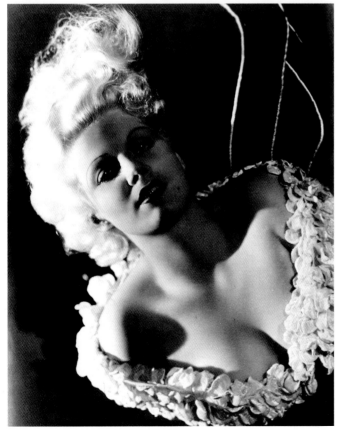

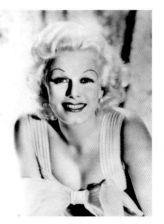

This selection of photos is of Jean Harlow both before and after the stricter enforcement of the Hollywood Production Code in 1934. It was no mere coincidence that Harlow emerged as a major star in 1932-3 at the same time as Mae West. The censorship code began to be administered more strictly soon after, both on films and the publicity stills which accompanied them. Harlow's ample figure is much in evidence in *Red Dust* (1932, top left) and in this publicity pose again with Clark Gable, for *Hold Your Man* (1933, top right), as well as in the quite erotic portrait which freezes her in an unreal pose, like a classical piece of sculpture. The lighting is used to mould her face and figure, but although her face is half in shadow, her eyes are given life by the reflection of tiny points of light (far left). But by the time of *Riff Raff* (late in 1935), the cleavage has been retouched out, aided by a strategically placed bow – as with the smiling portrait above left. She is seen here, above right, with a very suave-looking Joseph Calleia.

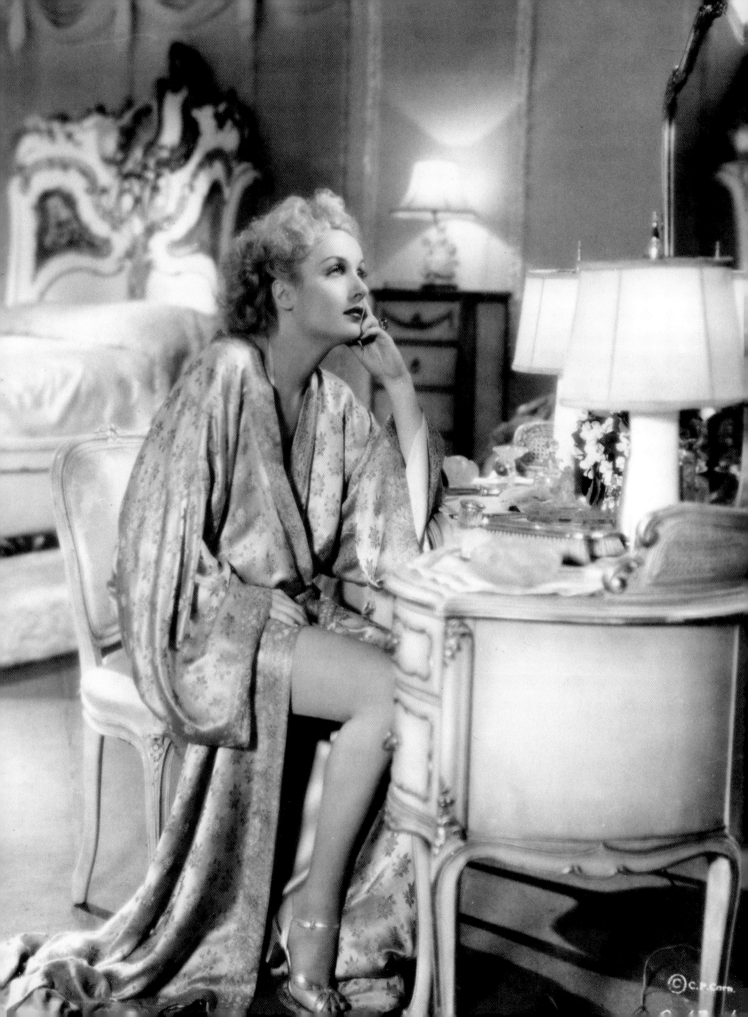

When Carole Lombard (facing page) was loaned out by Paramount to Columbia, the small company – which had few stars of its own – took advantage of the opportunity to make some especially glamorous photos of her to promote the film. Here the photographer has caught the actress in a pensive mood, seated at her dressing table, with one sexy leg exposed. But there is a hint of mischief in her eyes, the only clue to the fact that the film *Twentieth Century*, filmed late in 1933, was actually a screwball comedy. Lombard's special talent as a comedienne was given full reign for the first time (under director Howard Hawks), and the film helped boost her flagging career.

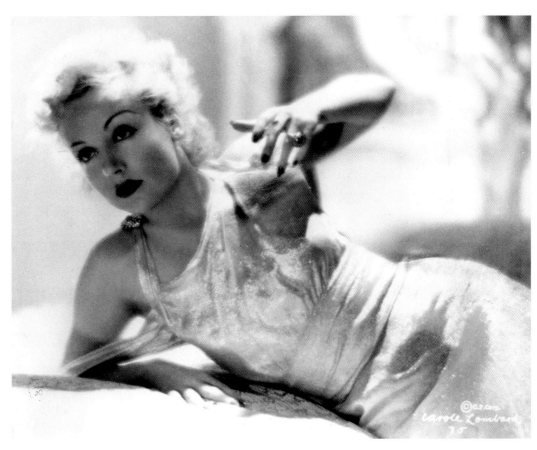

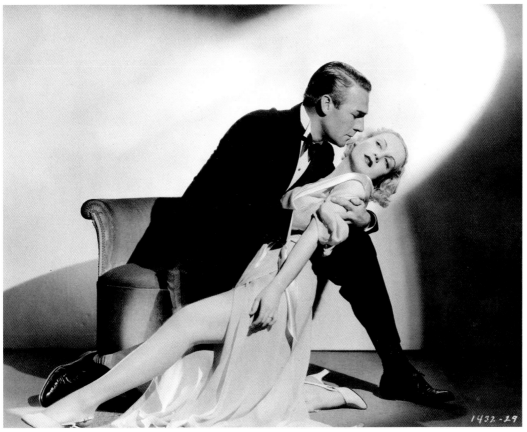

Again, in *Twentieth Century*, Miss Lombard is caught in a horizontal pose with one arm raised, as though she is about to ask a question, her face framed by a halo of soft light through an effective use of back lighting. She looks stunningly beautiful here, and this glamorous but tasteful portrait makes a striking contrast with the extraordinary-looking publicity shot for the 1933 B-movie *Supernatural*. In fact, the photo can only really be understood with reference to the plot of the movie: Lombard's expressionless, mask-like face and limp looking body, with one leg awkwardly bent under her, reflects the fact that her body has been taken over by the spirit of a dead woman, while Randolph Scott, her worried fiancé, tries desperately to revive her.

An unusual photograph taken at the MGM studio in Hollywood. A group portrait of four leading male stars in costume, on the back lot, early in 1936, all readily recognizable from their current film roles. Robert Montgomery appears impeccably attired in cape and formal evening wear for his role in the Victorian drama *Trouble for Two*, in contrast to Clark Gable with a torn trouser leg, smudged face and soiled evening jacket, since he has just been hit by the 1906 earthquake in *San Francisco*. In *The Devil Doll* Lionel Barrymore disguised himself as a sweet little old lady, but was really bent on revenge, while Paul Muni got his chance to extend his great range as an actor even further by playing the Chinese farm hand in *The Good Earth*.

Below left and right: The contrast between these two matching photos of Jean Harlow and Joan Blondell neatly reflects the differences between their studios: at MGM, the home of Garbo, Crawford, Shearer and Harlow, the stars were given the ultimate glamour treatment, carefully made up, costumed, posed and lit, and the resulting negatives were specially retouched to achieve an idealized, if highly artificial, end result. At Warner Bros., however, the stars worked harder and were treated more informally. Thus, this portrait of Joan Blondell feels spontaneous and casual, as if she has just stepped off the set of her latest movie and has been caught by the stills camera in a happy moment. The Warners stills were shot more quickly and simply than at MGM, but this was not necessarily a disadvantage, as this delightful portrait proves.

Opposite: This unusual shot of Paramount star Lilyan Tashman is packed full of interesting detail of the period including a very 1930s, Art Deco-style dressing table and mirror behind her. She appears to be wearing an elaborate trouser suit, specially designed for evening wear and is partly hidden by one of the elaborate, flowing sleeves which is draped across the floor. This portrait is also a fashion shot, but the artificiality of the pose is given a slightly ironic edge, for we are reminded that a photo is being taken – by the lights looking down from the upper right corner, neatly balancing the composition and completing the overall effect.

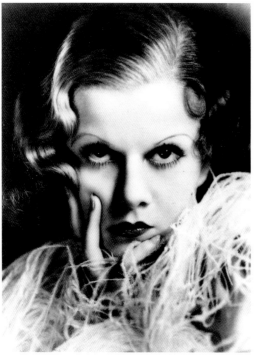

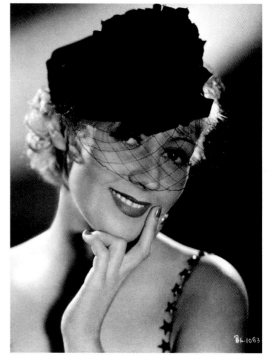

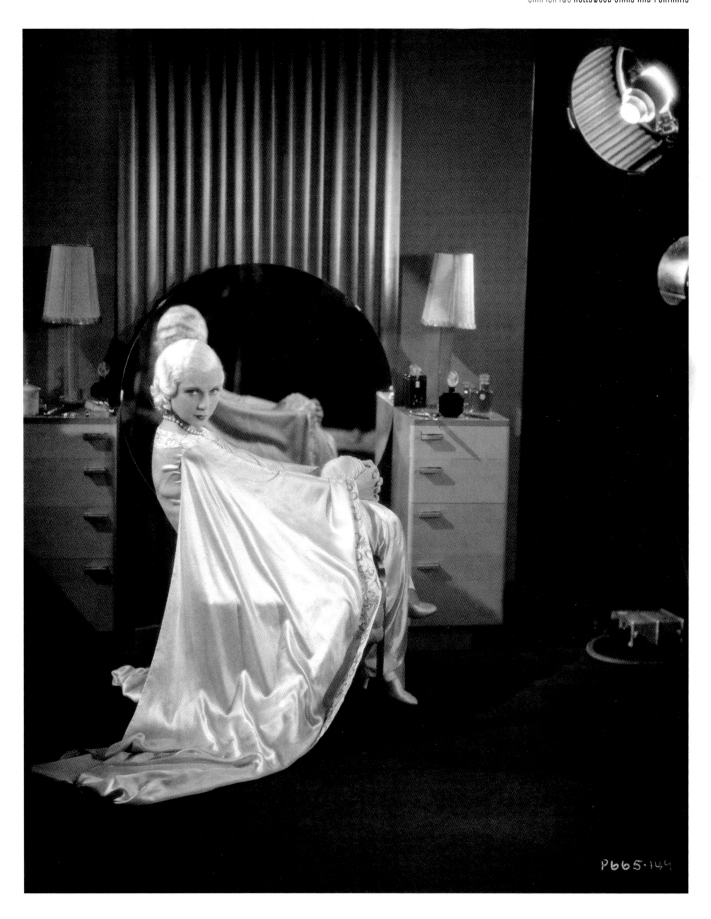

P665·144

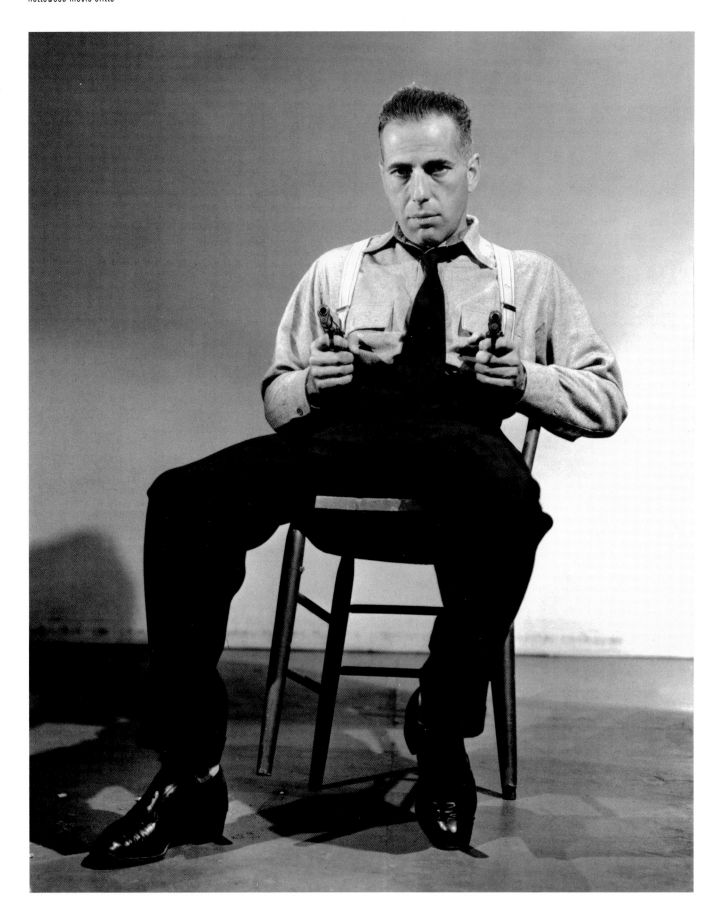

Humphrey Bogart's performance in the role of the sympathetic gangster, Roy Earle, in *High Sierra* revealed his qualities as an actor and his real star potential for the very first time. And a special photo session with Scotty Welbourne, head of the stills department at Warner Bros. in 1940 helped to publicize his new, leading man image. Wearing only the ordinary looking clothes worn by his character in the film, the power of the photos derive in part from the fact that they were mostly taken with the actor looking directly at the camera. He is armed with a shotgun or a pair of automatics as the only props, aside from a plain wooden chair, posed against a plain, light background, simple but effective, with the occasional shadow effect on the wall behind. Not surprisingly, one of these powerful black-and-white images was selected to be included prominently on the film's poster.

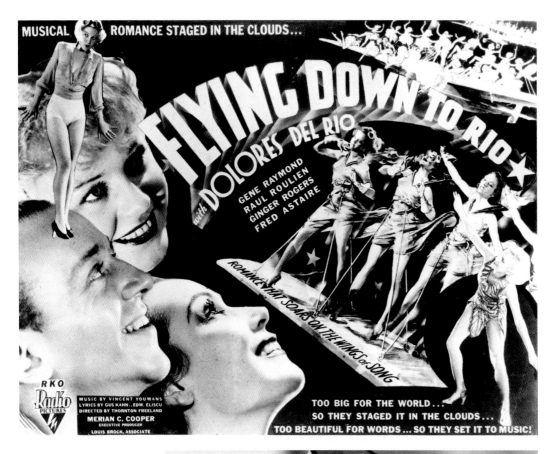

Not only were studio portraits used widely for publicizing the stars and films, but they frequently served as a prime source for the poster designers as well, as in the case of *High Sierra* on the previous page. A second, amusing example can be seen on this page: a double portrait of Fred Astaire and Ginger Rogers has been neatly taken apart and then put back together to achieve the desired effect. A little cut-out figure has been added to cover up the goggles on Miss Rogers's head. In their first film together as a dancing team the pair are billed low on the credits, and a profile shot of the main star, Dolores Del Rio, is featured prominently.

In the case of *A Star is Born*, on the facing page, the poster designer has seized on this striking portrait of Judy Garland as his centre-piece, balanced by an artistic reworking of four other stills from the film. In fact, the double profile on the left has been redrawn from a production still showing a very slimmed down George Cukor instructing one of the supporting players (actress Lucy Marlow), though one is obviously meant to take them for James Mason and Judy Garland. Similarly, the accidental, back-handed slap from the original scene still shown here has been strangely altered.

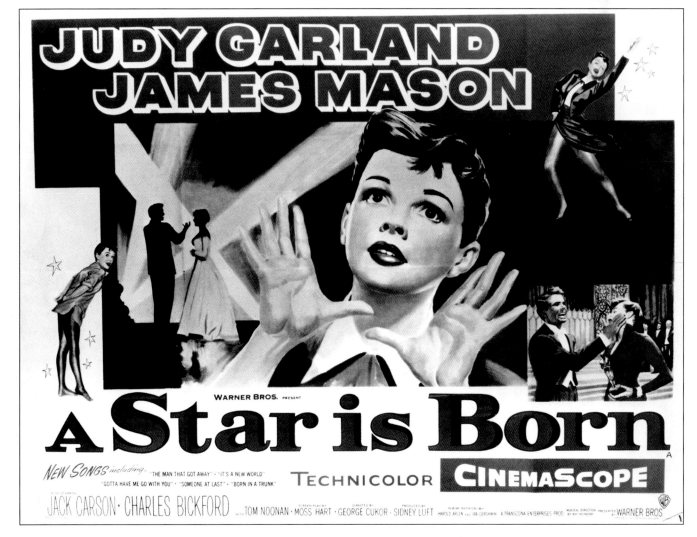

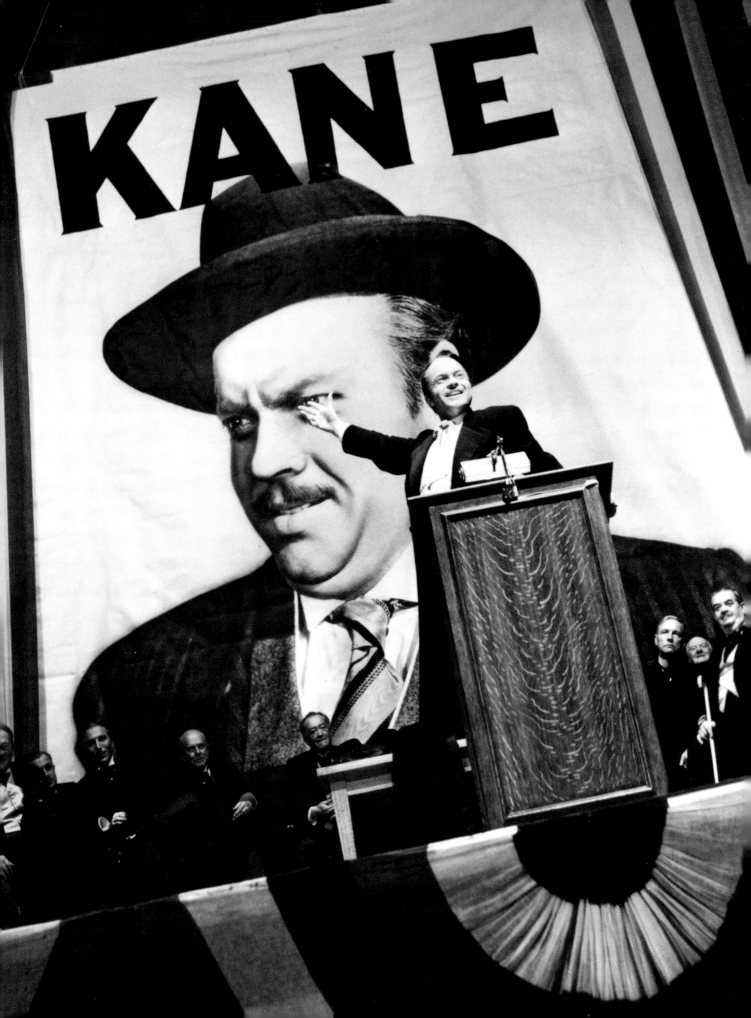

CHAPTER THREE
STILLS PHOTOGRAPHY IN HOLLYWOOD

During the past thirty years or so there has been a renewed interest in the portraits of Hollywood's golden age, especially the 1930s. Such photographers as George Hurrell, Laszlo Willinger and Clarence Sinclair Bull have become widely respected figures. Their pictures are recognized as occupying a special niche in the cultural history of the 20th century representing perhaps the ultimate expression of Hollywood glamour of the star era. They have been truly rediscovered, with exhibitions of their work, lavishly illustrated books featuring their pictures, and limited edition sales, with the most stunning, signed portraits often selling for thousands of dollars apiece. Yet these photographs represent but a small fraction of the tremendous number of pictures which poured out of the Hollywood movie studios during the peak years.

As we have noted, the portraits generally had only a tenuous link with the films which they were meant to help publicize. Though the stars might pose in the same costumes, with similar hair and make-up styles, there is a clear distinction between the photographs made during a special sitting in the portrait gallery and the scene stills or production stills made on the film set during the course of production.

Thusfar, we have concentrated on the work of the relatively well known portrait photographers, whereas most other photographs were taken by the mainly uncredited unit stills photographers.

At least one stills man would be assigned to each film, and he would be expected to contribute to the production in various ways. His assignment would typically begin as soon as the project was first being developed and long before the start of filming.

To begin with, he would accompany the director, cameraman or designer in the search for suitable locations or settings which would then be photographed for future reference. For example, Cecil Beaton notes in his diary on the making of *My Fair Lady* how one of his first tasks was to join director George Cukor, co-designer Gene Allen and a photographer in the search for London locations and period interiors to be photographed and later reproduced back at the Warner Bros studio in Hollywood.

Then, too, quite early on in developing a special new hair or make-up style for one of the stars, the question would arise as to how it would photograph. Thus, the stills man would be called upon to take a variety of reference photos for use by the technical staff. A quite unusual example of this happened during the extensive pre-production work on *Tootsie* (1982). As the book on the making of the picture pointed out:

> *Tony Marrero the hair stylist for Dorothy Michaels, kept a drawerful of stills from early camera tests that were part of a monumental effort to help Dustin Hoffman look like a real woman. There were stills of Dustin (as Dorothy) in every type and style of wig and base and powder, every cut and color of dress. Dustin blonde and Dustin dusky. Dustin chic and Dustin dowdy.*

Quite simply, the unit stills photographer is expected to make reference photos of virtually everything that appears on screen – including shots of all the sets and costumes from many different angles for continuity and reference purposes, also make-up and hair styles. Of course, the stars hated the tedium of posing for these test shots, weeks or months before the beginning of filming, yet occasionally this could be turned to good use. A quite ingenious example of this occurred on *The Private Lives of Elizabeth and Essex* (1939). Determined to wear costumes that were as authentic as possible, in spite of the objections of producer Hal Wallis and director Michael Curtiz, Bette Davis teamed up with costume designer Orry-Kelly to outwit the studio bosses. For the test photographs she wore the kind of smaller size farthingale favoured by the producers, but in the actual film she reverted to hoop-petticoats of the correct, larger size.

During the studio era, whenever a new star was signed up, the photographer would be involved from the moment that he or she first arrived at the studio gate. The star might be posed with the producer, director or even the studio head as he or she first put their name to a contract. Mary Martin, for example, tells the story of her very first arrival in Hollywood in 1939 when the studio arranged a publicity stunt, to have her photographed at the entrance shaking hands

An example of the outstanding quality of Hollywood stills photography, this striking image from *Citizen Kane* (1941) is not only an effective photograph but also captures one of the key scenes in the film. Orson Welles as Kane is addressing a large political rally at a late stage in his election campaign for governor of New York State. The slightly tilted composition suggests that Kane's shaky world is about to come tumbling down. Since the stills photographer is generally required to take any photos needed as props in the film itself, it is likely that Alex Kahle, the unit photographer on the film, also took the portrait of Kane which has been blown up on the giant poster in the background.

with a giant, tame bear which unfortunately, had other ideas and ended up on top of her.

During the peak studio years when so many films were being turned out at a rapid rate, it was not uncommon for a picture to be sold to exhibitors on the basis of a title alone and the names of the stars, and the publicity campaign would often be mounted even before the film was shot. Since still photos, especially portraits, were requested quite early on for posters and other advertising, a stills session, in costume, would pre-date the filming. There was even the rare example, as with *A Farewell to Arms* (1932) when the effects achieved by the portrait photographer prior to the production could influence the look of the film itself. Apparently, director Frank Borzage was so impressed by the love scenes between Gary Cooper and Helen Hayes, as imagined by John Engstead, that he used these stills as a guide when he came to shoot these same scenes later on (see page 83).

The wide range of pre-production photos would include costume tests and a variety of amusing or posed shots showing the stars in training for their new role, being given lessons in dancing, swimming or fencing, for example. Other shots might show the work of a leading scriptwriter or production designer or the various studio departments in operation seamstresses busy on the costumes, plasterers and carpenters constructing the sets – in short, any of a number of different activities connected with the shooting of a major film which begin long before the cameras begin to roll.

In fact, the stills photographer is likely to be involved in the production longer than anybody else. He might still be taking photographs well after the filming is completed, posing the stars for additional poster or publicity shots, or photographing the composer at work on the score, or the editor, sound mixers and others whose main task begins after the filming is completed. Also he would be expected to record any publicity stunts or other noteworthy aspects of the film's launch – the arrival of the stars at the premier screening or at openings in the major American cities.

Although we have already mentioned the standard, 8 x 10 camera at various points in our discussion above, it should be stressed that both the portrait and stills photographers used similar, large format cameras during the classic years of Hollywood. And these were extremely useful for all types of photos. Not only were the large portrait negatives ideal for retouching, but they could easily be cropped to adjust the composition or to get a large head close-up. Ruth Harriet Louise, for example, was one of the early photographers who often preferred to shoot full length shots of their subjects, though she knew that only the central portion of the negative was likely to be used.

Similarly, sharp detail contained in the large size negatives meant that they were well suited for recording normal scene stills and especially the important reference stills, used to keep track of the various sets and costumes on a production. In addition, any production stills were also likely to be packed full of interesting information on the methods and kinds of cameras, microphones and other equipment used in the shooting of the film. And finally, the 8 x 10 negatives were easy to work with in creating the many types of trick photos – photo montages or multiple exposure shots – which were often used for movie publicity.

Although the functions of the portrait and stills photographers were generally separated, in practice there occasionally was an overlap between them – as in the poster photographs mentioned above – an example of a special type of portrait, likely to be handled by the portrait photographer on a major film with top stars such as *A Farewell to Arms*. (Product endorsement photographs of the major stars would be treated in a similar way.)

Although the unit stills men were never allowed into the portrait gallery and the portrait men rarely appeared on the set, the most imaginatively composed and lit close-up photos on the set could aspire to quality portraiture. And assignments to photograph visitors to the studio or stars at home could be undertaken by either portrait or stills men depending on the importance of the subjects. For example, Bull at MGM took some memorable photographs on the set of *Broadway Melody of 1936* and was the photographer of record when Albert Einstein visited the studio in 1931.

Of course, many of the portrait men started out by doing unit stills work. Virgil Apger, for example, graduated from the MGM publicity department to do unit stills on Jean Harlow pictures, then moved on to portraits in the 1940s. As he noted, 'Doing stills was invaluable training for gallery work.'

Most preferred the added prestige and recognition which went with portrait photography. As British photographer Cornel Lucas expressed it, 'As a stillsman, it was always a case of grubbing for pictures and not being able to concentrate properly on people.' Yet Bud Graybill was one who liked to get a wide variety of assignments. He, too, started out in the publicity department at MGM. He shot publicity stills on big costume pictures like *A Tale of Two Cities* (1935) and *Romeo and Juliet* (1936), before moving on to specials with the top stars – 'working on the set or in the stars' homes, catching them in informal poses.' As he recalled,

Some days I'd be shooting fashion for Maureen O'Sullivan; then I'd be doing glamour for Lana Turner; the next day I'd be on the set doing publicity, taking pictures that would make good layouts. And when political or military statesmen visited [the studio] … I'd cover it, too…

At the smaller or independent studios, however, the photographers were more likely to be asked to do a variety of pictures as a matter of course. Thus, Bob Coburn was proud of the fact that when he worked for Sam Goldwyn

Elisha Cook Jr and Marie Windsor in *The Killing*.

in the late 1930s, he did just about everything. 'I not only did the gallery,' he recalled years later,' but I also continued to shoot special stuff on films... I was unique in that respect... As a matter of fact, Goldwyn insisted on that. This gave me a better all-round view of what was wanted to help sell the picture...'

The clear distinction (or 'demarcation') between the stills and gallery men in the larger studios, however, was also maintained by the still photographers union that had been established in 1928 and was especially active throughout the 1930s. There was even a useful magazine, *International Photographer*, devoted to cameramen and still photography during these years. Whereas the list of portrait photographers would include all the best known names, such as those mentioned in the previous chapter, the unit stills photography was mainly anonymous. The portrait man worked on his own in the quiet and intimacy of the gallery with his own selection of props and control over the composition and lighting, while the unit photographer was forced to adjust his work to the hurly burly of the film set, picking his way among the cast and crew and confusing clutter of cameras, microphones, electric cables, props and other movie making equipment. The lighting was controlled by the film cameraman, in consultation with the director, and the taking of still photographs had to be fitted in with the demands of the filming, which always took precedence. Nevertheless, the stills man was expected to capture every important scene in the film, with special attention to the most dramatic, intimate or spectacular moments. In fact, his brief was a wide one – to keep an eye out for any interesting shots, posed or action, close, medium or long shots, in front or behind the camera, i.e., scene stills and production shots.

In a more subtle way, of course, the photographer is often attempting to capture a particular atmosphere or mood, or to sum up the relationship between the characters in a single image. A good example occurs in Kubrick's *The Killing* (1955), representing the scene where we first encounter the hopelessly mismatched married couple (Elisha Cook Jr. and Marie Windsor). As David Thomson notes: 'he stares at her while she gazes at impossible futures... it [the still] catches the forlorn union wonderfully well.'

Hired by the producer or studio, the photographer occasionally found himself trying to cope with a particularly difficult director or assistant. For, whereas the director makes the creative decisions, his assistant is responsible for dealing with the logistical problems connected with the shooting and functions like a kind of foreman on the set. (One trick practiced by the stills man is to make sure that the director is within earshot when he is trying to deal with an unhelpful assistant director, who is more concerned to keep the production moving ahead on schedule than in providing photo opportunities for the stills man.) Thus, director Lindsay Anderson made the point that the stills are normally taken just after a scene has been filmed – '...which is always rather vexing since everyone wants to get to the next (camera) setup and hates having to delay for the wretched stills...'

Clearly, it is an important part of the job for the photographer to be as diplomatic as possible, with a talent for developing a good working relationship with members of the cast and crew. But for most of the time the stills men would make themselves as inconspicuous as they could, even wearing a dark suit and keeping well in the background until called to take a photograph. Whereas a few directors, such as Cecil B. DeMille and Josef von Sternberg, were specially interested in the stills and would accommodate the photographer on the set, these were the exception. In most cases he was merely tolerated and

One can easily imagine this amusing photograph from the Hitchcock film *Champagne* being taken by the young photographer Michael Powell in 1928. Packed full of detail, the still tells an entire story, of the blatantly sexist treatment of a young girl applying for a theatrical job. Powell's job as unit photographer provided his first opportunity to direct a group of actors on the movie set and it looks as if he made the most of it.

had to be as tactful as possible in selecting the right moment to intervene to catch a particularly interesting bit of action or key dramatic moment, either in rehearsal or after the shooting when the scene would be restaged for the still camera. He was then expected to work quickly and efficiently to take the photographs he needed.

Since the photographers often spent a number of years at the same studio, the word would soon get around that such and such a director was especially difficult to work with – like John Ford, at RKO, in the mid-1930s. 'That man hated photographers (being) around.' recalled Bob Coburn. 'He didn't even like his own cameraman. In fact, John was a pretty hard Irishman to get along with... and a lot of the fellas were scared to work with him.' First assigned to take stills on the set of *The Informer*, Coburn rightly recognized that the usual, discreet approach was not the way to earn the respect of Ford. Rather, he took the opposite tack:

The very first morning, the very first scene, I went in and sat on a box right next to him, under-neath the camera... I kinda sensed him looking at me, but he never kicked me out... Well, I'm Irish, too... We became fast friends...

If Coburn's account is to be believed, he was one of the first Hollywood stills photographers to shoot with the new, small (35mm) Leica rather than the larger 4 x 5 cameras or the more usual 8 x 10. This, of course, gave him a much greater degree of flexibility on the set, though, as he notes, 'I had a thing cooking with every sound man that I would never ruin a take with the click of my camera.' It was also at RKO a couple of years before that G. Felix Schoedsack, brother of the director of *King Kong*, had used his new Leica to

shoot stills on the miniature setups for the film, in preference to the usual, bulky stills camera.

Since the stills man was not a regular part of the film crew and often felt a bit like an outsider on the set, it was important for him to try to be accepted by the others. Thus, when the young and inexperienced Eric Cross first ventured onto the set of Alfred Hitchcock's production *The Ring* (1927), he knew that he had won his spurs when Hitch, a great practical joker, played the first trick on him:

You know the studio was often quite noisy (in the silent days) with a lot of hammering going on, building sets. I wore crepe rubber sole shoes, and Hitch crept up behind me and nailed my shoes to the floor through the heels... then called for a still... Another time he unclipped the back of the 8 x 10 camera and put a live pigeon inside, then called for a still. Of course, I went to take the shot and got a big surprise when I encountered the pigeon...

Cross even remembers his first encounter with a young Michael Powell, an assistant to director Harry Lachman, who spent a lot of time hanging around the studio. Cross even had to kick him out of the stills department a few times. In fact, Lachman and Powell were both photographers – probably the two best known directors who started out as stills men. (Lachman had worked for Rex Ingram at his Victorine Studios in southern France.) It is thus appropriate that Powell's autobiography should provide one of the most entertaining accounts of the work of a unit stills man, though it is unlikely that the scene unfolded exactly as Powell recalled it, many years later:

I had my Akeley tripod with the hand grips and the special head... The big camera with Bausch & Lomb lens was in the case with the loaded slides and the usual gadgets. I hefted the tripod on my shoulder, picked up the case and made rather a noisy entrance onto the Champagne *set. It was a scene in a manager's office. Betty Balfour was applying for a job...*

According to Powell, he turned down a few static scenes as unsuitable for making an interesting still before he saw his chance. He then proceeded to change the lighting on the set, with the permission of Hitchcock and his cameraman, then gave his instructions to the actors:

I said to the actors: 'Action, please!' They looked blank. I said: 'Go through the action, and when I say 'Hold it!'... I explained to them: The stills are to sell the story outside the cinema. You need to overact in a still. Action!' They got the idea and this time I was happy...

For Michael Powell his mastery of stills photography

merely provided him with an easy way to break into the British film industry. And after doing the stills on one more Hitchcock picture, *The Manxman*, in 1928, he gave it up. He then worked as an editor and scriptwriter before moving on to his true metier, as a director.

Given the fact that the shooting of stills on the set is a somewhat haphazard enterprise at best, it is not surprising to find great variations in the quality of the results. In the 1930s the studios provided special opportunities for the stills men as well as the portrait photographers, but these were rarely exploited to the full. Some idea of this unrealized potential can be seen in the work of Josef von Sternberg – the only major Hollywood director in the 1930s who was also a professional photographer (and cameraman) and a great visual stylist. Not only did he exercize a great control over the lighting, photography and overall look of his films, but he also maintained a special interest in the stills photography, too. With Marlene Dietrich as his willing subject, Sternberg was able to balance the demands of the star system with the studio-bound conventions of early 1930s movie-making while creating escapist entertainment of remarkable quality. His pictures presented an imaginative vision of exotic settings ranging from China to Spain, and from Morocco to the Russia of Catherine the Great, all created on the Paramount back lot. His accomplished use of atmospheric lighting, which all his pictures have in common, was not only effective on the movie screen but was also ideally suited to the demands of the stills photographer. Thus, the photos taken on the set of his films have a special quality all their own that match the visuals of the movie scenes. In addition, Sternberg was probably the only director in Hollywood who accompanied his star to her portrait sessions. As recalled by William Walling, he dressed the set the way he wanted it and took charge of arranging the lights and camera. Then, when everything was at last exactly as he wished, he would stand behind the photographer and carry on directing him and Miss Dietrich as the photos were being taken. The results thus achieved clearly bore the stamp of the director and perfectly complemented the scene stills and the images found in the films (see pages 90 - 91).

Sternberg, in fact, had played an active role in creating the new star image of Dietrich from the time that he first brought her to Hollywood in 1930. One of the most stunning of the portrait photos supervised by him was blown up to billboard size and widely displayed with the simple caption: PARAMOUNT'S NEW STAR – MARLENE DIETRICH. Sternberg continued to refine and develop the special Dietrich 'look' throughout the period that they worked together at Paramount from 1930 to 1934. By the time that they went their separate ways, Miss Dietrich had become something of an expert on photography herself. When posing for photographs she continued

A typical scene still from *Suicide Fleet*, filmed at RKO's Pathé Studio in 1931, shows the three stars, left to right, Robert Armstrong, James Gleason and William Boyd (better known in later years as Hopalong Cassidy). Though an unremarkable scene from a long forgotten B movie of the 1930s, the use of light and shadow gives an added interest and reflects the high professional standards found in even the most ordinary stills made during this era.

to insist on the same high standards of photography set by her mentor, Sternberg. As the leading portrait photographer, Al 'Whitey' Schaefer, wrote a few years later: 'Most camera-wise of all my subjects, Marlene knows instinctively when a camera angle is right... Marlene often edits her own publicity stills and nobody objects because she knows what she's doing.'

At the other end of the spectrum was the routine shooting of stills on the large numbers of forgettable pictures being turned out by the Hollywood studios throughout the 1930s. Occasionally, an alert producer might spot some shortcomings in the still photos before filming was completed and take steps to see that this was remedied. For example, a memo from Harry Joe Brown, associate producer on the RKO Pathé production, *Suicide Fleet*, dated August 20th, 1931, reads as follows:

Wish you would take a look at the stills... Evidently Whitey and (William) Boyd are bed-fellows, all I get is shots of Boyd. He has absolutely, utterly, lost the whole sweep of the picture in the stills. Close-up after close-up, nothing interesting. I certainly think he should be told about it... Be sure and get a long-shot of our boat taken from the aft end, with the crew. A low setup with the sails showing...

Whether Brown got his stills or not, this picture sank without a trace, though its female lead, a very young Ginger Rogers, would subsequently develop into RKO's top female star of the late 1930s.

Clearly, some types of action and slapstick comedy pictures do not lend themselves easily to being captured in still photographs, and unless the director and stars make a special effort to accommodate the stills man, the results are apt to be unsatisfactory.

To catch the spontaneous feel of an action sequence, the photographers generally preferred to use a smaller (4 x 5) camera when possible. Yet, the results were still apt to look overly posed and static. The manic and frequently unpredictable comedy routines of the Marx Brothers, for example, obviously created problems for the stills photographers. The stills from their films are generally disappointing – perhaps an unfortunate example of a failure to accommodate the demands of the photographer within the pressures of studio time and space.

In marked contrast, independent producer Hal Roach maintained a quite high standard of stills photography for the Laurel and Hardy comedies – as reflected in their continuing popularity and frequent use by newspaper and magazine advertisers, as well as in movie books and magazines up to the present day. Movie historian William Everson, for one, has remarked on the fact that,

Laurel & Hardy stills have a very happy knack of being entirely representative of the films they illustrate... The stills invariably tell a story in themselves and, as in the actual films, it is the expressions and attitudes of their faces and bodies, in response to a clearly shown situation, that provokes the laughter...

An entire book, titled simply *Laurel & Hardy*, has been devoted to illustrating every one of their one hundred and five movies together in great detail, making use of almost 1500 stills. These include a number of photographs of deleted scenes which were filmed but then cut because they held up the flow of the film or otherwise disrupted the carefully structured and paced continuity. Author John McCabe notes how the stills photographer was always positioned close to the movie camera in order to get a result quite similar to that found in the films. He was obviously encouraged to capture the special quality of the individual scenes, concentrating on the key moments and foregoing the kind of artificially posed publicity shots provided by other comedy stars (such as the Marx Brothers) around this time (see page 99).

Over at RKO a useful first-hand description of the problems faced by a stills man trying to capture action shots on a feature film was provided by Fred Hendrickson in an article published in the *International Photographer* in June 1940. Recalling his earliest experience shooting action stills in the silent days, he observed that not much had changed since then. In 1940 they were still using a cumbersome 8 x 10 view camera as they had done 20 years earlier, the main difference being that the celluloid negatives were a lot lighter and easier to handle (and carry on to location) than the fragile glass plates. A strong advocate of the smaller, 4 x 5 graphic camera – the negatives of which could be easily blown up to the preferred 8 x 10 – he made good use of it in shooting some of the stills for *Tom Brown's Schooldays* (1940). For the sequence showing Tom being roasted over a fire by the school bullies, the camera was positioned at the back, shooting through the fireplace and above the flames. But most of the stills were shot on 8 x 10.

Hendrickson recalled that assistant director Sam Ruman was especially helpful and allowed him to shoot his stills during the brief breaks in the action. For him the highlight of the picture was the climactic fight between Tom (Jimmy Lydon) and Flashman (Billy Halop).

The biggest problem in getting stills was to get the boys to hold still long enough to get an exposure without someone moving. We had from ten to fifty boys ranging in age from eight to eighteen and they wriggled around as boys always do...I know the publicity office wanted some good action shots of the fight... I was able to shoot at one-hundredth of a second at f4.5 and by watching the action closely and shooting during the slight pauses, I got some very good shots... In order to get some with a greater sharpness and depth of focus, after each scene I got the boys to fight for me and shot them with the graphic camera and flashbulb... (see page 92)

At the same studio the previous year (1939) Alex Kahle claimed that he exposed over 100 plates during the fight sequence between Lincoln (Raymond Massey) and the New Salem thugs led by Jack Armstrong (Howard Da Silva) in *Abe Lincoln in Illinois*. He especially liked working on this film, as director John Cromwell was extremely helpful, and he was able to take a wide variety of photos, several thousand in all. These ranged from artistically posed portraits to action stills and atmospheric location shots along the McKenzie River in Oregon and on the town set representing Springfield, Illinois in the early nineteenth century specially constructed on the RKO ranch.

It was, of course, standard practice for the studio to assign one unit stills man, such as Hendrickson or Kahle, to each picture. But there were times when a team of two or more still photographers would be assembled to catch some special sequence or once-only movie stunt. Thus, the *International Photographer* notes the special efforts made to ensure that a key stunt in the John Wayne Western, *Dark Command*, would be recorded by the stills camera. When a wagon pulled by two horses crashed over a cliff into the water below, it was not only filmed by two movie cameras, but two stills photographers were also present with five cameras between them – two large, 8 x 10s on tripods along with three, smaller and more flexible 4x5 cameras.

Although the stills men most often made an effort to match their photos to the scenes as staged in the films, there are innumerable examples of variations in composition, camera angle, and even in lighting too,

Since unit photographers were rarely credited and even more rarely photographed themselves, this must have been an unusual experience for stills man William N. 'Bill' Crosby, suddenly thrust into the limelight on the set of *Dr Rhythm* at Paramount in 1937. He is joined by three other Crosbys, all unrelated and working by chance on the same production. Left to right, dance director Jack, camera operator Floyd, stills photographer Bill and star Bing in costume.

which demonstrate that the photographer has seized the opportunity to make a still photograph which will stand up better on its own and add a bit of variety, too. As soon as he turns the camera on its side to make a vertical shot, for example, he is already making a significant change, since the film scene is always a horizontal composition. And by moving in closer, he can create the still photo equivalent of a movie close-up, which may also resemble a portrait (or double portrait). Thus, Bob Coburn never forgot the advice he received during his early years at RKO:

Bachrach taught me and Alex (Kahle) never to take a straight shot. We always cocked our cameras. We'd go for the composition of the picture and make something interesting out of it rather than what we called 'the company front'.
[As seen in Kahle's striking *Kane* still which opens this chapter on page 72.]

However, it occasionally happened that an important scene would not lend itself to a still photo at all, and it was necessary for the stills man to devise a new way of capturing it with his camera. A good example of this is the well-known hitch-hiking sequence in *It Happened One Night*, filmed in 1933. As staged by director Frank Capra, Clark Gable and Claudette Colbert take turns trying to hitch a ride, while the other watches from a fence in the background. Not only difficult to compose as an interesting still, the

result would have favoured one star over the other, too. The simple solution, as seen in the well-known photo of this scene has the two of them perched side by side on the fence with their thumbs out – a more simple and direct image which neatly encapsulates the moment (see page 96).

A key sequence in the Deanna Durbin musical *One Hundred Men and a Girl* (1937), presents an interesting variation on this same problem. At one point, late in the film, she hides at the back of a rehearsal hall, and when Leopold Stokowski and the orchestra begin to play, on stage, her voice suddenly rings out from the auditorium. It was important for the stills man to record this emotionally charged scene which was impossible to photograph as filmed. The obvious solution here was simply accomplished – in the still Deanna joins the orchestra on stage...

Aside from this kind of rearranging of scenes for the still camera, out of necessity, one quite often comes across stills showing scenes which do not appear in the film at all. For example, Fiona Lewis tells the bizarre story of her experience on Brian DePalma's horror-thriller *The Fury* (1978). According to her, 'the movie featured a particularly gruesome sex scene, which was later cut, apparently because it looked too disturbing... however still photos turned up years later after I had spent ten years as a screen writer and had written my first novel. I was giving a reading in a Los Angeles bookshop... After I had finished a man in the front row got up and fumbled

This pin-sharp still showing Deanna Durbin and Leopold Stokowski in the Universal film *One Hundred Men and a Girl* in 1937 demonstrates the quality that could be achieved with an 8 x 10 camera. It is so full of detail and, although the musicians appear to be playing, every single violin bow and every finger is in sharp focus. Perhaps typical of the orchestras of the period, and echoing the movie's title, it is made up entirely of men, but does include two women harpists, hidden discreetly in shadow at the far right.

for something he wanted me to sign. What he held up, however, was not a copy of my book but a blow-up of me naked, wide-eyed, and, of course screaming...'

The fact that the stills are shot as soon as the production gets underway means that they can be (and frequently are) used to publicize the picture long before the filming and final editing are completed – as part of the advertising campaign to develop audience interest in advance. The fan magazines or newspapers are generally quite happy to publish a still from a forthcoming picture which no one has yet seen. And since the stills are what the potential movie-goers see before buying a ticket, at least one leading American cinema owner was known to base his choice of films booked for his theatres on the stills, title and cast list, rather than on viewing the movies themselves.

Thus, it occasionally happens that one or more of the most interesting stills from a film, perhaps used prominently in the advertising or outside the cinemas, might depict a scene, or part of a scene, which was cut out of the final edited version of the picture. Some movie-goers may perhaps be annoyed by this, yet these same photographs often provide fascinating

clues as to how the film evolved toward the completed version we see on the screen. A recent deplorable development in this respect is the current obsession for using colour images (in newspapers, magazines, on DVD covers, etc.) whenever possible. This often means a preference for terrible and often artificially posed colour photos to illustrate a black-and-white film even when excellent black-and-white stills are readily available.

There are, in fact, a variety of ways in which the stills may differ from the films they are meant to illustrate. For example, a well known still from *I am a Fugitive from a Chain Gang* (1932) shows Paul Muni being beaten by the nasty sheriff and his deputies. Although this scene may have originally been filmed, the sequence, as photographed, has been cut, and only the sound remains. The film-makers have heightened the effect by *not* showing the whipping. Rather we hear the sounds of him being flogged as the camera moves from face to face showing the reactions of the other convicts in the next room.

The system employed in Hollywood, even up to the present day, of sneak previewing films at a local cinema in front of a typical audience, before the official premiere

and release, means that relatively late alterations to many famous (and not so famous) features have been a well documented part of Hollywood history. Important changes were often made even after the main filming and editing was completed. In serious cases where the audiences failed to respond as expected, it was possible to go back to the studio and reshoot a sequence or two. However, the most usual adjustments were made by re-editing existing footage with cuts or other changes most likely to be made in the openings (*Lost Horizon*, *Sunset Boulevard*) or in the endings (*Double Indemnity*, *The Champ*, *The Magnificent Ambersons*). In some cases a number of alternative endings were filmed and tested on different audiences before making a final decision, as happened in 1987 with the smash hit *Fatal Attraction*.

The extensive use of this system means that many stills exist of alternative versions. There are also the rare examples of a later attempt to put back important sequences which were cut. Here the stills are not only a useful guide to the original footage, but may actually be used on the screen to fill in a brief gap where the soundtrack has been found but the picture is still missing – as was done in the 1983 reconstruction of the George Cukor/Judy Garland version of *A Star is Born* originally released in 1954.

Another Hollywood practice used most extensively during the early years of sound, and occasionally tried in later years, was the simultaneous shooting of a picture in both English and foreign language versions making use of alternative casts. It is quite amusing to be able to match up stills of different casts who obviously filmed the same scenes alternately on the same set, making use of identical props and matching costumes, lighting and camera angles, etc. Similarly, a still showing Greta Garbo in a dramatic scene with a German actor named Hans Junkerman or with Herman Bing and Salka Viertel, merely reflects the fact that she starred in both the English and German language versions of *Anna Christie* in 1930 (see page 105).

Stills may occasionally show an actor or actress who has been cut out of a film – such as Kevin Costner in *The Big Chill* or Marilyn Monroe in her first feature, *Scudda-Hoo! Scudda-Hay!* (All her scenes were eliminated and only one extremely long shot remains, in which she is too tiny to recognize.) Alternatively, there may be a change of cast at some point during the filming, requiring some scenes to be reshot with the new actor, yet stills may well survive from the earlier version.

In addition, it is occasionally possible to recognize a player in an uncredited bit part from a still taken on the set. A bizarre example of this can be found in *Suddenly, Last Summer* where the character of the homosexual brother (Sebastian Venable) is only glimpsed from behind in a flashback, yet a full face portrait exists in still form. (See Vito Russo's *The Celluloid Closet*, p. 117)

Some of the most familiar Hollywood faces – of

"I AM A FUGITIVE FROM A CHAIN GANG" *with* PAUL MUNI R56/402
Re-released by Dominant Pictures Corp.

I am a Fugitive from a Chain Gang (1932). In his autobiography, *Take One*, director Mervyn LeRoy claims that he had the idea of not showing the beating of Paul Muni (by the vicious sheriff and his two deputies) on the movie screen. However, what the audiences at the time did not see in the film itself they may well have spotted outside their local movie house instead. As one of the best known publicity stills, this dramatic shot was widely used to stir interest in the film's hard-hitting portrayal of prison conditions in the deep South.

the many fine character players, for whom it is often difficult to supply a name – frequently turn up in stills where they can most easily be spotted and identified. Alternatively, it is fun to spot a player who has only a tiny role at the beginning of his or her career, and may be virtually unrecognizable, someone who will go on to later stardom or great success as a writer or director. There is, for example, a well known still from D.W. Griffith's *Hearts of the World* (1918) which shows a very young Noel Coward in a tiny part, pushing a wheelbarrow as he passes by Lillian Gish. Similarly, a teen-aged Robert Parrish can be spotted in Chaplin's *City Lights*, (1930) while another, more famous director, Elia Kazan played supporting roles in two films in the early 1940s. A young and clean shaven Robert Towne was credited on screen as 'Ed Wain' when he doubled as an actor in Roger Corman's cheapie production of *The Last Woman on Earth* in 1960, while more recently another writer, S.E. Hinton appeared briefly as a nurse in the Coppola film version of her novel, *The Outsiders*. Only a surviving still tells us that Erich von Stroheim originally played a cameo role as a balloon seller in his film *Greed* (1924), and, similarly, John Huston's 'walk-on' in *The Red Badge of Courage* (1951) appears to have ended up on the cutting room floor (see page 104).

When scene stills are made during the course of filming, it is always possible that they will pick up some details which are not meant to be seen on the movie screen. Thus, a piece of equipment may appear in the background or one may see the top or back of a set, especially if the photographer is not positioned

in the same spot as the cine camera or is trying to snatch a shot during rehearsals. Also, the still camera may record an actual mistake or blunder – such as the misspelling of Philip Marlowe's name on the window of his office in *Lady in the Lake* (1946). But this should not be confused with the far more usual situation of catching an anachronistic detail which is not seen on the screen. For example, although an orange crate labelled 'Produce of Israel' appears in a still from the film *The Sound of Music* (1965), this label cannot be seen on the movie screen.

In contrast to these stills which show 'too much', there are, of course, scenes in films for which no stills exist. Although there should be at least one or two stills representing every important sequence and character in every film, for one reason or another, there are occasions when no stills appear to have been taken. This could be due to bad planning, an unfortunate accident in the stills camera or in the lab which was discovered too late to retake the shot, or simply the behaviour of an unhelpful director, assistant director or star. In the rush to get to the next camera set-up, perhaps in danger of running over budget and behind schedule, the stills may be neglected.

Of special interest here is the example of scene stills missing on purpose – whether from the desire not to spoil a good gag in a comedy film or a determination to ensure that some crucial aspects of the plot or some special make-up effects are not revealed in advance, thus tending to lessen the impact of the picture and perhaps spoiling the enjoyment of the movie audience. In some cases, such as the appearance of E.T. or of the unmasked Erik in *The Phantom of the Opera* (1925), the stills were made but were held back at the time of the films' initial release, whereas for *The Hunchback of Notre Dame* (1939) and some scenes in *Psycho* (1960) it appears that no stills were shot at all.

Described by his younger brother Frank as a 'masterpiece of make-up engineering', Perc Westmore's ingenious and grotesque transformation of Charles Laughton's face for the role of Quasimodo in *The Hunchback of Notre Dame* involved a false right eye and eyelid attached to the actor's cheek in such a way that when Laughton's real eye blinked, so did the false one. RKO did such a good job of controlling the stills, which only show the actor in shadow or from behind, that even today, over fifty years after the film was first released, it is virtually impossible to find a full face portrait of Laughton in this picture. Nor is

his face shown on the film's posters (see page 110).

Similarly, in the case of *Psycho*, producer-director Alfred Hitchcock was determined to maintain tight security and keep all the details of the production as secret as possible. This included strict control over the stills, as Hitch made sure that they did not reveal crucial aspects of the plot in advance. The restrictions he placed on stills photographer William 'Bud' Fraker provoked a heated reaction from Paramount publicity chief Herb Steinberg. He complained to Hitchcock about the overly 'static' stills that failed to capture 'the excitement or flavour of what I know you are getting on the screen. I understand your need for secrecy', continued his memo, 'I wish, though, that you would allow us to cover everything you shoot, so that we can at least have a record for future use at such time that these secret elements concerning *Psycho* may be released...' Steinberg even suggested a compromise whereby the photographer would be allowed to take stills, but the negatives would remain undeveloped and unreleased as long as Hitch wished. But the director remained unconvinced and all extant stills from the film are quite unrevealing of the horrible events which take place in the Bates house and motel (see page 112).

Finally, this chapter on the shooting of stills would not be complete without reference to the many photos which survive from films that were never completed. Since, as has been noted, the photographer is often present from the time that a project is first being developed, stills can be seen from productions which were abandoned quite early on or which never got underway. A good example of the latter is *Joseph and his Brethren*, scripted by Clifford Odets, with Rita Hayworth cast in the role of Potiphar's wife. Although some Biblical sets were built and costumes designed in 1955, the project was finally written off by Columbia studio boss Harry Cohn at a cost of almost $2 million. However, the best known examples of films abandoned midway through production, with interesting stills and film footage surviving, are *I, Claudius*, produced by Alexander Korda, directed by Josef von Sternberg, starring Charles Laughton and Merle Oberon, and *Something's Got to Give* – best remembered as Marilyn Monroe's last, uncompleted picture at the time of her death in 1962. Sadly, she never looked more radiantly beautiful than in the surviving stills and footage from this ill-fated project (see pages 114 - 117).

When MGM's new comedy star, Bert Lahr, arrived at the front gate ready to begin work on his first movie *Flying High* in 1931, the photographer was already waiting to take a photo. In fact, the stills photographer's job generally starts long before the cameras begin to roll.

In the case of *A Farewell to Arms* in 1932, for his first pre-production photo sitting with the stars Gary Cooper and Helen Hayes, John Engstead had the idea of asking them to lie down and embrace on the Paramount gallery floor. These love scene photos turned out so well that they were imitated in the actual filming. Clearly, all these photos are useful in developing advance audience interest in new movies, often released to newspapers or magazines long before the filming is completed, or even started.

Above: One of the main activities prior to the shooting of the film is the design, manufacture and fitting of the costumes. Right, Jeanne Crain, who stars in *The Model and the Marriage Broker*, is shown a selection of costume designs by designer Renie (left), while top model and consultant Zore Jannings gives her advice.

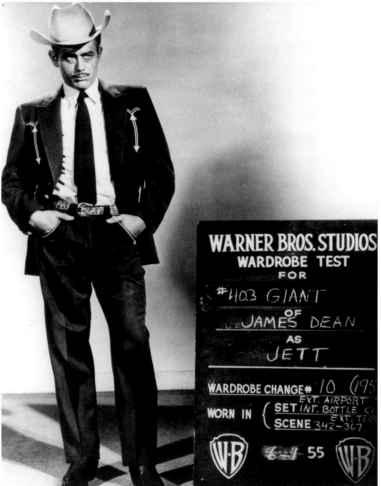

Above, Ginger Rogers confers with designer Bernard Newman and his wardrobe assistant on one of her stylish dresses for *Top Hat* in 1935. The photographer is not only on hand to record these informal moments, but has an even more important role to play once the wardrobe has been completed, namely to record the final version of each costume.

Left: A wardrobe test shot of James Dean in *Giant*.

This unusual photo of a wardrobe stills session with Bette Davis for *Now, Voyager* in 1942 probably took place relatively early in pre-production before the depiction of her character had been fully worked out. Thus, her hairstyle, dress and general appearance are nothing like this in the final film. The large stills camera and assortment of lights dominate the picture, while the stills photographer (in dark jacket) confers with leading Warner Bros. lighting cameraman Sol Polito on the far right.

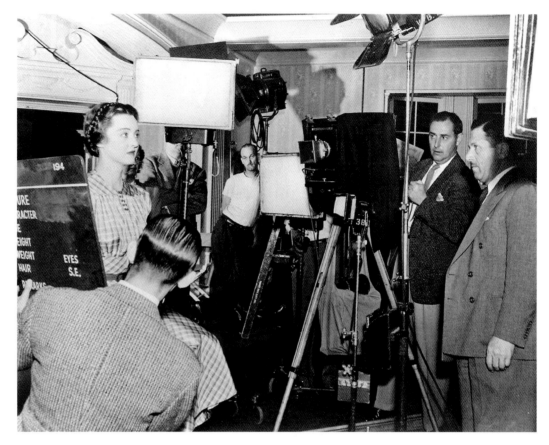

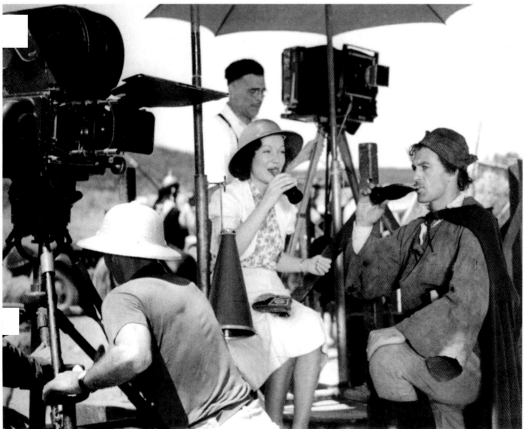

Two examples (left and overleaf) of the stills men present during the shooting of a couple of Hollywood features in the late 1930s. On location for *The Adventures of Marco Polo* in 1937, an unidentified stills photographer appears discreetly in the background preparing his large plate camera during a break in filming. Gary Cooper in costume is visited by his co-star, Sigrid Gurie, who is not on call this particular day, wearing a light summer blouse and skirt outfit as they share a coke. The large Mitchell camera is prominent on the left with its "flag" out to shield the lens from the bright sunlight.

WAYNE MORRIS · ROSEMARY LANE · HUMPHREY BOGART in "RETURN OF DOCTOR X" — A First National Picture

An unusual photo taken during the filming of *The Return of Dr. X* in 1939 with the large stills camera prominent on the right and only the hand of the photographer in frame to suggest that he is actually present behind the camera. In fact, Vincent Sherman, on the right, looks like an actor posing for a still rather than the film's director, caught by a second photographer while rehearsing a scene with two actors, Dennis Morgan and Rosemary Lane. Complete with caption below, this looks like a still sent out by the studio, Warner Bros., to publicize the film. Very strange...

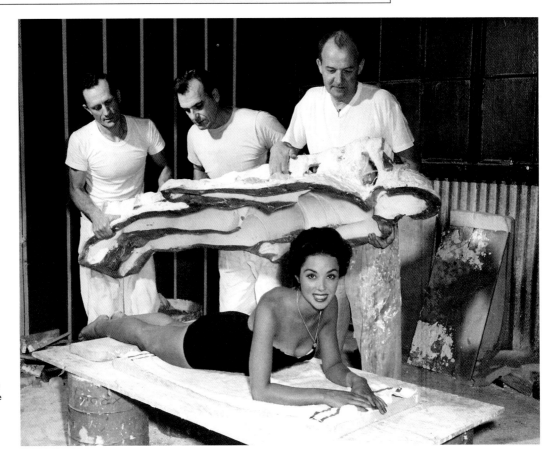

For her role in *Invasion of the Body Snatchers* (1956), an exact, life-size replica of her body was required, so actress Dana Wynter dutifully complied – seen here with three of the studio's plaster workers.

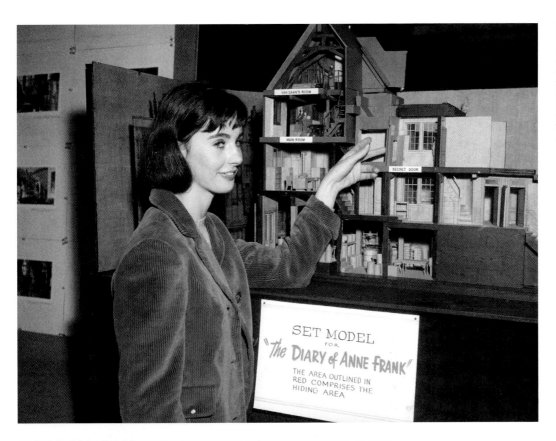

Left: Prior to the shooting of *The Diary of Anne Frank* actress Millie Perkins poses in front of a cutaway model for the film's main setting, which can be compared with the final version constructed on the Fox sound stage (below left). A giant crane is being used for filming and actress Shelley Winters can be glimpsed seated on the floor in the top room.

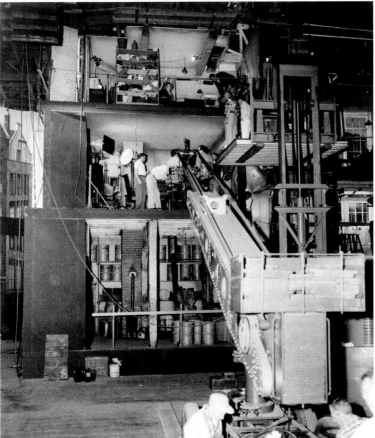

Below: Gene Kelly rehearses with his dancer brother Fred for their only appearance together on screen in the MGM musical *Deep in My Heart* in 1954.

As part of the preparation for their screen roles, the movie stars were often given lessons in a variety of skills, and the stills man was often present to take photos for use in publicizing the film. The results were often strange or amusing and rarely uninteresting. In this spread from the MGM studio, champion swimmer Johnny Weissmuller is seen giving Maureen O'Sullivan an impromptu indoor swimming lesson for her role as Jane in the studio's forthcoming Tarzan series in which he stars (top left). Ann Sothern is instructed in the rudiments of how to hold a violin by music teacher Oscar Baum for *Three Hearts for Julia* in 1942 (top right). Judo expert Peggy Daniels helps Loretta Young and Marilyn Maxwell in planning out their big comedy fight scene for *Key to the City* (1949) (below right), while Gene Kelly rehearses with the studio's newest star discovery, French dancer Leslie Caron, for her movie debut in *An American in Paris* in 1951 (below left).

This shot of a young Marlon Brando working out with a punch bag is not just a publicity stunt. Brando enjoyed boxing when he was young and tried to keep himself in top shape for his role as the muscular-looking Stanley Kowalski during the run of the play in New York and during the shooting of the movie version of *A Streetcar Named Desire* in Hollywood in 1951.

Starlet Julie Adams was instructed in dancing the hula for her role in Universal's *Away All Boats* in 1956.

According to the caption supplied by the studio, Stewart Granger here demonstrates perfect fencing form as he parries a lunge from his Belgian instructor, Jean Heremans. He and co-star Mel Ferrer were given extensive lessons and forced to practice long hours in preparation for their roles in the lively swashbuckler *Scoramouche* in 1952.

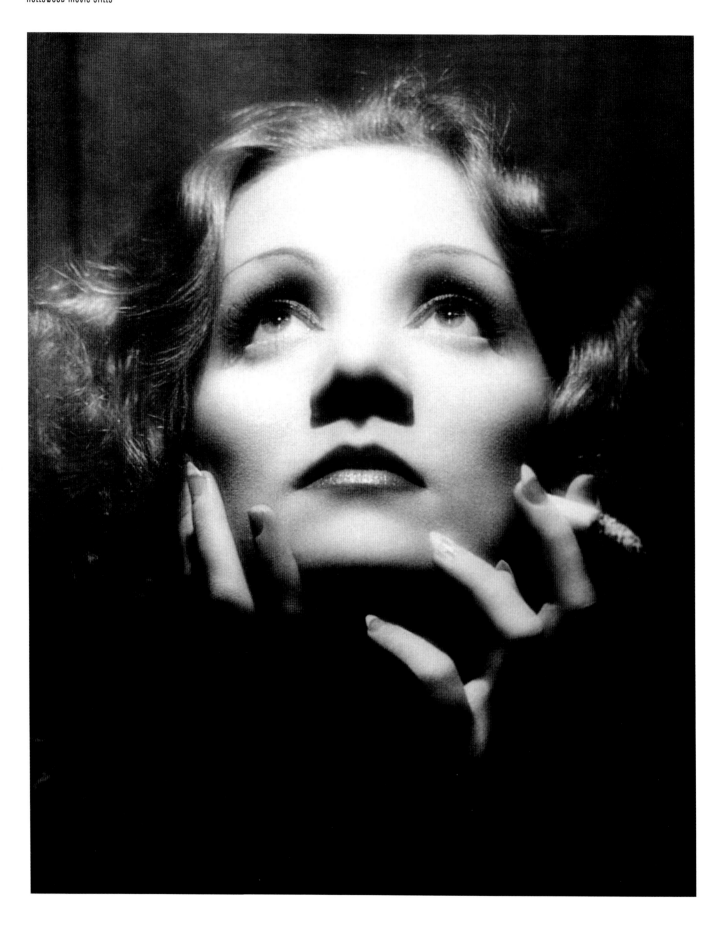

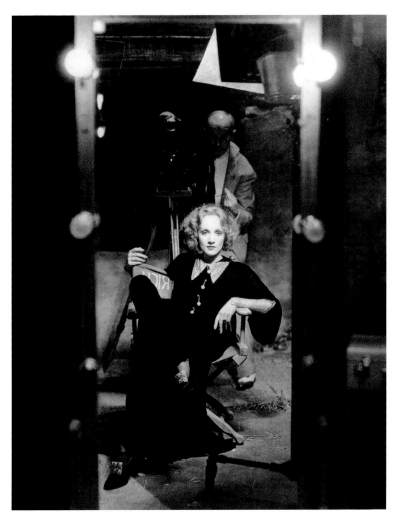

Some idea of the special quality of the portraits and stills taken on the set of the Von Sternberg-Dietrich films at Paramount in the early 1930s can be gained from this small selection for *Shanghai Express* in 1931, perhaps the most successful of the group and their fourth feature together. Generally held in high esteem by the other studio photographers, the comments of John Engstead, a young photo assistant at the studio at the time, seem quite appropriate here. According to him, all the photos were diffused by Sternberg, who made use of a very sheer material (mousseline de soie) which he placed in front of the camera lens to get the effect he required. 'Josef von Sternberg taught me the importance of creating the roundness of face by lighting', Engstead recalls in his book *Star Shots*. 'And he showed me how to have a spot fall off and shade very slightly the top of a forehead to show that it is not flat'. In Sternberg's words, 'a good photograph has tones of pure white and black and all the shades of grey in between.' Dietrich is seen here (above) with co-star Clive Brook and in an unusual mirror shot taken by Don English, which also shows the photographer with his favourite 8 x 10 camera.

Action and fighting scenes on screen obviously present special problems for the photographer. On the one hand, a sharply focused shot carefully arranged for the camera can look overly posed, while a genuine action shot is often blurred and out of focus. In fact, this amusingly juxtaposed pair of stills from *Nothing Sacred* (top) makes the point quite clearly. In the first (left) Carole Lombard looks beautiful in profile, Fredric March handsome, and the supposed action ridiculous. In the second (right) her fist is moving so fast that it appears as a blur, while the expression on her face reflects the real effort she has put into throwing the punch, watched by Walter Connolly. Neither shot is really satisfactory on its own, though it is fun to see them together. The other examples on this page are more successful: Raymond Massey grapples with Howard da Silva in one of the more exciting sequences in an otherwise slow-moving, if worthy, adaptation of the Robert E Sherwood play *Abe Lincoln in Illinois* (filmed in 1939) (above). Billy Halop (left) as Flashman squares up to young Tom (Jimmy Lydon) in *Tom Brown's Schooldays* (1940) (right), an English story filmed with a largely American cast. The quality of the still suffers slightly from the fact that it has been blown up from a 4 x 5 negative, photographed by Fred Hendrickson.

The stills photographer has to be well positioned in advance with his camera ready to capture the most exciting movie stunts, although there is always an unpredictable element involved.

Left: A member of the Hole-in-the-Wall gang is shot during the holdup of the train in *Butch Cassidy and the Sundance Kid* (1969). (Robert Redford can be glimpsed in silhouette in the background).

Above: A stuntman flies through the air in an unreal-looking scene from an unidentified silent film of the 1920s.

Right: Similarly, a stuntman takes a dangerous-looking fall in the midst of a typical western brawl in *Guns of the Timberland* (1960). (A pile of mattresses discreetly out of shot will break his fall.)

Above: An actor floats in space, aided by some hidden wires, during the filming of George Pal's *Destination Moon* (1950). This still also provides an excellent view of an unblimped Technicolor camera.

Right: Hollywood B movies and serials included lots of spectacular action and provided regular employment for many expert stuntmen. This amazing leap occurs in the 1941 Republic serial *Dick Tracy vs Crime Inc.*

One of the photographer's jobs is to provide reference stills of all the main sets which can be used during the course of filming and consulted if sets have to be matched or rebuilt. The example shown here comes from the Warner Bros. studio in the 1940s and presents a Hollywood view of what a lavish New York apartment should look like. The main set, designed by Anton Grot – representing Bette Davis's lavish penthouse apartment in *Deception* (1946) – is dominated by a grand piano, reflecting the fact that she plays a famous concert pianist in the film. The matching shot shows Miss Davis and Paul Henreid in an intimate love scene being filmed on a corner of the same set with cameraman Ernest Haller and director Irving Rapper behind the Mitchell camera. (Note how their chair has been slightly raised off the floor in order to get the right camera angle.)

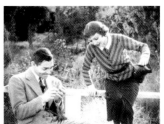

Here are three examples of well known stills which differ to more or less extent from the images seen in the original films. On the facing page, the still of the famous hitchhiking sequence in *It Happened One Night* (1934) is juxtaposed with a series of frame enlargements showing how the same scene appears in the film. In this case the posed still can be better understood after we have seen the film. For example, Gable's sour expression reflects the fact that he has no success at all, while Claudette Colbert's blank look conveys the idea that she is purposely 'playing dumb' and will let her actions speak louder than words. Her own effective method of hitching, of course, takes the smug Gable by surprise. And in the film she adopts this dead pan look, appropriately enough, at the very end, seated in the back of the car, as they drive away.

An important theme in *The Informer*, Victor McLaglen's relationship to Wallace Ford (Frankie), is expressed symbolically through Frankie's face on the poster, which continues to haunt him after Frankie's death. Here the photographer, probably Bob Coburn, demonstrates how a single photo can effectively capture the mood of the film. His accomplishment is a double one in that Coburn was probably asked to take the shot of Ford which appears on the poster and has managed to capture the quality of an informal portrait which still appears to be staring out accusingly at his betrayer.

For the memorable fun fair, hall of mirrors climax to *The Lady From Shanghai*, Columbia studio boss Harry Cohn apparently ordered the stills to be made with Rita Hayworth wearing a low-cut and backless dress along with decorative, elbow length gloves – a far more sexy and revealing outfit than the formal suit she wears in the film. In addition, the whiteness of her bare skin provides a central focus for the picture and makes the overall effect that much more striking. (She is seen here with director and co-star Orson Welles, who was married to her at the time and had the idea of transforming her familiar appearance by turning her into a short-haired, bleached blonde which fitted her role as the mysterious and murderous heroine of the title.)

Facing page: This still of Boris Karloff as *The Mummy* (1932) makes use of light and shadow to present a strikingly gruesome portrait of the title character who can be seen more clearly here, and in much sharper detail – including, especially, the elaborately constructed make-up – than at any point in the film itself.

Right: A rare example here of a scene cut from the Laurel and Hardy short, *Below Zero* (1930) with Frank Holliday as the cop. The still shows each of the characters wearing the wrong hat, suggesting that this was probably a reworking of the 'mixed up hats' routine used in others of their films – which must have appeared ripe for cutting at the time.

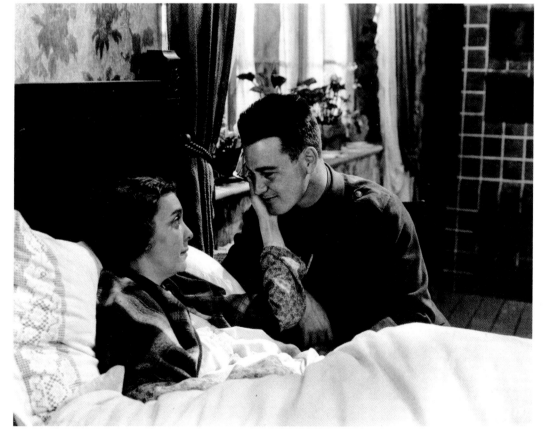

Left: ZaSu Pitts originally played the mother of Lew Ayres in *All Quiet On the Western Front*. She perfectly fitted this role and probably gave a moving performance, but her success as a comedienne around this time meant that the studio, Universal, decided to re-shoot her role with Beryl Mercer instead. (However, she can still be seen in the silent version of the film, mainly distributed in Europe.)

The original ending of *Double Indemnity* (1944) (later cut as unnecessary) had Edward G. Robinson observe the execution of convicted murderer Fred MacMurray in the prison death chamber. This effective still composition makes use of contrasting lighting, the gravity of the moment reflected in the dark shadows which conceal the eyes of Robinson on the right. Similarly with MacMurray, whose apparently sightless eyes appear to anticipate his imminent death.

Below: John Garfield and Lana Turner in a beach scene from *The Postman Always Rings Twice* which was cut from the film.

This still (below) looks like a scene from *Citizen Kane* (1941), but it is a posed version of a sequence which is glimpsed briefly in the fake newsreel, *News on the March*, early in the film. As it is referred to in the shooting script: 'reconstructions of very old silent newsreels of wedding party on back lawn of the White House'. While the narrator intoned 'twice married – twice divorced – first to a President's niece who left him in 1916...'

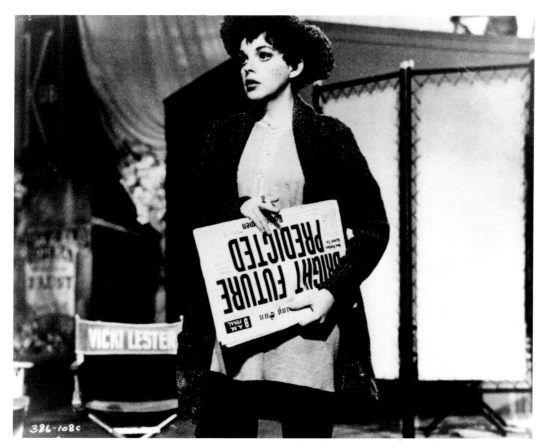

When *A Star is Born* was first released in 1954, a number of important scenes had been cut including this 'film within the film' sequence – a musical number with Judy Garland called, 'Lose That Long Face'. This is also one of the scenes which was later rediscovered and restored to the longer, reconstructed version of the film released almost thirty years later in 1983.

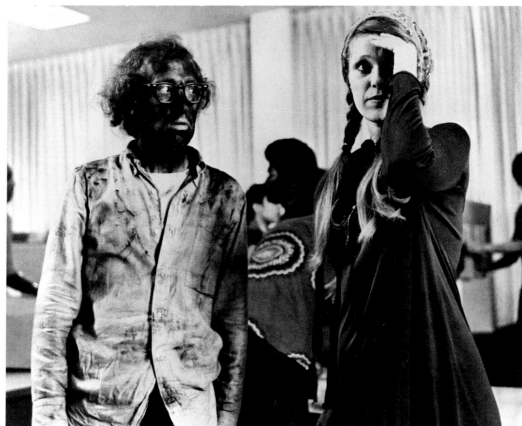

Woody Allen's film *Bananas* (1971) originally had an entirely different ending. Having gained a reputation as a rebel hero, Fielding Mellish (Allen) is invited to give a revolutionary speech at Columbia University. But when a bomb goes off, he emerges from the rubble with a blackened face. An Afro-American militant catches sight of him and exclaims, 'Man, you're a brother'. (Allen is seen here with his second wife, Louise Lasser who plays the role of Nancy in the film.)

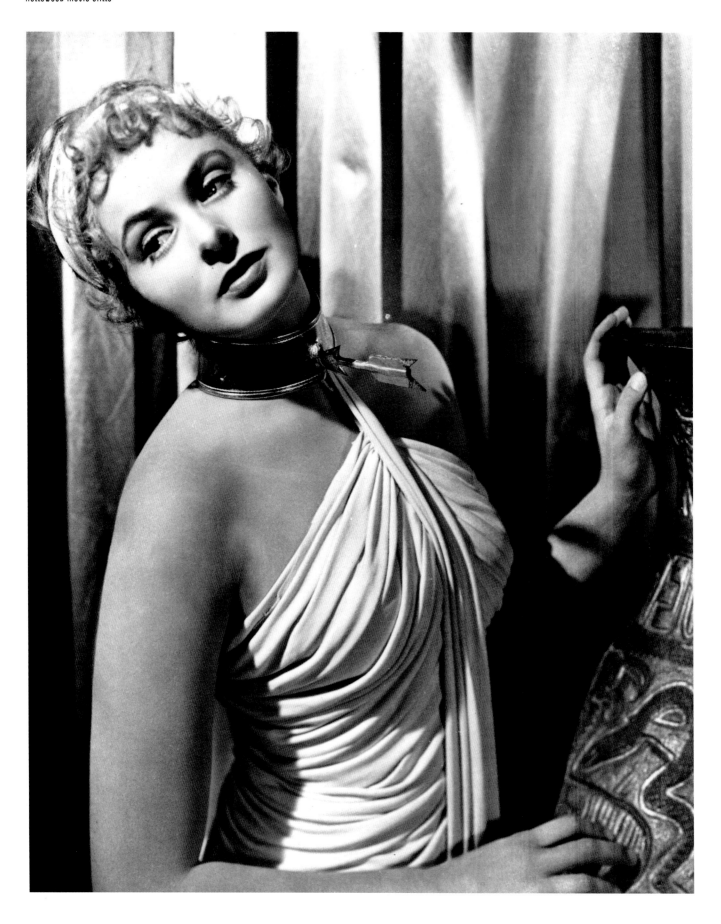

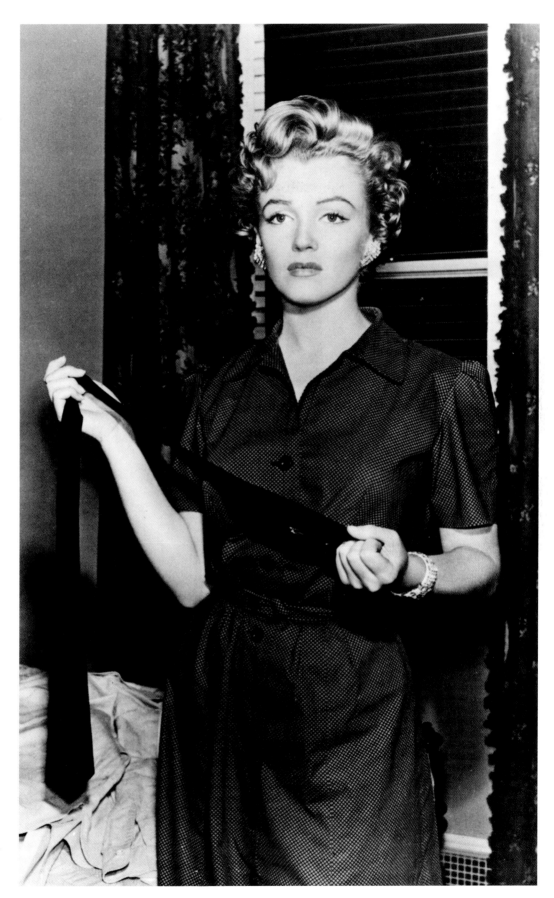

Opposite: The dream sequence designed by Salvador Dali for Hitchcock's *Spellbound* in 1944 was originally meant to include a brief ballroom scene with the two stars. As Ingrid Bergman later recalled, 'the idea was that I would become, in Gregory Peck's mind, a statue... I was dressed in a draped Grecian gown with a crown on my head and an arrow through my neck...' All that survives of this scene are the stills such as this carefully posed portrait shot.

A posed photo of Marilyn Monroe in one of her earliest starring roles, as the mentally disturbed baby-sitter in the suspense drama, *Don't Bother to Knock* (1952). Here she looks as if she is preparing to strangle the little girl in her charge, but is, in fact, just going to tie her up. Aside from its qualities as an excellent portrait, this shot provides a clue as to how the little girl has been bound and gagged, which we never see accomplished in the film itself.

Writers, directors and others connected with the production occasionally make uncredited appearances on the screen and may be caught by the stills camera in costume looking almost unrecognizable. Director John Huston, who years later was to develop a second career as a movie actor, originally played a cameo role in his own film version of *The Red Badge of Courage* in 1951 (top left). Similarly, Tony Richardson, seen here (top right) on set with Albert Finney, played a tiny part in *Tom Jones* (1963) as Squire Weston's steward.

Middle row (left to right): Early in his career writer Robert Towne (right) was credited as 'Ed Wain' when he acted in Roger Corman's cheapie sci fi thriller,

The Last Woman on Earth (1960) (seen here with Anthony Carbone and Betsy Jones-Moreland). Writer S.E. 'Susie' Hinton appeared briefly as a nurse in one scene with Matt Dillon in *The Outsiders*, based on her original novel. Scriptwriter Charles Beaumont was cast in his only acting role as a sympathetic Southern school teacher in Roger Corman's *The Intruder* (1962), which included many local townspeople.

Right: In keeping with the spirit of this wildly hippy-inspired comedy, director Otto Preminger (top left) dressed himself in prison garb and joined the cast of his 1968 movie *Skidoo* including Carol Channing, Jackie Gleason, Frank Gorshin, Peter Lawford and Burgess Meredith.

Johanna Matz · Hardy Krüger · Johannes Heesters
in der frechsten Filmkomödie des Jahres
DIE JUNGFRAU AUF DEM DACH
UNITED ARTISTS Regie: Otto Preminger

A rare still showing Greta Garbo in the German language version of *Anna Christie* (1930) – which she actually preferred to the English version filmed on the same sets at the same time, but with a different director and supporting cast. She is seen here (above left) with Herman Bing and the Polish-born Salka Viertel who would contribute to a number of Garbo's scripts in the 1930s. Since the writer of the original play version of *The Moon is Blue* was a fellow Austrian, F. Hugh Herbert, this gave Otto Preminger the idea of preparing the film in two different language versions simultaneously, a practice that had been far more common in the early 1930s before the widespread adoption of dubbing. Preminger assembled two different casts which he directed in alternating shifts, making use of the same props, sets and production, as can be seen from these matching stills. The American version starred William Holden, Maggie McNamara and David Niven (above right), while Hardy Kruger, Johanna Matz and Johannes Heesters played the same roles in German.

The scene stills taken during the course of filming will often catch bit players at an early stage in their career, before they have become famous. Such was the case with the 17 year old Noel Coward, who had his first brush with the cinema in 1917 when he was cast in a tiny role opposite Lillian Gish in one of the few sequences in D. W. Griffith's *Hearts of the World* which was shot in England.

Both Betty Grable and Paulette Goddard began their movie careers playing small parts in the early 1930s, many years before they emerged as leading stars. Paulette is just about recognizable as the fourth girl from the right in this chorus line (below left) from the Sam Goldwyn movie, *The Kid from Spain* (1932), while the blonde young Betty Grable, only 16 years old, is already adept at catching the camera's eye. Her engaging smile makes her appear more the centre of interest than the film's star, brunette Jean Parker dancing in the foreground in this still from *What Price Innocence* (1933) (below right).

As Evie, the young waitress in a juke joint, Marilyn Monroe got her first on-screen lines of dialogue in *Dangerous Years* (1947) (left), at the age of twenty-one. Like so many before and since, she continued playing minor roles for many years, in such films as *A Ticket to Tomahawk* (1950) (above), seen here far right with star Dan Dailey, before she began to get larger roles.

Since the stills photographer
shoots his photos when he can,
often during rehearsals or
between takes, it occasionally
happens that he will catch some
interesting additional background
detail of the production which is
not meant to be seen by the
movie audience. For example, in
this intimate bathroom scene from
The Devil's Pass Key (1920) –
showing Mae Busch in the bath,
visited by a pedicure (left) and her
friend (Maude George) – a glimpse
of the director Erich von Stroheim
can clearly be seen in the mirror.

In the case of the lavish 1925
production of *Ben-Hur*, this posed
still shows the dramatic
confrontation between Ben-Hur
(Ramon Novarro, right) and his
arch rival Messala (Francis X.
Bushman), which takes place
during the chariot race in the
Coliseum. However, the stands in
the background are not only
empty, since the photo was taken
during a rehearsal, but one can
see that the top portion is missing.
(It would, in fact, be added to the
final print making use of a double
exposure special effect known as a
'hanging miniature'.)

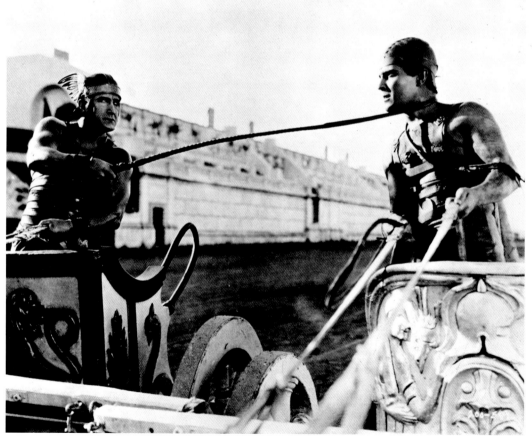

In the photos on this page, the stills man has seized his opportunity to make an interesting shot of the leads as they are rehearsing, not bothered by the fact that his camera is also recording some unusual background details. At first glance the top photo looks like a typical scene between the two leading characters in the popular *Andy Hardy* series – Judge Hardy played by Lewis Stone and Andy, his son – Mickey Rooney – in *Andy Hardy's Private Secretary* filmed in 1940. However, a more careful examination shows that the photographer has captured a view of the MGM back lot in the background, including a giant arc light and some technicians busily at work.

In the case of *Duel in the Sun* (1946), this pin-sharp shot of Jennifer Jones and Gregory Peck has been taken inside the Selznick studio in front of the back projection screen, providing us with a useful clue as to how this scene will be accomplished in the final film.

Whereas the photographers generally work very hard to make sure they get good shots of all the important scenes, stars and other elements of special interest on each production, occasionally they are prohibited from showing things which the producer or director do not want seen by movie-goers before they view the film – such as the extraordinary make-up of Charles Laughton as *The Hunchback of Notre Dame* (1939), or the unmasking of Erik (Lon Chaney) in *The Phantom of the Opera* (1925, on facing page). It is rightly felt that this might spoil the audience's enjoyment of the picture and also give away one of the prime selling points in advance. Such a situation poses special problems for the photographer, especially, as in *Hunchback*, where so much of the action revolves around the character of Quasimodo. This portrait of Charles Laughton in profile is all the stills man was allowed to show. The most striking make-up effects were on the right side of his face, and this cannot be seen here. The scene still is typical of the publicity shots provided, most often showing Laughton from behind or with his face in shadow.

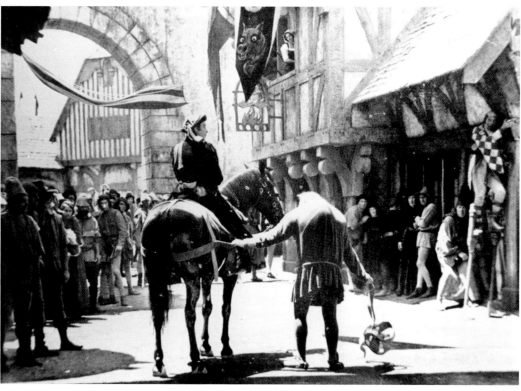

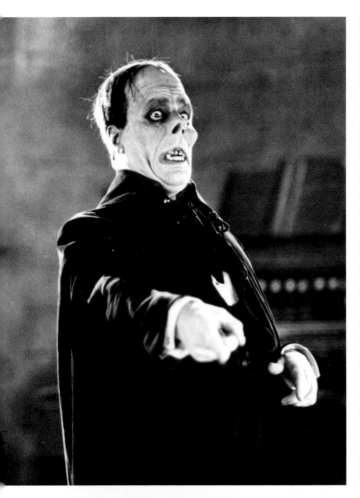

This selection from *Psycho* (1960) gives some idea of how photographer Bud Fraker tried to present the scary elements of the film without giving anything away, as instructed by producer-director Hitchcock, by making special use of strong spots and shadows. Of course, the overall result is that all four leading characters appear frightened, so one has no idea if one of them might be the psycho killer of the title. Most bizarre of all is the full length shot that comes closest to giving a clue regarding the real nature of the horror – John Gavin and Vera Miles gazing fearfully at an old fashioned, wooden rocking chair. It is hard to imagine what movie audiences would have made of this still before they had seen the film... the two other leads seen here, of course, are Anthony Perkins as Norman Bates, and Janet Leigh.

After the film is completed the stills photographer's work is not yet done. He may be asked to take photos at the première, to cover any publicity stunts or other events connected with the opening of the film, and may receive other special assignments. The RKO photographer snapped Jane Russell during the launch of *Two Tickets to Broadway* at its Hollywood première, while also managing to include the cinema marquee advertising RKO's *Mighty Joe Young* in the background (left), along with UA's *D.O.A.* It was also important to make a record of one of RKO's most spectacular signs ever, erected at the corner of 47th Street and 7th Avenue in NY to advertise the opening of *Underwater* in 1955 (below left).

The film studios were eager to contribute to the war effort in the 1940s, so when Warner Bros. starlet Irene Manning was selected as the 'Buddy Poppy Girl' in 1943, the studio sent unit photographer Jack Woods to take the publicity shots.

This stills spread comes from Marilyn Monroe's last, uncompleted movie, the appropriately named *Something's Got to Give* (1962). Much of the completed footage, almost one half hour in all, has been seen in documentary form. It is likely that these photos were taken by Fox's unit stills man on the film, Jimmy Mitchell. He was also present on the day when Marilyn went for her famous nude swim in the pool, which was also photographed by freelance photographers Lawrence Schiller and William Woodfield. Although the nude shots have subsequently become famous and were widely reproduced all over the world, they have little to do with the film, unlike these stills which show her in a number of different costumes and in a scene with co-star Wally Cox. Though Monroe looks stunning, the script was weak, and the filming not going well: way behind schedule and far over budget when Fox decided to call a halt.

A varied selection here of films that were never made or completed. On the facing page, Rita Hayworth and Jean Louis, the leading costume designer at her studio, Columbia, select fabrics for the costumes to be made for the Biblical epic *Joseph and his Brethren* in the mid-1950s. But the project ran into difficulties and was finally abandoned after over $1.5 million had been spent on sets, costume designs and a screenplay by Clifford Odets.

At least shooting did get under way on the World War I flying movie, *The Bells of Hell Go Ting-a-Ling-a-Ling* in 1967. But filming was abandoned after only five minutes were shot when star Gregory Peck broke his ankle. Here the director and stars are seen on location in Switzerland with a 1915 Avro 504K biplane in the background. Left to right, Peck, Burr De Benning, Ian McKellen in what would have been his first film role, producer-director David Miller and David Battley.

As with *Something's Got to Give*, at least half an hour of filming was completed on *I, Claudius*, in 1937, before shooting was halted by producer Alexander Korda. Again there was a serious accident as in *The Bells of Hell*: star Merle Oberon was injured in a car crash – and much of the best of the surviving footage has been seen, included in a special BBC documentary called *The Epic That Never Was*. According to the original caption, 'Caligula (Emlyn Williams) who believes that he has become a god, summons Claudius (Charles Laughton) to his bedroom to perceive the amazing change' – observed by centurion Robert Newton. This evocative still gives some idea of the quality of the production design (by Vincent Korda), lighting by Georges Périnal and direction by Josef von Sternberg.

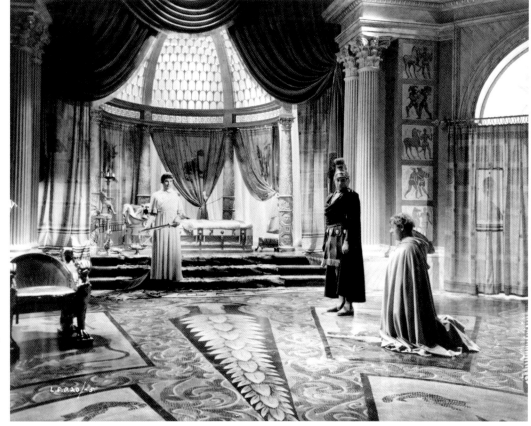

CHAPTER FOUR
A PEEK BEHIND THE SCENES

So far our discussion has concentrated on the two most familiar categories of movie photos – the star portraits and the scene stills. Yet from the very beginnings of movie stills photography, the photographer was encouraged to take other kinds of shots – of the personalities connected with a production, of the producers or director, and a variety of behind the scenes photos during the making of a film. In addition, during the 1930s in particular, when virtually everyone was under contract, the photographers' brief was a wide one. Publicity for each individual film fitted within the general, ongoing effort to keep all the studio's personalities in the public eye as much as possible. Thus, the photographers' assignments were naturally extended to cover the home life of the stars, leisure activities, restaurants and night clubs as well as any special events – parties, weddings, film premieres and awards ceremonies.

Such photographs were provided to the press and fan magazines on a regular basis, along with the portrait or publicity stills to publicize the release of each new picture when there was special interest in the leading stars of that particular film. But even between pictures the studios would keep up a continuous flow of photographs of this type, with accompanying captions suggesting, for example, that 'Bette Davis is currently working on her latest film which will be released later this year' or 'Bette Davis has just finished shooting her latest picture' or 'Bette Davis is just about to start work on her newest film which will co-star James Cagney and George Brent'. Since the stars were kept busy under the studio system, there were only relatively brief gaps between pictures and always new projects on the way. And this meant that the studio photographers would be kept busy, year in and year out, on the set, behind the scenes, on location, visiting the stars' homes and in and around Hollywood generally.

In the previous chapter we referred to the fact that the unit stills man would be taking photos before and after the actual shooting of the picture, including everything from costume tests and rehearsals to studio technicians and personnel at work: editors in the editing room, carpenters building sets and the studio orchestra recording the score. But during the period when the picture is being filmed, only a relatively small proportion of the time is spent actually shooting. And this is when many of the most interesting production stills are made.

There are long periods of inactivity when the actors are waiting for the lights to be arranged, the set to be dressed or the camera set in position for the next shot. The stills photographer, too, is present on the set or location to record the necessary scene stills. And the possibilities for making other types of photos of interest at the same time are virtually unlimited. Given a suitably wide brief and encouraged to take lots of photos, the results were often quite fascinating and provide a comprehensive record of every aspect of Hollywood film-making.

However, while such behind-the-scenes photos may give the illusion of having been snapped 'off the cuff', as it were, showing the stars in a private moment between takes on the set, they were generally artfully planned and posed for the benefit of the stills camera. It is rare to see a genuinely 'candid' shot taken, for example, with a smaller, hand-held camera.

If the photographer is allowed to take shots while the director and cast are rehearsing, merely by shifting the angle of his camera slightly, he may be able to catch a shot of the director and other members of the crew at work with the actors. This is probably the most familiar type of production still. And such a shot may well be encouraged by a director who is aware of the presence of the stills man and may enjoy posing for photos. The stills of especially well known directors such as C.B. DeMille and Alfred Hitchcock, for example, were often used to help publicize their films along with the usual scene stills and pictures of the stars, and for Hitch, in particular, such photos represented a natural extension of his famous cameo appearances on screen. From a general familiarity with the many stills showing directors in action, it appears that some directors, such as Hitch or Elia Kazan, who was originally an actor, especially enjoyed playing the role of director on the set, for the benefit of cast and crew... and the stills man.

Occasionally these photos also provide a unique record of the kind of equipment and movie techniques being used – cameras blimped or unblimped (i.e. soundproofed or not) or mounted on a crane or dolly, the different types of microphone, the positioning of the lights and a variety of other production details. An alert photographer might wish to show how special trick or stunt shots were achieved. But such photographs always ran the risk of being rejected by the film's producers.

For example, photographer Phil Stern once com-

An imaginative collage-portrait of Busby Berkeley, the famous dance director, and creator of some of the most remarkable sequences ever seen on the screen, for the Warner Bros. musicals of the 1930s. Surrounded by a montage of shots from the 'My Forgotten Man' number, the climax of *Gold Diggers of 1933*, the camera has caught Berkeley in a contemplative mood – he appears to be dreaming up some fantastic new images for his next film.

Richard Egan plays one of the Spanish Conquistadors in eighteenth-century California attacked by hostile Indians in *Seven Cities of Gold* (1955). He has just been shot in the chest but is protected by an arrow-proof waistcoat made of balsa wood and metal hidden beneath his jerkin.

Since film-making is such a slow, tedious, business, it is not surprising that the stars, and especially a very young star like Shirley Temple, can get terribly bored. An unscripted moment is captured here by the photographer with a 3 x 5 camera on the set of *Captain January* in 1935. Seen in this shot are, left to right, Slim Summerville (partly hidden), Miss Temple seated on the lap of Guy Kibbee and Buddy Ebsen (far right).

plained about the experience he had with one of his favourite photos, taken on location during the filming of John Huston's western, *The Unforgiven*, in 1959. His photo showed Albert Salmi rising from a river bed with an arrow in his back, having just been shot 'dead'. According to Stern, 'the studios "killed" this kind of shot because it revealed "movie magic".' But this was not always the case, for they too recognized

that unusual photos had a special appeal and could be useful for publicity.

As we have already noted, many interesting and amusing photos are taken during breaks in filming. Whereas some stars could be reluctant to attend special portrait sessions or have the stills men photograph them at home or in their private life, during the actual filming they might well be more available. Thus, the photographer could snap the stars on set having their hair or make-up done, their costume adjusted between takes, reading the script, or merely relaxing with a cigarette or cup of coffee. The photos immediately become more interesting if the stars are still in make-up and costume, such as Boris Karloff in his Frankenstein monster make-up eating his lunch on the set or smoking a cigarette (see page 175).

In addition, many stars had taken up hobbies which they pursue during the many spare moments during filming, such as knitting, painting, or photography. On a film set of course there are lots of people ready to give some friendly tips on the taking of photos, beginning with the lighting cameraman and members of the camera crew. The comedy star, Harold Lloyd, for example, was an accomplished amateur painter who also became interested in photography and even experimented with the taking of stereoscopic or 3-D photos. (A selection of his pictures of Hollywood stars was published in a book titled simply *3-D Hollywood*, which came complete

with a 3-D viewer.)

If there was a piano or other instrument handy, the photographer might catch a shot of the stars indulging in some impromptu music-making or singing or just clowning about to pass the time and entertain each other. Occasionally one sees photos of the star posed with his or her stand-in, wearing closely matching costumes, like a pair of not quite identical twins. Often a star would have a regular stand-in on a number of films, and they might become friends, after working together over a number of years.

An interesting example is shown here of how even a simple photo of actors and stand-ins can be revealing of an aspect of the film-making process and of the special demands of this particular job. The stand-in makes the actor's life a bit easier, for he or she spends long hours on the set and under the hot lights when the camera and lighting is being prepared for the next shot. Thus, the star does not have to appear until everything is ready for filming. This is especially important in the case of child actors, for there are strict regulations regarding the amount of time children are allowed to work each day, and their tolerance of the strong lighting sometimes used in filming is also much less than that of an adult. Thus, our example shows the quite practical solution whereby, according to the caption supplied by the studio, 'two diminutive adults serve as stand-ins for two youngsters in the Bing Crosby starrer, *Here Comes the Groom*'. However, a somewhat different solution must be found when a tiny baby is used in a scene... (for the answer see page 136).

Yet another quite familiar type of behind-the-scenes shot shows the star posed with visitors to the set ranging from family and friends to VIPs or others with a special interest in the particular film being made. A favourite type of photo is that which shows the star of a biopic or other film based on real characters and events posed with the person whom he or she is portraying on the screen: Sam Shepard with the real life test pilot, General Chuck Yeager, who also served as a technical advisor on the film, *The Right Stuff*, or a remarkably youthful and attractive looking Louise Hovick (Gypsy Rose Lee) with Natalie Wood on the set of *Gypsy*. Then too, there is the obvious, and even embarrassing incongruity of the nice plump, elderly, white-haired lady posed with the slim, stylish and young-looking Rosalind Russell, who is portraying her on film in *Sister Kenny* (1946) as one of this actress's many career-woman roles (see page 137).

Of course, the producers are always happy to introduce a bit of sex appeal into the publicity. Even a producer of quality pictures such as David O. Selznick was not adverse to exploiting the presence of the attractive and sexy young Rhonda Fleming in filming *Spellbound* in 1944. Although she only played a small part in the film, a report from the set on the very first day of filming mentions that, between takes, Selznick had arranged for the stills photographer to take a

The two young actors and their adult stand-ins in *Here Comes the Groom*.

number of shots of her provocatively posed on a couch. (He was more careful, however, in his treatment of Jennifer Jones whom he was trying to promote as a serious actress. As he noted at one point in one of his famous memos: 'The fan magazine photos seem all right, provided that they are not staged for either semi-cheesecake or for fashions or for anything of that sort. They must have dignity and taste...'.)

Another amusing example on page 140 is a behind-the-scenes shot during the filming of *A Farewell to Arms*. Gary Cooper and Adolph Menjou have been joined on the set by a group of scantily clad extras who were originally included in the background of the café/brothel sequence which has just been filmed. Occasionally vulgar and in bad taste and in the best (or worst) tradition of showmen and showbiz the world over, such photos would be labelled 'sexist' today. And of course, Helen Hayes, the film's serious dramatic star is missing from this shot. She can be seen elsewhere, more tastefully posed by the stills man, on the set with the movie camera. (Best known as a star on the Broadway stage and married to playwright Charles MacArthur, perhaps these shots were meant to suggest her new attraction to and fascination with the movies at the time, though she would return to the theatre and leave film-making behind only a few years later.)

One category of photograph not mentioned so far, but which is also the responsibility of the stills man, is the snapshot or photo needed for use in the film itself. It may appear only briefly when one character shows another a picture of his new girlfriend; it may be used as part of a montage of images or even figure in the

The film could just as well be called 'Between Two Men', as suggested by this very posed looking portrait of the three leads used by MGM behind the opening credits of the film. The studio was always looking for new ways of promoting its stars, not just in pairs (Gable-Harlow, Powell-Loy, Eddy-MacDonald), but in groups of three or more. The real title is *The Last of Mrs Cheyney* (1937) and the stars are Robert Montgomery, Joan Crawford and William Powell.

snapshot version can be glimpsed early on when Miss Tierney, in a disturbed state after having been caught shoplifting, takes refuge in their bedroom and picks it up, recalling a time when she was younger and happier (see page 139).

In order to provide this snapshot, a special photo session was arranged with the stills man, and the photo seen in the film was merely one of a number of shots taken at the same time. But rather than merely discarding the ones that were not used, the studio later included them among the large selection of scene stills used for publicizing the film, though they were quite unlike anything else in the film, a tasteful bit of 'cheesecake', in fact.

Similarly, in the case of *Rebecca* (1940), when some silent, and slightly grainy, footage of Olivier and Joan Fontaine on their honeymoon had to be filmed, the stills man was also present. Thus, one of the most familiar publicity stills shows a scene which is never seen in the movie itself, but is included in the short 'film within a film' when the couple later look at their 16mm 'home movies'. A bit more unusual, however, is the still showing the first wedding of Charles Foster Kane. You could be forgiven for thinking that this scene never appears in *Citizen Kane*. But, as with *Rebecca*, it flashes up briefly in the 'News on the March' sequence. (When this was staged for the fake newsreel cameras, the photographer was there, too, to record a nicely posed group shot of the wedding party: see page 100).

Occasionally the stills man may be called upon to make a quite important, on-screen contribution, as happened with the elaborate title number for the Technicolor musical *Cover Girl*, in 1943. Here Columbia's top photographer, Bob Coburn, devised and photographed a larger than life series of women's fashion magazine covers which come spectacularly to life in front of our eyes.

In addition, the stills man is often required to fake a photograph. Perhaps a family group shot is needed using earlier, younger shots of the stars or even just head shots which can then be superimposed in such a way as to create the desired effect. An amusing variation of this occurred during the filming of *Such Good Friends* where it was necessary to show a nude photo of the leading female character. Since the star Dyan Cannon, refused to pose for this shot herself, the stills man was able to take a nude photo of another girl and superimpose Miss Cannon's head – which led to yet more friction between director and star.

But undoubtedly the most remarkable use of doctored stills can be seen in Woody Allen's *Zelig*. Here shots of the fictitious title character, played by Allen himself, have been added to group photos of famous personalities of the 1920s and 1930s. By carefully overlaying a matching shot of Zelig to replace an existing figure, the deception is then complete (see page 141).

In fact, tricks of double exposure were sometimes

film's opening credits, as in *Bureau of Missing Persons* (1933) or *Under Two Flags* (1936) or behind the credit titles as in the Joan Crawford vehicle, *The Last of Mrs Cheyney* (1937). And sometimes a photo may be used quite prominently and play a symbolic function in the film, such as happened with *Greed*. Taking his cue from the original novel, Stroheim made special use of the wedding portrait of McTeague and his wife. It appears prominently on their bedroom wall when they are happily married, then reappears at various points during their decline, first losing its frame, then torn and thrown away, serving as an ironic reminder of earlier, happier days. Finally, it is discovered in a dustbin by the lead character and serves as a clue to the whereabouts of his missing wife shortly before he murders her (see page 138).

An example of how the stills photographer carries out his assignments can be deduced from the photos provided by 20th Century-Fox for the Otto Preminger thriller *Whirlpool* (1949). These included a series of pictures of Gene Tierney and Richard Conte, posed in bathing suits by the sea. But this beach scene is never seen in the movie. Only a small,

required to make the publicity stills correspond to what one sees on the screen, for example, when an actor or actress would play a dual role, such as Edward G. Robinson in *The Whole Town's Talking* (1935), Olivia de Havilland in *The Dark Mirror* (1946) or Bette Davis in *A Stolen Life* (1946), most often achieved in the film through the use of a simple split screen effect. Then too, there are the many science fiction or horror films in which the characters are shrunk in size, with the miniaturization accomplished through a combination of double exposure and the use of outsize props. Again the photographer could make use of simple double exposure or composite techniques to create his stills (see page 141).

In the case of the photos used to publicize Universal's series of *Invisible Man* pictures, the stills department occasionally made use of a kind of silhouette effect to represent the title character himself. They may have actually taken this idea from one of the films – *The Invisible Man Returns* (1940) – in which the pursuing police devise a plan to fill some rooms with smoke so his outline or silhouette can be seen. A bit of artistic licence in the stills here, for the whole point of the movies and their many ingenious effects was that you could not see the Invisible Man at all and when he picked up a gun or smoked a cigarette, these inanimate objects appeared to float about, seemingly suspended in mid air.

Similarly, for *King Kong* (1933) the stills had to be devised specially, since the film itself depended on so many different special effects: especially models and miniatures of various sizes, double exposure, matte effects and stop motion to animate the title character and the prehistoric monsters. Here the many imaginative and superbly crafted stills were created by the young Bob Coburn who was assigned to the film by Ernest Bachrach, head of the RKO stills department at the time (see pages 148 - 149).

As Coburn later recalled, it was quite a delicate and complicated operation:

We'd ask them to call up our department every time they changed to an interesting shot of Kong... [on the set] *Sometimes I'd stay all day if it was an interesting setup, shooting him every kind of way. I shot all the stills on the set and Bachrach taught me how to superimpose Fay Wray into Kong's paws... You had to cut out a line and not have it show when we made the whole picture, so you could print those things with very little retouching. It would look as if it just came out of the film. Of course, we'd photographed Kong so that we knew where we were going to put Fay, and we had to have a background that would take to this cutting-out technique and also enhance her being in his paw... It was very laborious...*

But most memorable of all were the many striking compositions that Coburn devised, quite different from anything seen in the film, such as the justly famous shot of Kong with Fay Wray in his paw, looming up over the New York skyline.

An imaginative use of composite stills was a regular feature of Hollywood stills photography. For example, Clarence Sinclair Bull had the idea of superimposing Garbo's face on the famous Egyptian Sphinx. When he showed her the result, she howled with laughter and approved; MGM immediately had copies made and widely distributed. There were a few men, such as Bert Longworth, who were known for their expertise in this area. He was the one who created some of the remarkable stills inspired by the Busby Berkeley musicals at Warner Bros, in the 1930s. But most often it was the horror, science fiction or thriller genres which sparked off the most inventive responses.

In the 1950s, for example, the publicity photos for a number of Hitchcock pictures demonstrated a particular creative flair, inspired by their general themes but not always adhering too closely to what was seen on the screen. Whether Hitch himself

Rita Hayworth was the star of *Cover Girl* (1944) and this mock up of a *Vanity Fair* cover was one of a series of shots designed to publicize the picture. Bob Coburn received screen credit for photographing the cover girl images which appear in the film, the first time that a still photographer's contribution had been so recognized.

encouraged the stills men to come up with original ideas or whether the films themselves stimulated a special response from the various studio stills departments, the results were often quite striking. (Some of the most famous photos representing scenes in the films actually had to be reconstructed from different elements, such as James Stewart gazing at his neighbours from his *Rear Window* or Cary Grant pursued across a field by a small plane in *North by Northwest*)

When one turns from mainstream Hollywood to the cheaper type of exploitation flicks, it is clear that science fiction and horror offered the greatest scope for eye-catching publicity. Not restricted to representing scenes shown in the films, the stills men were encouraged to devise the most lurid or bizarre poses, anything in fact to attract the movie-goer's interest. Especially popular was the sight of an attractive and partially-clad heroine being menaced by a giant alien creature or monster. The publicity for *The Strange Case of Dr Rx*, for example, prominently featured a

giant ape, armed with a club, and attacking the provocatively posed leading lady in a scene which never appeared in the movie. And similar examples could be cited from innumerable pictures of the 1940s and 1950s, in particular.

If such photos succeeded in arousing expectations in the movie audience which could never be fulfilled, especially in such quickly and cheaply filmed B-features, they are quite entertaining and occupy their own niche in the history of the cinema, providing a rich treasure trove of illustrations for picture editors to draw on. Not surprisingly, the photos are often better known than the pictures they represent. And the stills are likely to survive better, while the films may only be available in scratched or badly damaged prints.

In fact, these stills and some of the more striking Hitchcock and *King Kong* photos mentioned above, represent what the stills men refer to as 'poster art'. Often featured prominently in the publicity for a film, and occasionally on the posters too, these photos generally showed the leading stars in costume along with a few key props. In aiming at relatively simple but strong compositions, the photographer hoped to come up with at least one especially striking image that could serve as the main visual hook for advertising the film. As John Engstead recalled it, this is what happened with him on *The Canary Murder Case* at Paramount in 1928. The star, Louise Brooks, arrived at the photo session dressed in an extraordinary skimpy feather costume and matching skull cap designed by Travis Banton.

I had an idea to pose her, looking terrified, stretched out on the floor with the shadow of a menacing hand (mine) on the background above her. This still then became the basis for advertising the film.

This session took place before the main shooting of the film, but in many instances the special photography was accomplished after filming was completed. As one stills man, Hal McAlpin, half jokingly described his own, typical experience in the early 1940s:

You can always bank on one certain factor in relation to the advertising campaign – you will receive it about one week before the picture closes. Then the mad rush begins to try and grab pictures that were passed over weeks ago. For several rushing, endless days you go crazy trying to shoot pictures for publicity stills, poster art and exploitation tie-ups.

In fact, this is more or less what happened on *A Streetcar Named Desire*. It was only after filming was completed that producer Charles Feldman came up with the idea of basing the publicity on the intensely dramatic moment in the picture when Marlon

Ray 'Crash' Corrigan is the stunt man inside the badly fitted monster suit in this obvious publicity rip-off of *The Creature From the Black Lagoon*. The film was *It! The Terror from Beyond Space* (1958), best remembered today as the inspiration for *Alien* twenty years later. As often is the case with such films, the alien killer of the title is far more threatening and scary when only indistinctly glimpsed, hidden in the shadows early in the film.

Brando's back is to the camera as he embraces his wife (Kim Hunter). Thus, back in New York, 3000 miles from the Hollywood studio, Brando was asked to pose for 'poster shots' on this scene, dressed in a torn T-shirt, as in the film, with a model stand-in for Miss Hunter (see page 160).

He was reluctant at first, thought the idea was vulgar and was concerned about what it would do for his screen image, as this was only his second feature film. And he was right. The publicity campaign turned out to be tremendously successful (as was the film) and Brando was identified with the torn T-shirt image for many years after. Of course, for Warner Bros., the film's distributor, it was the result which mattered. For example, just a couple of years earlier, studio boss Jack Warner, had congratulated his head of publicity on his promotion of the latest Joan Crawford vehicle with these words: 'The campaign on *Flamingo Road* with that hot photo of Crawford with cigarette in mouth, gams showing, etc. had much to do with public going for this picture. Try use this type photo on any picture you can in future...'

Not surprisingly, the stars often resented the fact that they were called back to do these 'poster art' photos after filming was completed. These were different from the on set stills or individual portrait sessions and sometimes produced unexpected results. For example, British actress Anna Lee recalled her experience with co-star Paul Muni in 1942 on the roof of the small Columbia studio after finishing *Commandos Strike at Dawn*. Apparently more able to relax in front of the (stills) camera now that shooting was over, Muni was suddenly more amorous than before, which took her by surprise. It was only some time later that she learned that on set and location Muni's wife watched him like a hawk and forced him to keep his distance from his leading ladies!

But perhaps the most notorious mishap of all occurred during a photo session with Cesar Romero and Carmen Miranda to publicize the Fox musical, *Weekend in Havana* (1941). Since Frank Powolny's new Speed-Graphic Graflex camera with flash attachment allowed him to shoot with an exposure time of as little as 1/400th of a second, he recognized that it would be ideal for capturing the spontaneity of the dance numbers. Among the many shots that Powolny got was one of Carmen Miranda being lifted into the air with her skirt flying up over her hips. As he later explained, without realizing it, 'I had taken a shot of Carmen without her undies. You could see everything.' Although the studio destroyed the original negative, a print had been stolen, duplicated and circulated privately. Miss Miranda was so furious that she wanted to sue Powolny, who was fired, briefly, but was possibly saved by the fact that he had already spent almost 20 years at the studio. He remained at Fox for many years after, one of the rare examples of a leading photographer who spent his entire career, over

40 years, at the same studio.

In fact, there was a wide range of 'poster photos' that were popular with the fan magazines, such as the 'leg art', pin-up or cheesecake pictures. These were provided by the studios, most often to publicize their attractive young women stars, though the young men could also be posed in bathing suits with an appropriate backdrop or prop.

Then too, there was the 'calendar art' with the stars dressed up in holiday costumes relating to Christmas, New Year's Day or the Fourth of July – the photo often signed with a seasonal greeting or inscription to the movie-goers. The fan magazines would often feature a seasonal star spread late in December each year, such as the one which appeared in the *International Photographer* of December 1939. Titled 'Holiday Poster Art', the brief text which accompanied the pictures pointed out how the holidays provided 'the stillman [with] another opportunity to do his stuff, while the subheading says it all: 'Stillmen put holidays to good publicity use with timely shots of studio players in gags appropriate to the event' (see pages 150 - 153).

Though *Flamingo Road* (1949) was a strong dramatic vehicle for Joan Crawford, who plays a tough carnival dancer stranded in a hick town, the studio (Warner Bros.) preferred to sell it on sex appeal instead. The star was forty-four years old at the time, but still looked great in a series of provocatively posed shots such as this one.

As part of their contract, not only were the stars obligated to show up for portrait sessions, but they were expected to do 'pin-up' photos as well. It was a measure of a star's power at the time whether he or she could refuse such requests, which they generally avoided if at all possible. Of course, the newer and younger players had no such luck. (Greta Garbo is perhaps the best known example of a star who absolutely refused to pose for these shots once she became a top star.)

One other important area of stills which has not yet been discussed is the glamorous fashion photography. These pictures ranged from simple costume test shots required for virtually every film and meant to show how an outfit would look on the star, from a variety of angles, to the most beautifully and elaborately posed and lit photos. These latter could aspire to the quality of the best Hollywood portrait photography, but were generally required to show the full length figure.

This type of photo was first developed by the studios in the fashion-conscious 1920s, but, like so many aspects of the Hollywood system, only reached its fullest expression during the star era of the 1930s. The most glamorous stills were generally used in fashion spreads and were an extremely popular feature in the fan magazines, newspapers and women's magazines. At the same time they were useful for publicizing the stars and their latest films.

Movie costumes, however, had only a limited impact on the fashions of the era. There was a clear distinction between Hollywood costume design and the fashion industry, as Margaret Bailey has pointed out in her book *Those Glorious Glamour Years: Classic Hollywood Costume Design of the 1930s*. The film costumes were created to be photographed and to fulfil a dramatic function in the films, not to make fashion. Thus, the leading costume designers were experts in knowing what was photogenic, both in still photos and on the movie screen, in black-and-white or in colour, and how much detail was appropriate for a particular scene or camera angle. And although the costumes generally looked superb on screen, they often looked even better in the photos where they could be carefully posed and lit for the stills camera. Unlike real clothes, subject to the stresses and strains of normal wear, the finished movie costumes were treated with the greatest care up to the point when they were to appear on camera. According to Robert La Vine:

A star was attended by her personal dressers and maid, as well as several wardrobe workers whose job it was to see that the precious garment was protected from soil and damage. Wrinkles in the fabric became a matter of great concern; to prevent them, the 'leaning board' was invented... This contrivance which included a footrest at the bottom, allowed an actress to relax in a leaning

position with some semblance of comfort between takes – without wrinkling her gown.

Such a contraption was especially necessary in the case of the kind of skin-tight, form-fitting dress worn by Jean Harlow in *Dinner at Eight* (1933). A perfect example of the kind of stunning but totally impractical garment only possible in the cinema, Miss Harlow looks as if she has been sewn into it. In the film she is only required to move a few steps at a time, and it is unlikely that she could sit down in it, even if she tried.

The fashion photography was not limited to established players, but was often used as part of the publicity build-up for a new star whom the studio was trying to promote. However, fashion shots, like so many of the photos and other publicity material released to the fan magazines and the press, were not always what they seemed. A good example comes from the Hal Roach studio which had signed up the

Jean Harlow in her skin-tight gown for *Dinner at Eight* (1933). At first this looks like a typical fashion shot of the period, but a closer look reveals that Miss Harlow is relaxing on a leaning or slant board. A kind of padded wooden plank, like an oversized ironing board constructed at a 90 degree angle and equipped with arm rests and a foot rest at the bottom, it is required during breaks in filming when the actress may wish to relax without wrinkling or creasing her dress.

Opposite: A young and sexy Sophia Loren poses for an unidentified photographer in 1955. A caption is hardly necessary – the glorious tackiness and vulgarity of the image says it all.

Lizabeth Scott poses for Paramount photographer Bud Fraker in 1947.

beautiful photos of the star, Audrey Hepburn, and statuesque extras posed in the costumes which he had designed. More recently, on *Tootsie*, Dustin Hoffman's portrayal of Dorothy Michaels was a key selling point in the special appeal of this unusual comedy. Thus, toward the end of the filming schedule, a special 'fashion shoot' was arranged which would double as a sequence to be used in the film itself – with one of the Columbia still photographers, Greg Gorman, actually seen in the movie taking photographs of Dustin Hoffman/Michaels at a special stills session. A montage sequence in the finished film shows Dustin in various high fashion outfits leaping from the cover of *Newsweek* to the covers of *Cosmopolitan*, *Woman's Day*, *People* and *New York* magazine, among others, while the stills provided some of the best known publicity images for the film, including the well known shot of Hoffman in a red sequined dress which was used on the posters.

With film production at peak levels during the 1930s, the photographers were kept busy within the studios. Yet, as we have already noted, there was an insatiable demand for other types of photos of the stars, too – at home, with their families or attending a variety of special events – weddings, parties, night clubs, banquets, awards ceremonies. The stills men were expected to provide eye-catching photos of all these activities as well as just about everything relating to the release of the new pictures – premieres, publicity stunts and all public appearances of the stars.

These photos were an important part of keeping the fans interested in the world of Hollywood and the movie colony and helped to create the particular star images which the studios wished to project to the public.

Outside the studio walls, the photographers had to compete for interesting photo opportunities with the many other professional photographers in Hollywood, including those employed by the fan magazines themselves. One such was Gene Lester. He worked for *Silver Screen* magazine for a time and even described his work in a short piece in *International Photographer* in 1941 called 'Snapping the Stars'. As he noted, in order to take his photos quickly and efficiently, with a minimum of inconvenience to the people posing for him, he generally worked with two or three cameras – a Speed Graphic (which exposed a 4 x 5 negative) supplemented by the smaller size Rolleiflex or Contax. However, he stressed that the glamour and excitement of meeting the stars and being present at many special events had to be balanced by the special (and unpredictable) requirements of the job, which often meant 'late working hours, irregular eating habits and an almost complete lack of social life'.

However, the vast majority of the outside assignments were carefully planned in advance and involved a visit to the star's home or other suitable venue. It was easy, of course, to paint a glowing picture of the stars,

young Paulette Goddard in 1932. A particularly stunning photo shows her wearing an elaborate bridal dress supposedly designed for her to wear in a 'forthcoming Laurel and Hardy picture'. But she never appeared in any of their comedies, only in a couple of other Roach shorts before her contract was bought up by Charlie Chaplin. She would become his third wife and co-star with him in *Modern Times* and *The Great Dictator*, emerging as one of the leading Hollywood stars of the 1940s. Thus, this particular fashion shot has acquired a special interest in retrospect. In fact, the vast numbers of stylish fashion photographs from the 1930s, the great era of Hollywood glamour, have gained a special nostalgia value for us today. And they also serve as a lasting record of thousands of stunning costumes, only a few of which have themselves survived or been specially preserved (see pages 162 - 163).

Finally, it should be noted that, depending on the star and type of film, the shooting of the fashion shots was often one of the most important photo sessions on a picture, capturing images which could be extremely useful, even essential, for publicity. Thus, Cecil Beaton made a major contribution to publicizing *My Fair Lady* in 1964 by his ravishingly

as the young John Engstead recognized quite early in his career, given a willing subject and a picturesque setting. Employed as an office boy at Paramount in the late 1920s, he discovered a surprising gap in the studio's regular stills output, namely, a failure to make good use of the many superb natural settings available in and around the Hollywood area. Having decided to do something about it himself, he surprised everyone when he arranged a special sitting for the studio's top star, Clara Bow, and succeeded in organizing everything himself, including the necessary reflectors (and the grip or photo assistant to operate them), the photographer Otto Dyar, and permission to use a lavish local garden. Since Miss Bow was an especially photogenic and enthusiastic model, it was merely necessary to let her loose with a variety of stylish costumes and the rest was easy:

She was hanging from the trees, reclining by the pool, coming through the gates. Nobody had to tell her what to do. All that was necessary was for Dyar to focus the camera and be sure that she was in the frame.

In fact, the studios recognized that the stars' own lavish homes and gardens often provided the ideal setting for publicity photos. This meant that such picture spreads became a regular feature in all the fan magazines, with accompanying stories designed to suggest to the readers that they were being given a uniquely 'candid' glimpse into the private lives of their favourite stars.

These photos could easily be used, of course, to promote a particular view of the star. At one extreme it was possible to draw attention to his or her normal, everyday, home life, showing that the stars were just ordinary people, like you or me. Or, at the other, the photos could focus on the exceptional qualities of their life style – the glamorous wardrobes, collections of valuable antiques or paintings and lavish mansions set within vast estates and gardens.

Kitchen shots stressed the domestic side, with the men even shown helping out with the dishes. (An MGM publicity photo showing Dick Powell and June Allyson in their kitchen at least makes the point that it's 'the maid's day out'.) A living room pose could be domestic and intimate – the Rock Hudsons seen by the fireplace in medium shot with their pet dog – or shown in extreme long shot, for maximum impact, especially in the case of the more spacious and luxurious mansions. Bedrooms, of course, conveyed a special feeling of intimacy, while nursery shots, including the children, drew attention to the importance of family life. Poses with pets or engaging in favourite hobbies were always a popular subject: aquatic star Esther Williams teaching her baby son how to swim or musical star Dick Powell at the piano with his wife and daughter, while comedy stars would often be expected to adopt funny poses (see pages 166 - 172).

The photographers, however, rarely remained indoors for long. True to the character of Los Angeles in general and Hollywood in particular, known for its fresh air and sunshine in the 1920s and 1930s, many stars had taken advantage of the opportunities offered by the mild climate and virtually unbroken sunshine to develop an interest in a variety of outdoor sports and hobbies. And, of course, it was also important for the stars to keep fit and looking as attractive as possible on the screen. Thus it was natural for the photographers to follow up on this. The outdoor shots, too, could present a wide range of images. Aside from the lavish houses, gardens, swimming pools and private tennis courts, there was an interest in familiar sports and hobbies which the ordinary cinema-goer could relate to. For the studios, especially after 1934 when the Hays Office began to enforce the provisions of the Production Code more strictly, it was beneficial for the stars to project as clean, healthy, outdoorsy, all-American image as possible. And there was an important fashion theme to be exploited here, too, with the stars dressed in appropriately sporty or casual clothes and even, occasionally glimpsed wearing little or no make-up.

At MGM, in particular, studio boss Louis B. Mayer, champion of the *Andy Hardy* and *Dr Kildare* pictures, regarded his stars as part of his extended 'MGM family'. Here they were groomed and

Cary Grant and Randolph Scott shared a house in the early thirties, when they were both under contract to Paramount. Studio photographer Otto Dyar took this shot in the kitchen of their Beverly Hills home.

presented in the most wholesome manner possible. A special effort was made to give the rather too pretty looking Robert Taylor a more masculine appeal. Similarly, Clark Gable was encouraged to develop an interest in hunting and fishing to live up to the studio's efforts to present him to the public as an all-American sportsman type, through this was not at all his natural style when he was first taken up by the studio. Of course, many of the stars, like Chaplin, Keaton, Ginger Rogers and Katharine Hepburn were genuinely athletic and provided the photographers with lots of photo opportunities.

It was a simple matter to pose the star out of doors and provide an appropriate caption for the press. Thus, a shot of Cyd Charisse in a bathing suit, cavorting on the beach, was accompanied by a publicity blurb from the studio, MGM, which read, 'Brisk sea air, warm sun shine combined with mild exercize is Cyd's favourite pick-me-up' (see page 154). Even an outdoor fashion shot of Lizabeth Scott wearing gloves and open style high heels, rather unconvincingly asserted: 'No hothouse beauty, glamorous Lizabeth Scott enjoys being an outdoor girl when she is away from the studio sound stages and is a beach devotee.'(see page 128).

Similarly, George Burns and Gracie Allen were posed in a series of outdoor publicity shots when they were first signed up by Paramount in 1933. But with comedy stars there was at least a suggestion that no one took the photos too seriously. In one shot, for example, George with a tennis racquet was joined by his dizzy wife carrying a wooden snow-shoe (which actually looks like an old-fashioned tennis racquet), while in another they are both dressed for polo – Gracie with her long-handled mallet gets to ride the hobby horse while George looks slightly uncomfortable. (According to him, Gracie was always a good sport when it came to posing for photos, though he also admits that 'she never participated in any sport that required getting up from a table! Her favourite game was backgammon'.) When the couple adopted two children and moved into their first Hollywood home a few years later, Paramount sent a photographer to do a full picture spread with the entire family; but this time the tone was rather different suggesting that they took their new role as parents

quite seriously (see page 165).

Aside from the regular photo sessions at the stars' homes or regular night spots, there were always the unexpected assignments – a surprise wedding or hastily arranged dinner party for a newly arrived celebrity. The photographers could be called out at a moment's notice, as Philip Dunne recalls in his autobiography, *Take Two*. Here he tells how, as a young writer, new to Hollywood, he was out on a date with the young actress Margaret Sullavan, when she was arrested for a minor offence. Not sure to whom he should turn for help, he rang the publicity department at Universal where she was under contract. 'Jesus Christ, don't let her get away' was the reaction of the publicity chief who then hung up. The rescue team which arrived at the police station soon after included a stills photographer along with the publicity boss and two gossip columnists. Clearly, the studio was desperate for publicity during the difficult years of the early 1930s and felt that even this minor incident, if properly exploited, could be developed into an amusing news story item.

By the end of the 30s literally hundreds of thousands of photographs had been taken in and around Hollywood, documenting every aspect of the lives of the stars and other leading members of the movie colony, along with the equally vast numbers of photos relating to the films and film-making. These, of course, drew attention to its special position as the undisputed movie capital of the world. The sum total represents a unique record of an era, of a very special world, not just showing the clothes, cars and houses, but also reflecting a fascination with all things new, such as the interest in airplanes and flying. (Among the leading stars, Ruth Chatterton was an aviatrix who flew her own airplane, while James Stewart was a qualified flier who would put his experience to good use during World War II.) Thus, in addition to the credited work of the leading portrait photographers, there is a vast body of work with a strong nostalgia value today, the product of hundreds of little known or anonymous photographers who were employed by each of the studios at the time. In the following and final chapter we shall examine how this tradition underwent many changes during the 1940s and 1950s when the methods of film-making, too, were radically transformed.

Opposite: Busby Berkeley created some of the most memorable images of the 1930s – captured by the Warner Bros.' photographers in stills such as this one from *Dames* (1934).

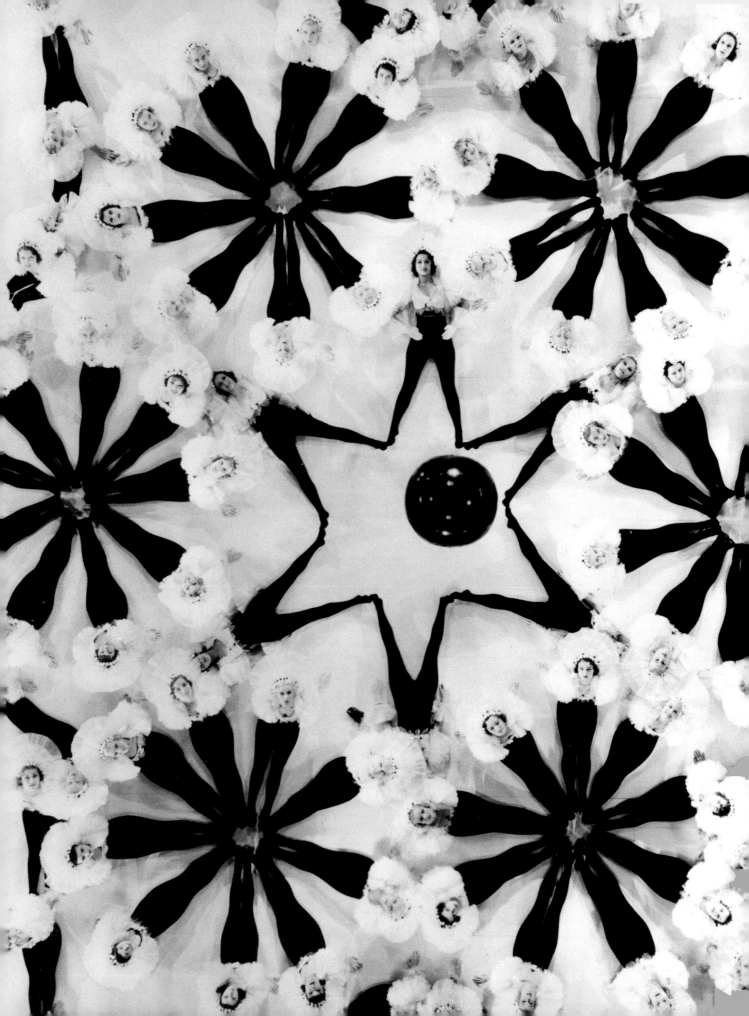

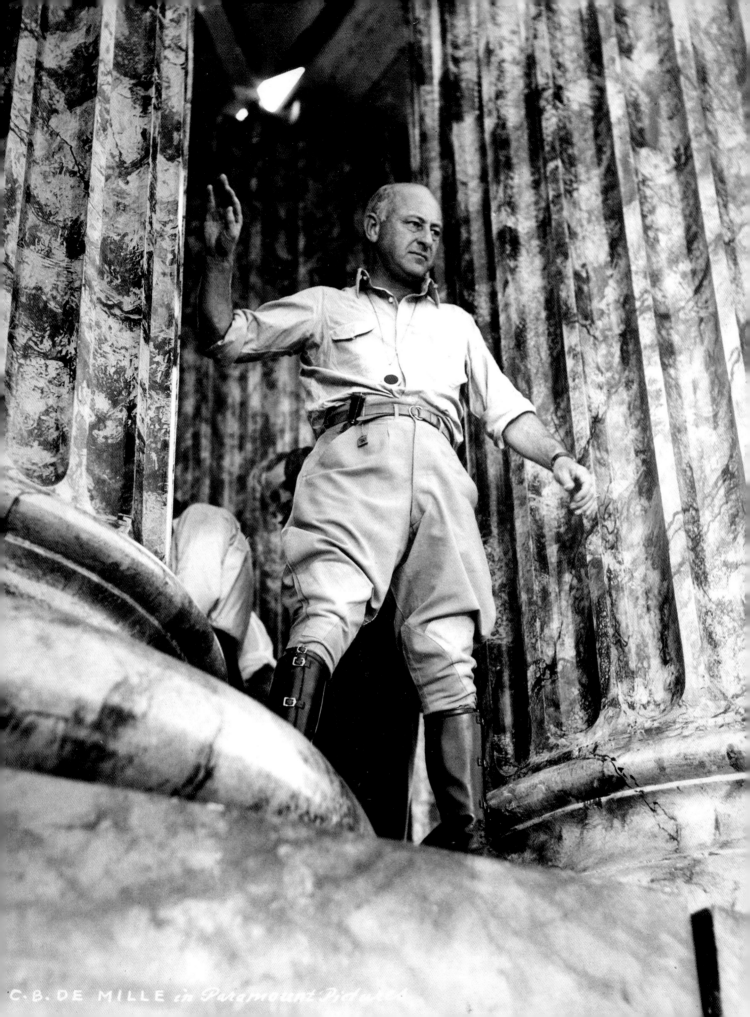

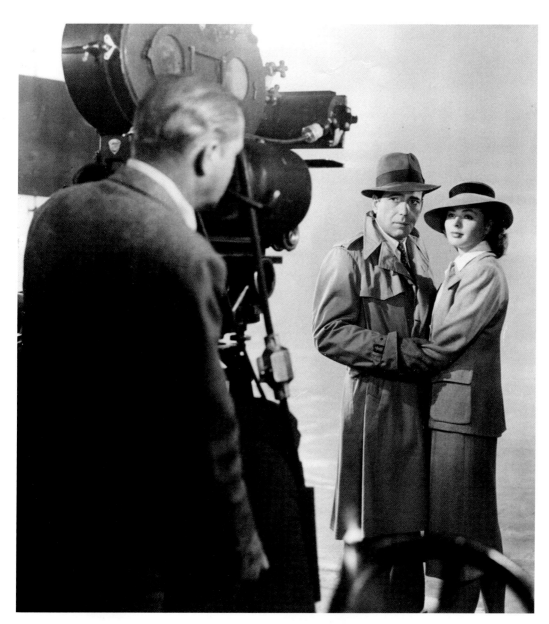

Production shots and scene stills could be taken at the same time, as these matching pairs of shots demonstrate. By changing the position of his camera, the photographer could get a simple shot of the cameraman at work (Arthur Edeson filming Bogart and Bergman in the airport, leave-taking scene in *Casablanca*) or get a shot of the entire crew.

Opposite: A former stage actor himself, legendary producer-director Cecil B. DeMille played the role of the Hollywood movie director to the hilt. Here he is seen in a suitably domineering pose, dressed for action on the set of one of his Biblical epics with his shirt sleeves rolled up, open neck shirt and riding boots. The stills camera has been positioned below for a low-angle shot, which adds to the overall effect.

On *The Prisoner of Zenda* (1937)
set (below) director John
Cromwell is to the left of the
camera, cameraman James Wong
Howe in the hat, while the others
appear to be pushing forward to
get a better view of the action.
(Note that between the time that
the scene still was shot with
Douglas Fairbanks Jr. and Ronald
Colman, and the production shot,
the fire appears to have gone out.)

Most interesting of all, however, is
the production still which tells us
something about the filming and
has not been so obviously posed.
In fact, one may well be baffled by
a production still such as this one
from *In the Heat of the Night*
(below right and facing page)
unless one has seen the film and
remembers the particular scene.
This location sequence takes place
at Jess's car repair lot. He is lying
on the ground working under a
car when the two law officers
arrive. (Not a dead body on the
ground as one might suppose.)
Rod Steiger and Sidney Poitier
have been placed on an
improvised platform and are being
filmed from a low angle in order
to simulate the POV (point of
view) of Jess who continues to
carry on a conversation with them
while he is working. Note the
mike at the top, reflector on the
right and director Norman
Jewison sprawled in the
foreground, which neatly frames
the composition. Yet the shot
retains the immediacy of a photo
taken 'off the cuff', with one
assistant just moving out of frame
and another turning to the right.

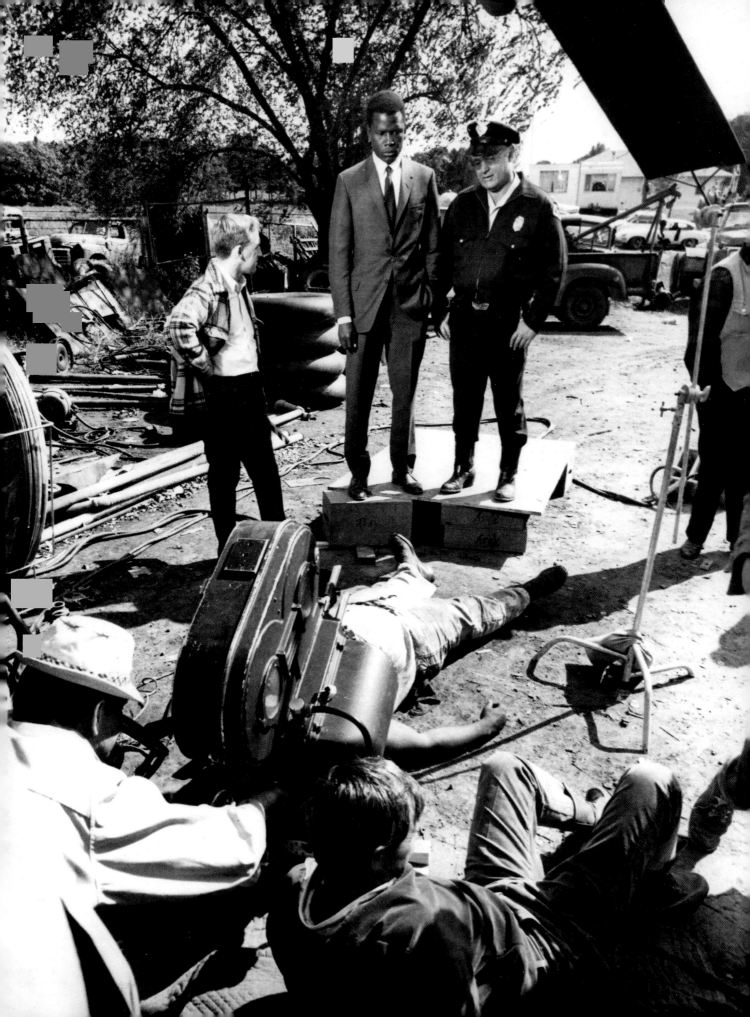

Movie stand-ins come in all shapes and sizes and occasionally provide the stills photographer with amusing or unusual picture opportunities. Sometimes it is even difficult to tell the stand-in from the star when they are dressed in exactly matching costumes. For example, Brian Donlevy (above right) with his 'twin', Lionel Palmer, on the set of *Thirteen Hours by Air* (1936) posed in front of a 1930s airline map of the US. Audrey Hepburn (above left) reads through the script of *Funny Face* with stand-in Madeline Hubbard in 1956.

Late in Elia Kazan's film version of his novel, *The Arrangement* (1969), Faye Dunaway comes to visit Kirk Douglas at the home where he is staying and brings her baby with her. Here director Kazan is seen rehearsing the couple in a key scene, apparently with a doll – which is serving as a 'stand-in' for the baby.

The Hollywood studios are always eager to exploit the publicity value of a movie based on real people and real events. In the case of a biopic of a living person, such as Sister Kenny, in the course of acquiring the rights to her story (published in book form as *And They Shall Walk*), the studio (RKO Radio) naturally invited her to Hollywood and gave her the usual star treatment. The photo of her with Rosalind Russell (taken by Fred Hendrickson) then went out as a newsy item and as part of the advance publicity for the film. 'Rosalind Russell arranges to assume the identity of Sister Elizabeth Kenny whose life and character she will portray in a forthcoming film for RKO Radio' reads the crudely worded official caption provided with the picture. Other examples shown here: the real Gypsy Rose Lee (Louise Hovick) meets Natalie Wood on the set of *Gypsy* in 1962 – a much better match here between the real personality and the star who will play her on screen – while Sam Shepard and the real Chuck Yeager pose beside a mock-up of the X-1 experimental rocket plane used in the film version of *The Right Stuff* in 1982.

Photographs are often used in films as a visual 'prop'. They turn up most often as family snapshots, formal portraits or 'mug shots'. All three types are illustrated here. On *Greed*, Von Stroheim arranged to have the portrait man, Clarence Sinclair Bull, take a wedding photo of the lead couple, Gibson Gowland and ZaSu Pitts, which exactly matches the description found in the original novel, *McTeague*, by Frank Norris: 'Trina sitting very erect holding her wedding bouquet, McTeague standing at her side, one hand upon her shoulder, his left foot forward in the attitude of a secretary of state'. As in the book, the portrait takes on a symbolic significance during the course of the film – seen prominently in their bedroom, then the last item to go when they are forced to move. In a scene which has been cut from the released version, the couple take one last look at the empty flat and the portrait reminds them of their wedding day.

A photo of the lead couple, Richard Conte and Gene Tierney, possibly taken on their honeymoon, is used in a similar way in *Whirlpool* (1949). A series of publicity stills were made at the same time that the stills photographer was taking the prop snapshot, showing a scene which does not appear in the film.

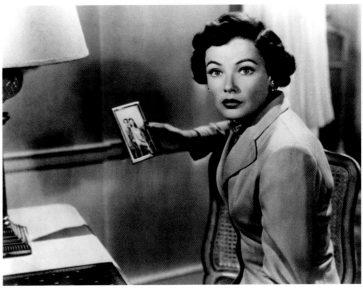

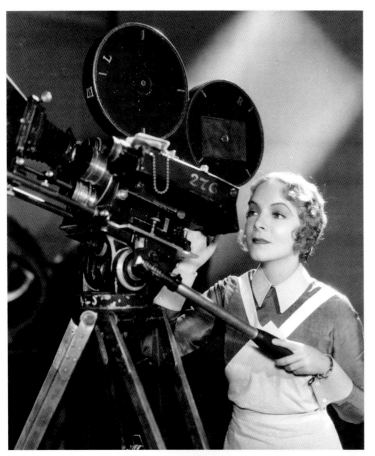

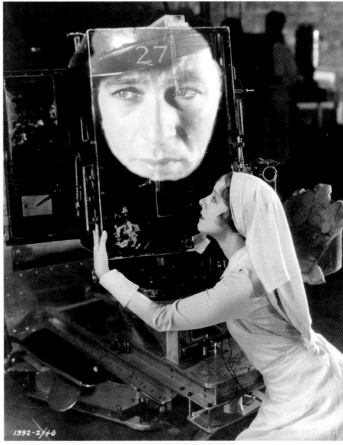

This unusual selection of shots from the 1932 Paramount production *A Farewell to Arms*, gives some idea of the kind of unexpected stills which are apt to turn up for virtually any Hollywood movie of that era. The photog-rapher (probably Bert Longworth) was given the freedom to try out all kinds of ideas, making use of the studio's own 8 x 10 cameras, well equipped labs and other photographic facilities. To supple-ment the normal scene stills, the stars could be simply posed with the movie camera – Helen Hayes seen here with the unblimped Mitchell. There was always an effort made to inject some sex appeal into the stills, no matter how absurd and out of character with the film itself – such as this shot of Gary Cooper and Adolphe Menjou on the set surrounded by a group of scantily clad starlets, who were meant to appear in the cut down café/brothel sequence. But perhaps, most surprising of all, it is hard to know what Miss Hayes thought when the photog-rapher suggested that she lovingly embrace the (blimped) camera (enclosed in its sound proof casing), only to discover later that the face of Gary Cooper had been matted in onto the side of the camera in the final print.

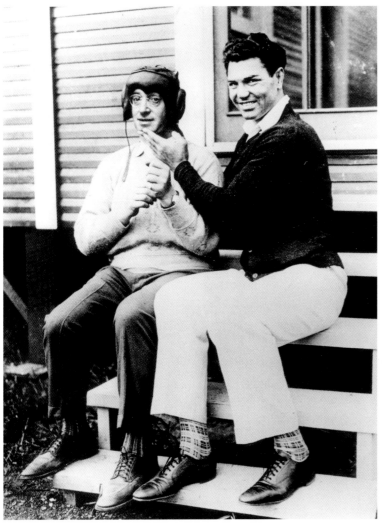

It was generally easy for the photographer to produce stills which matched important scenes in each movie. Simple double exposure could show Edward G. Robinson talking to the second Edward G. in *The Whole Town's Talking* (1935)(top right) or duplicate the miniaturization effects found in *Dr Cyclops* (1940), with Albert Dekker in the title role (top left). However, the use of a silhouette effect in *The Invisible Man Returns* (1940) really spoils the joke which one reviewer especially appreciated when the film first opened: 'We don't suppose there has ever been a sequence to match the one in which Sir Cedric [Hardwicke] is being hustled along by his collar, with a pistol prodding him in the back, and not another soul in sight'. With *Zelig*, of course, the doctored stills are not just for publicity but were actually used in the film itself. Here the 'human chameleon' takes on the guise of a boxer, posing with Jack Dempsey at his training camp in Chicago, but looks very dignified and statesmanlike with US Presidents Calvin Coolidge (left) and Herbert Hoover in Washington (above and left).

The selection of production shots on this and the following pages is meant to give some idea of what the stills photographer was capable of, positioned well back from the action. Packed full of fascinating detail regarding the methods of filming and equipment used during Hollywood's golden age, these photos can be compared with the more intimate types of shots showing the director working with his actors, illustrated in the pages that follow on.

Broadway is perhaps the only film which has had a piece of equipment named after it. The fifty foot long 'Broadway crane', a spectacular piece of machinery, can be seen here in action for the first time. It was specially designed by director Paul Fejos and cameraman Hal Mohr for shooting on this production, but was subsequently used on other films at Universal which followed, including *All Quiet on the Western Front* and *King of Jazz*. The director (with megaphone) and camera crew can just be glimpsed high above filming one of the many night club sequences with a large number of extras, and a line-up of chorus girls just waiting to go on in the far background (right).

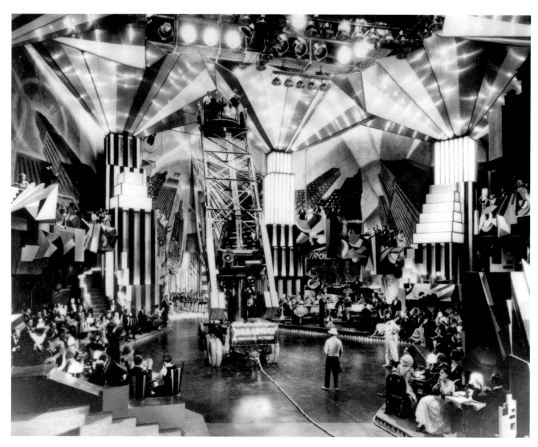

This amusing and very 1930s shot (left) from a long forgotten musical was sent out by Paramount as a publicity still stamped on the back 'Scene Not in Film', but with no indication that the tall and stylish looking gent on the left, with Carl Brisson, was actually the film's director, Robert Florey on *Ship Café* (1935).

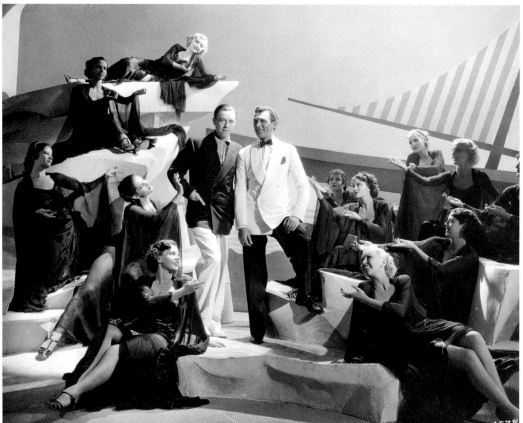

From this unusual rooftop view of the filming of *Dr Jekyll and Mr Hyde* at Paramount in 1931 (on the facing page) one can appreciate the quality of art director Hans Dreier's contribution to the picture. His remarkable studio recreation of the gas-lit streets of Victorian London combined with the lighting of cameraman Karl Struss to achieve an authentically atmospheric result. Fredric March and his companion appear to have spotted the photographer up above as they await their cue to pick their way through the cables on the floor, then descend the steps where the camera and microphone are positioned to film and record their conversation.

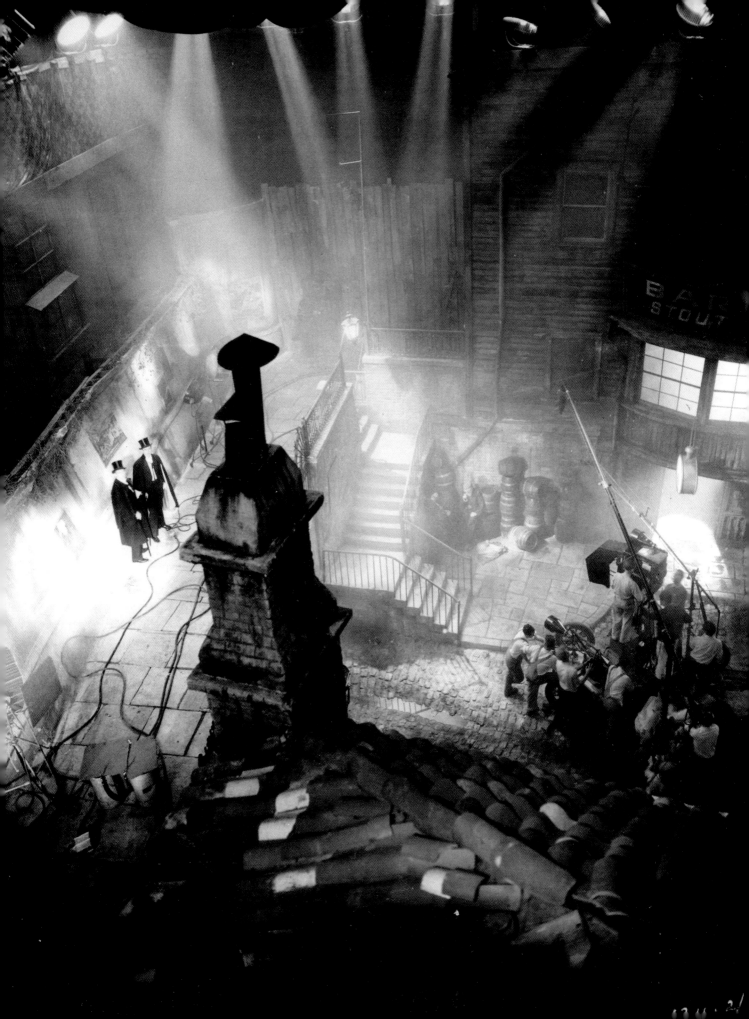

A stunning result was achieved by the photographer who has set up his 8 x 10 camera to get a clear image reflected in the oasis pool that was specially designed by art director Lyle Wheeler. This location sequence for *The Garden of Allah* was actually filmed near Yuma, Arizona, in 1936. Providing an informative record of a film crew in action, one can clearly see the microphone boom man on an improvised platform at the left behind the stars, Charles Boyer and Marlene Dietrich; the sound recordists are protected by the large sun umbrella in mid-shot, while director Richard Boleslawski is seated just in front of the Technicolor camera enclosed in its sound proof casing or 'blimp'. However, according to dialogue coach Josh Logan, in spite of all the trouble they went to, the recorded dialogue in this sequence never did work as it should have, and it was cut from the final film.

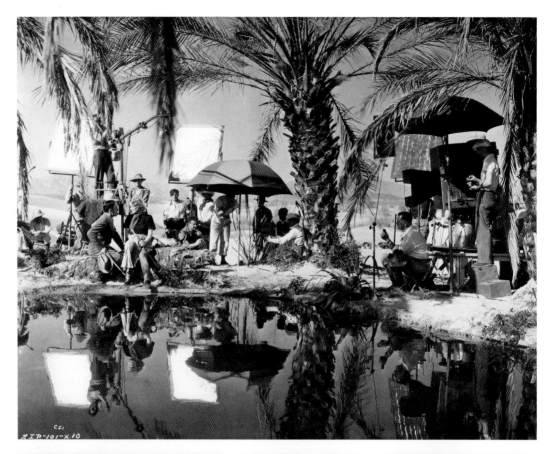

In contrast to the problems creating a new movie setting on location, this shot demonstrates the obverse situation: how a hillside location (in Tennessee) could be recreated inside the Warner Bros. studio in 1941. The camera crew is filming Gary Cooper as *Sergeant York* in medium close-up, so the crew members around him are safely out of shot, including the sound man, just above him, holding the microphone boom. Director Howard Hawks is seated beside the camera with cameraman Sol Polito standing just behind him, while producer Jesse Lasky stands on the same platform, to the left, wearing a jacket and bow-tie. By taking the photo from this distance the stills man provides a quite unusual and revealing perspective on the way in which studio filming was accomplished in the peak years.

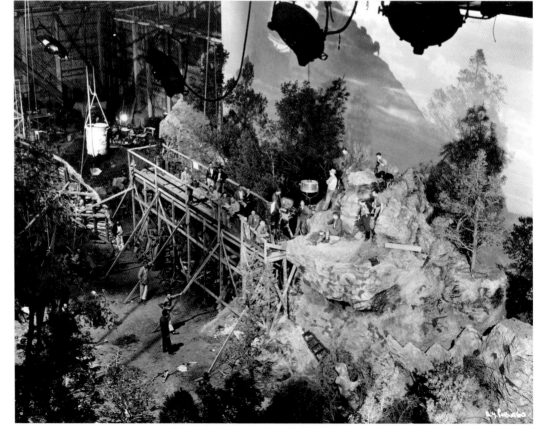

WILLIAM POWELL in "HIGH PRESSURE" A Warner Bros & Vitaphone Production

This varied selection of shots of well known directors with their stars shows the range of possibilities open to the stills photographer assigned to each production. This publicity still from *High Pressure* (1931) (left) looks like a scene from the film but actually shows director Mervyn LeRoy with William Powell. It is not clear whether the director is genuinely working hard to get a performance out of Powell, is demonstrating some bit of business for another actor (out of camera range), or is merely mugging for the stills camera...

Below left, Ernst Lubitsch reads through the script of *Trouble in Paradise* (1932) with Herbert Marshall and Kay Francis, seemingly oblivious to the great collection of lights and lighting equipment which provides them with a picturesque backdrop. Both stars are in costume for their first meeting in the film, suggesting that this was taken during a break in filming.

Below right, Jean Renoir demonstrates how they used to do the washing in France in the old days, for the benefit of Paulette Goddard who plays the title role in *The Diary of a Chambermaid* in 1945.

Above: Howard Hawks (left) is seen chatting with Carole Lombard and John Barrymore as they take time out for a smoke while filming *Twentieth Century* at the Columbia studio in 1934.

Above right: Appearances are sometimes deceptive. Director Billy Wilder is not showing John Lund how to play a love scene with Marlene Dietrich in *A Foreign Affair* (1948), but rather how he wants Lund to behave when questioning her about Nazi connections and she responds by trying to embrace him.

Right: John Ford on location with John Wayne and Ben Johnson (right) in 1949 for the filming of *She Wore a Yellow Ribbon*, the second of his trilogy of 'cavalry Westerns' made around this time.

This is not a behind-the-scenes glimpse of the studio hairdressing department (right), but rather Audrey Hepburn is about to have her hair cut on camera by the actor (Mario de Lanni, left) who plays an Italian hairdresser. The film is *Roman Holiday* and director William Wyler is demonstrating to the couple how he wishes the scene to be acted. According to Audrey, and as this shot suggests, he was tremendously supportive and helpful throughout the filming of her first big budget American picture, shot entirely on location in Italy during the hot summer months of 1952.

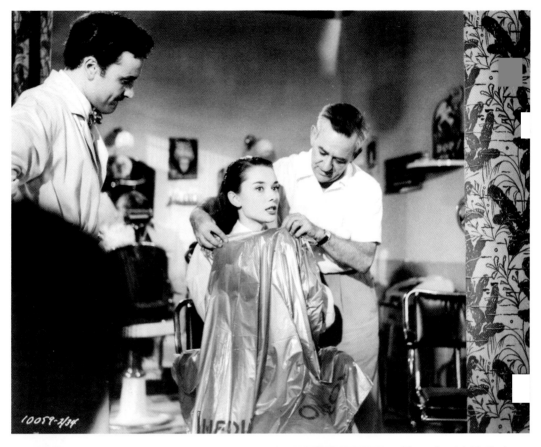

Director Joseph L. Mankiewicz rehearses Richard Burton and Elizabeth Taylor for the important banquet scene on the royal barge in Fox's lavish 1963 production of *Cleopatra*, returning to a subject which had served as an early vehicle for Theda Bara at Fox almost 50 years earlier. In spite of Mankiewicz's heroic efforts, Liz Taylor was unconvincing as Cleopatra, although she looked terrific in the stills.

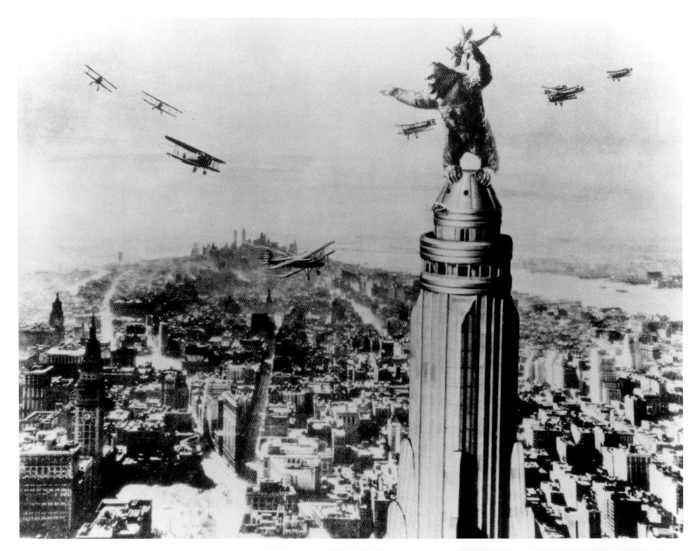

Creating the stills for *King Kong* (1933) was an extremely challenging task, given the fact that the film made use of so many complicated trick effects. The result was some memorable stills to go with a remarkable film. The views of Kong hovering over the New York skyline, with Fay Wray in his giant paw or fighting off the attacking planes on top of the Empire State Building, are among the most famous cinematic images ever conceived. Other imaginative trick shots show producer Merian C. Cooper's intense involvement with the project – contemplating Kong with a group of prehistoric monsters (Brontosaurus, Styracosaurus and Tyrannosaurus) as he imagines them reflected in his table top, and with star Fay Wray, conjuring up a classic image of Kong from the smoke of his pipe.



This selection of poster and calendar art demonstrates the wide range of possibilities – shadow and silhouette effects, multiple exposure and collage – exploited by the studios for a variety of different genres – musical, horror, thrillers and romance. The poster shots often made use of portraits and were occasionally done by the same leading photographers who handled the portrait photography.

Facing page: An imaginative collage of images showing the young Robert Taylor in the role of Armand playing opposite Greta Garbo in MGM's 1937 production of *Camille*.

Above: For one of the studio's rare ventures into horror, MGM borrowed Boris Karloff from Universal in 1932. The title, *The Mask of Fu Manchu*, is illustrated by the image of Karloff in Oriental make-up reflected in a distorting mirror, while his well equipped lab echoes that of Dr Frankenstein. Released late in 1932, the film

made an appropriate companion piece to *The Mummy*, which came out at virtually the same time.

Above right: For *The Wizard of Oz* (1939) a favourite type of photo montage simply poses the movie characters with an outsize mock-up of the original book. Left to right, Jack Haley as the Tin Man, Ray Bolger (the Scarecrow), Judy Garland as Dorothy with her dog, Toto, Frank Morgan as the 'Wizard' and Bert Lahr – the Cowardly Lion.

Right: This is the type of poster art portrait designed to launch an exotic new face in Hollywood in the early 1930s, at the time when Garbo and Dietrich were all the rage. Having been given a suitably exotic name, Sari Maritza (real name: Patricia Detering-Nathan) was brought over from England early in 1932 and spent just over a year at Paramount. But she made little impression on American audiences and retired from the screen one year later.

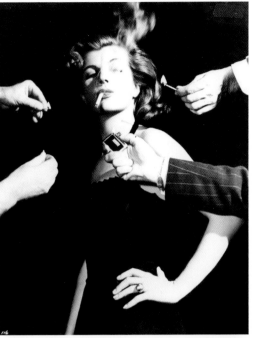

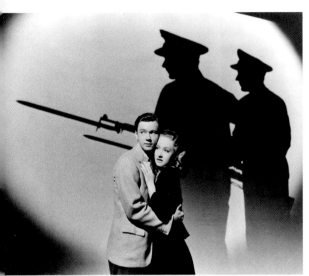

Facing page: Leading RKO photographer Ernest Bachrach has captured the main visual motif of *The Spiral Staircase* (1945) – victim Rhonda Fleming reflected in the eye of the killer.

Far left: Shadow effects were a familiar poster art motif for horror or thrillers. Ray McDonald and Bonita Granville are the frightened young couple from *Down in San Diego*, a story about a group of teenagers foiling enemy spies at a US Navy base. This topical, war-related subject was released a few months before Pearl Harbor in 1941.

Left:
Hollywood resumed its search for foreign beauties during the postwar years. French actress Corinne Calvet filled the bill nicely and was signed up by producer Hal Wallis. Here she is presented as a modern type of 'femme fatale' in the Gilda mould.

The calendar shots were a staple studio item, generally related to specific holidays of the year, with the stars matched to the appropriate type of setting. Thus, the earthy Mae West celebrates the arrival of 1937, while Universal's leading starlet of the early 1950s, Julie Adams rings in 1954 – complete with printed-on signature.

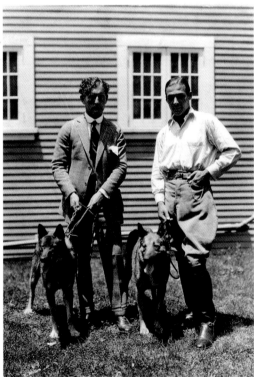

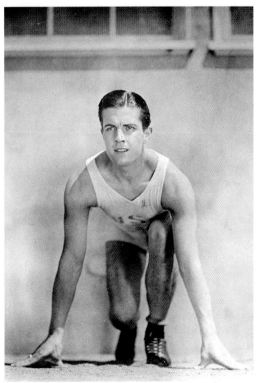

The sunny climate encouraged outdoor activities and was ideal for such sports as golf, tennis and swimming, also providing the photographers with many photo opportunities. In addition, all the film studios employed trainers and health experts to ensure that their stars and contract players kept in good physical shape. Many of the stars were attracted to those sports which allowed them to get away from the Hollywood limelight and gain a bit of much needed privacy in their spare time. These included not only hunting and fishing, but, with their star salaries they could easily afford to buy their own yacht, airplane or horses. However, most of the photos are quite obviously posed for the benefit of the photographer and are composed in the style of an informal portrait or fashion shot, with the ladies most often modelling the latest styles in sports clothes and beach wear.

Facing page: This delightful shot of Cyd Charisse was taken in 1949 when she was still playing mainly supporting roles at MGM. Ironically, this still was sent out as part of the publicity for, though totally at variance with, her latest picture, a downbeat thriller called *Tension*.

Top left: Starlet Dorothy Wilson photographed on the court by George Reineking, and the caption reassures us that she is 'one of Hollywood's best tennis players'. In fact, she was reasonably successful as an actress too, playing mainly supporting roles for a number of different studios before she met and married writer-director Lewis R. Foster and retired from the screen.

Top right: Ginger Rogers looks as if she knows how to handle a tennis racquet, though she appears a bit too impeccably dressed and made up.

Below left: Silent star Rudolph Valentino with his favourite German Shepherds, joined by fellow actor Douglas Gerrard.

Below right: Fresh from his triumph in *Ben-Hur* (1925), MGM star Ramon Novarro keeps in shape by training at the Hollywood Athletic Club.

Betty Grable (right) and Ida Lupino (far right) strike somewhat similar poses, and the golf clubs look more like props than something you actually use. To be fair to Miss Grable, she appears to be involved in a game of miniature golf rather than the real thing, and she is out-of-doors. Miss Lupino, on the other hand, has been supplied with some imitation studio grass, a wicker armchair and appears to be menaced by the shadows of a bag full of golf clubs looming up on the wall behind her.

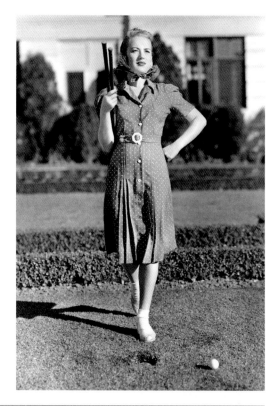

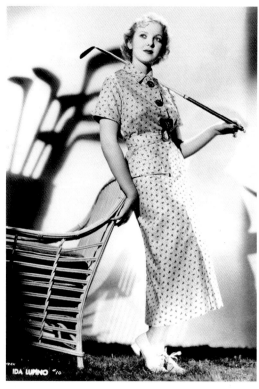

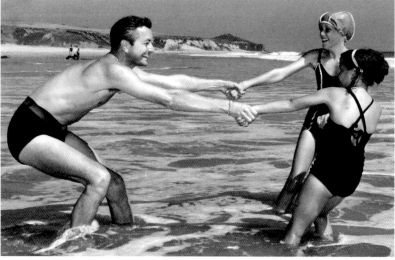

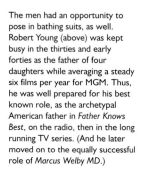

The men had an opportunity to pose in bathing suits, as well. Robert Young (above) was kept busy in the thirties and early forties as the father of four daughters while averaging a steady six films per year for MGM. Thus, he was well prepared for his best known role, as the archetypal American father in *Father Knows Best*, on the radio, then in the long running TV series. (And he later moved on to the equally successful role of *Marcus Welby MD*.)

In this photo of Pat O'Brien (above), an attempt by the photographer to give the shot a slightly candid feel is not very convincing, but with its unusual view of a residential area of Hollywood which has now been totally changed, it has acquired a new interest and nostalgia value for us today.

Since Hollywood was a movie town, there were lots of photo opportunities relating to the film industry itself such as film premières and awards ceremonies, while the stars were frequently photographed inside their favourite restaurants and nightclubs.

Left: The Mother Goose Pantry must rate as one of the most eccentric looking eateries ever to be dreamed up in sunny California.

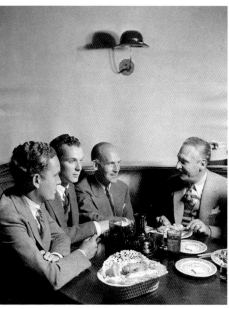

Far left: A stylish looking Evelyn Venable poses for a photo outside the Brown Derby – a favourite venue of the movie fraternity on Vine Street near Hollywood Boulevard.

Left: This group eating lunch at the Brown Derby in the early 1930s – at the time that it was first becoming established as a Hollywood landmark – are virtually forgotten names today: director Joseph Santley, left, with actors Russell Gleason, his writer and actor father, James Gleason and actor Lew Cody. Badly damaged in the LA earthquake of January 1994, the restaurant was demolished one month later just before reaching its 65th birthday.

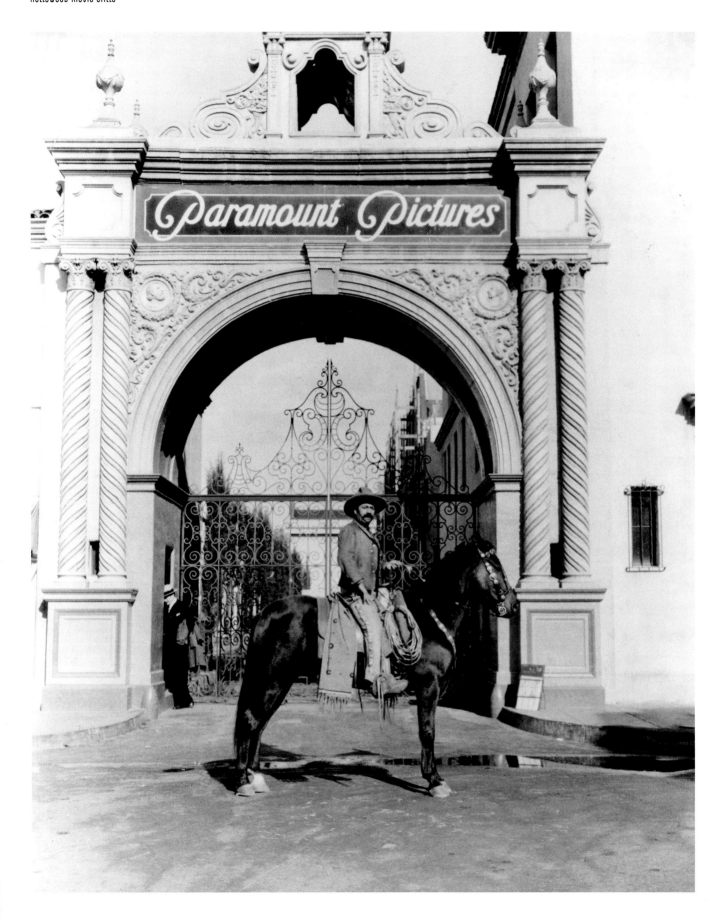

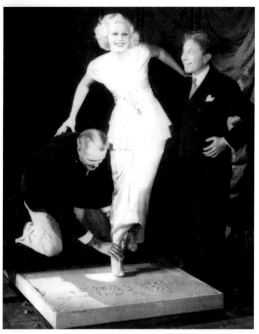

Facing page: An unknown cowboy extra poses outside the famous Paramount studio gate in the early thirties.

Far left: An impression of Jean Harlow's footprints was made in a block of cement to be added to the forecourt outside Grauman's Chinese Theatre in the early 1930s. Here she is assisted by MGM director Victor Fleming and showman Sid Grauman (right).

Left: In Hollywood to star in *The Heiress* in 1949, British actor Ralph Richardson paid a visit to the local open air concert hall, the celebrated Hollywood Bowl.

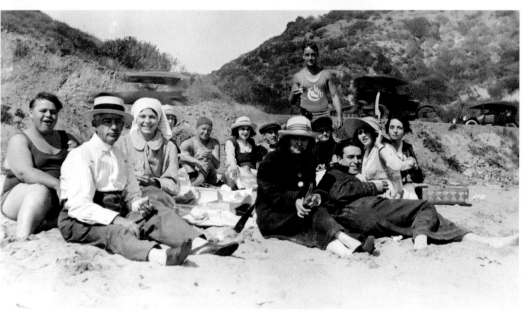

Left: A Hollywood beach party in the early days includes a young Harold Lloyd on the right with his even younger girlfriend and leading lady in the late 1910s, Bebe Daniels.

Below far left: This survey of Hollywood life would not be complete without an Oscar ceremony. This one took place at the Biltmore Hotel on 27 February 1941, when Ginger Rogers was presented with the coveted award by actress Lynn Fontanne (left) for her performance in *Kitty Foyle* (1940). 'This is the greatest moment of my life,' she said to the guests and radio audience. 'I want to thank the one who has stood by me faithfully, my mother.' As can be seen from this photo, the style of ceremony was much simpler in those pre-TV days. Academy president Walter Wanger can be glimpsed on the right.

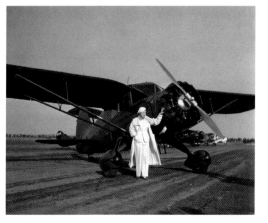

Left: Aircraft were not only a convenient new form of transport for many members of the Hollywood community. A large number of celebrities were attracted to flying as a pastime and were wealthy enough to afford their own private planes. Among the most accomplished fliers were Cecil B. DeMille, James Stewart and of course producer Howard Hughes. Here actress and aviatrix Ruth Chatterton poses beside her plane in a stylish, outdoor ensemble that could easily feature on the fashion pages.

Perhaps the best known sequence in the film of *A Streetcar Named Desire* (1951) is the poignant and erotic reconciliation between Stanley Kowalski and his wife Stella. As described by director Elia Kazan: '...it was a wonderful scene Kim Hunter had when she was responding to Brando calling her from the bottom of the stairs... She was excited by his need for her, she heard his voice desiring her and she responded to it.' Unfortunately, the censors considered her behaviour too overtly sexual and this sequence was cut by 40 seconds, much to the dismay of Kazan. However, the image of Brando in his torn tee-shirt lifting Stella off the ground as he embraces her, was seized on by the producer as the key image to be used on the posters and advertising for promoting the film. For this purpose the scene was re-photographed some months after filming was completed and appears very strange indeed, reconstructed with an anonymous female model stand-in, in a bare New York photography studio, in marked contrast to the atmospheric, original still from the film. Apparently the producer had convinced Brando that no still photo had been taken of this scene!

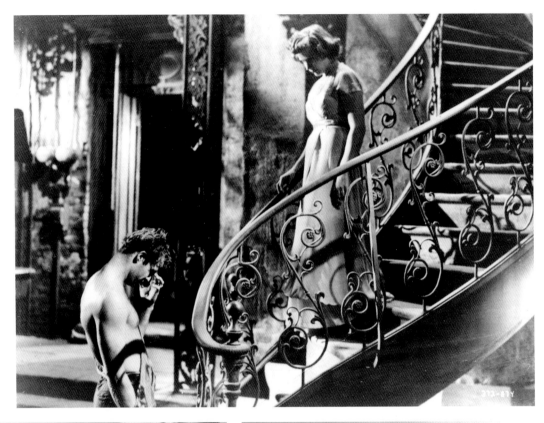

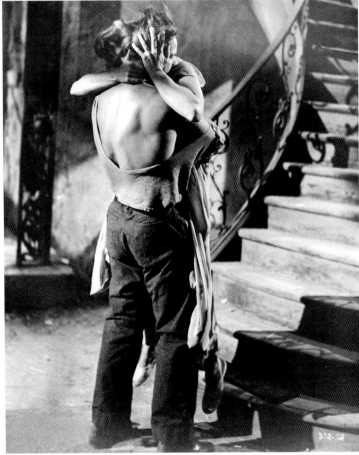

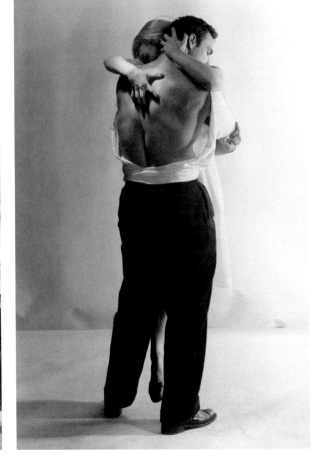

A glimpse here of the sleazy side of Hollywood, in the final fade-out of the beautiful and talented Frances Farmer which began in October 1942 when she was arrested for a minor traffic violation, charged with drunk driving and put on probation for 180 days. Rearrested for violating her probation after a drunken brawl in a night club, and for resisting arrest in January 1943, she was then sentenced to a term in jail. 'Frances Farmer on Rampage in Court', read the headline, 'Floors Policeman and Goes to Jail'. Desperately in need of professional help, instead she was transferred from prison to a private sanatorium and then to a state mental asylum where she remained for many unhappy years. Her story was retold in two biopics in the 1980s – *Frances* (1982) starring Jessica Lange, and *Will There Really Be a Morning?* (1983). Incredibly, these two mug shots of her in police custody, looking like something found in the *Police Gazette*, were reissued as part of the publicity for *Frances*. Juxtaposed above is a glamorous portrait taken when she was being groomed as a leading star at Paramount just a few years earlier, clearly the Hollywood dream turned into a well publicized nightmare.

A tiny sample here of the vast number of fashion photos that poured out of the film studios in the peak years to promote their female stars and their latest movies. These shots appeared most often in the fan magazines of the period and had a special appeal for readers who could keep up with the latest Hollywood fashions and also get advance word on the newest productions with their favourite stars. The stills were provided to a variety of publications, complete with elaborate descriptions. For example, the caption on the striking photograph of a young Paulette Goddard (right) reads in part: 'Unusual in its simplicity, this wedding gown was fashioned by the Hal Roach designing department... The circular skirt swirls gracefully into a train, as does the veil which is attached to the pearl studded cap. Note the high neck line. The pearl studded lower sleeve and lower bodice, both of unusual cut, are the only elaborations.'

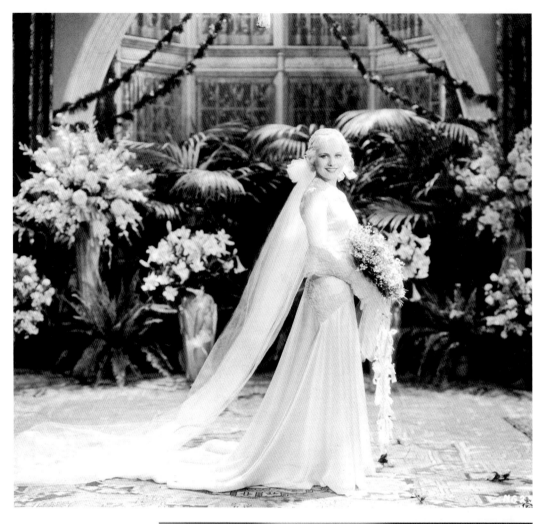

Right: A carefully composed fashion portrait of the stunningly beautiful Hedy Lamarr, shortly after she arrived at MGM in the late 1930s/early1940s.

Facing page: A typical selection of 1930s fashion shots. In each case the star (or stars) are posed against a plain backdrop to better set off their stylish outfits. Top left: Kay Francis; top right: Bette Davis; below right: Gladys Swarthout; below left: Clark Gable and Carole Lombard in No Man of Her Own (1932), the only film they made together, seven years before they were married.

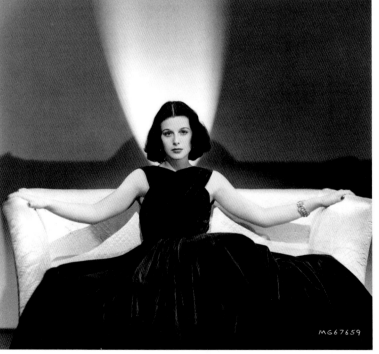

The romantic involvements of the stars were regularly exploited as newsworthy items by the studio publicists and photographers, and a wedding was often turned into a big event, especially when it involved famous personalities whose romance could be linked to their on-screen appearances. A well known example of this was the marriage of Humphrey Bogart and Lauren Bacall (top left) in 1945, both under contract to producer-director Howard Hawks and Warner Bros. Their romance had first developed during the shooting of *To Have and Have Not* in 1944 and continued through *The Big Sleep* in early 1945, both directed by Hawks. The marriage had the classic ingredients of a true Hollywood love story – Bogart just reaching his peak as a star after many years as a

supporting actor and with two failed marriages already behind him, finding the love of his life in a young newcomer from New York making her first movie. This one lasted until Bogart's early death from cancer in 1957, while that between Ronald Reagan and Jane Wyman broke up in the late forties, when she became far more successful than him. They are seen here (centre left) on their wedding day, 26 January 1940, outside the Wee Kirk O'Heather church in Glendale, photographed by Schuyler Crail. 'The bride wore a pale blue satin princess-style gown and mink hat with a bridal veil reversed into a huge bow at the back and carried a mink fur muff with orchids.'

Since Rock Hudson's marriage to Phyllis Gates was specially

arranged by his studio, Universal, as a cover for his homosexuality, it was well publicized at the time. The wedding took place at Santa Barbara on 9 November 1955, and a news item notes that he had vowed that he would be married by 30, and made it with a week to spare. Of course, there is no hint from the wedding shot (above) or the many photos of their happy home life supplied by the studio during the following years, that it was all a sham.

Finally, an example of an early Hollywood wedding, between Universal star Reginald Denny (left) and Betsy Lee, who co-starred with him in *The Night Bird* that same year, 1928. They are seen (below left) at the home of the bride with Judge Samuel Blake who performed the ceremony.

Home life in Hollywood was a natural subject for the still camera. The stars were visited at regular intervals by the studio photographer, and the resulting publicity spreads were often timed to coincide with the release of their latest films. When George Burns and Gracie Allen bought their first home in Hollywood in 1936 after adopting two children, Paramount sent over a photographer to do a full photo session with the entire family. The photos were then sent out with full explanatory captions: 'They found after years of living in apartments and hotels, that these places could not provide the necessary accommodation for the children and so George bought this luxurious mansion, specially fitted with gardens, swimming pool and nurseries as a Christmas present for Gracie.'

The Hollywood home shots of the stars generally included a familiar mixture of indoor and outdoor settings.

Top left: Louise Dresser strikes a very movie star-like pose with her pet dog on the steps of her lavish house in Glendale. This photo was taken around the time that she starred in *The Goose Woman* (1925) for Universal. The Freulich photo credit can be seen in the lower right corner. Almost twenty years later Freulich was still a leading photographer in the stills department at Universal and took this shot (above left) of starlet Jane Frazee in the yard of her Hollywood home with her dog Bossy in 1942. Doubling as a fashion shot, too, with a still fashionable pair of platform shoes, Jane was one of the studio's many young musical stars in the early 1940s.

Top right: W.C. Fields emerges from his Hollywood home in uncharacteristically happy mood.

Above right: Jean Arthur was also at Paramount slightly earlier, from 1928 to 1931. Here she is given a very homey look, her face lit up by the glow from the fire which also provides a bit of soft back-lighting. The quality of the photo is such that one can easily decipher the title and page number of the book she is reading: *The House that Shadows Built* by Will Irwin, covering the history of the Paramount studio up to 1928. Miss Arthur is midway through the chapter which tells of the early experience of studio founder Adolph Zukor as a nickelodeon owner, before he first ventured into film production.

 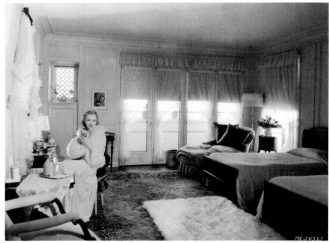

Top left: Writer and actor James Gleason is photographed beside the swimming pool of his new home in Beverly Hills while dictating to his secretary, Sydney Heinze. The caption on the back refers to the imminent release of his latest picture, *Suicide Fleet* in 1931 as a PDC production, but by the time it came out the company had been absorbed into RKO Radio,

along with Pathé, and Gleason, too, became an RKO star.

Top right: A portrait of Virginia Bruce with John Gilbert, which appears on the wall of her luxurious and spacious bedroom just behind her, looks as if it could well be a still taken on the film in which they played together, *Downstairs* (1932). They were married that same year – she was

his fourth and last wife, though they had divorced before his untimely death in 1936.

Above: An archetypal Hollywood view is this posed photo of Robert Young outside his home in Beverly Hills. The palm tree is impressive indeed, but jokingly referred to in the studio caption as 'artistic shrubbery'.

A mixture of genres on this page: Tom Mix (top left) at home wearing his familiar white ten-gallon hat among an eclectic mixture of Western and Mexican style souvenirs. Horror star Bela Lugosi (top right) looks more domesticated and less scary than usual, while MGM musical star Allan Jones is seated at the piano in his tastefully furnished Brentwood home.

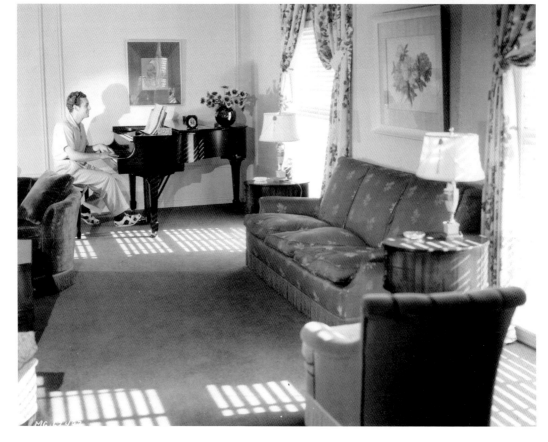

A diverse selection of Hollywood interiors. Gladys Swarthout (left) poses on the impressive curved staircase of her Beverly Hills home, and from what one can see of the rest of the house, it looks quite stunning, too. In contrast, Rock Hudson and Fred MacMurray (below left and right) appear to prefer a more modest, old-fashioned and homey style. (A fireplace appears to be a standard fixture in the living room, in spite of the mild year-round climate.) Fred appears surprisingly awkward and ill-at-ease in this shot, while the Rock Hudsons look the picture of domestic bliss, with their miniature French poodle, Demi Tasse or Little Bite. Similarly, MGM star Robert Montgomery looks rather too immaculate and obviously posed at his piano (below) as if trying hard to ignore the presence of the photographer.

The pictorial survey of Hollywood family life begins, appropriately enough, with Harold Lloyd who remained married to Mildred Davis, his former leading lady, from 1923 until her death in 1969. They are seen here (above) with their three children on a small corner of his luxurious Beverly Hills estate which covered an area of sixteen acres and was second only in size to Fairbanks and Pickford's 'Pickfair'. This imitation, English, Tudor-style, thatched roof cottage, designed as a children's playhouse, was completed at around the same time as the main building, an imitation Italian Renaissance mansion, and a few years after the birth of their first child.

Above right: Joan Blondell and Dick Powell are best remembered for their years as leading musical and comedy stars at Warner Bros. in the 1930s. They married in 1936 and were known for a time as one of Hollywood's happiest

couples before they split up in 1945: they are seen here clowning about at home with their daughter during happier times in the early 1940s.

Right: *Mommie Dearest* – Christina Crawford's book about her many years of ill treatment, growing up in Hollywood as the adopted daughter of movie star Joan – was first published in 1978, a year after the star's death, and was turned into a major movie three years after. This photo of the real Christina with her mother and younger brother Christopher, one of the many, many photos they were forced to pose for as children, looks very different after reading the book. 'I remember being dressed up and paraded out in front of interviewers and photographers with my little rehearsed responses and photo-perfect smile... A few minutes later [after the reporters had left] we were little more than extra servants doing Mother's bidding.'

Left: MGM star Cyd Charisse, gave birth to her son, Tony Martin Jr. in 1950, and motherhood may have delayed her emergence as the studio's top female dancer. It was just one year later, in 1951, that she was cast in *Singin' in the Rain* and her career took off. (Cyd's husband, Tony Martin was best known as a nightclub singer, but also sang and acted in numerous movies beginning in the late 1930s.)

Below left: After another MGM star Esther Williams married, then gave birth to her first son, the studio must have looked forward to getting this shot – of the most popular aquatic star of the movies giving her baby son (Benjamin Gage Jr.) his very first swimming lesson. The family are seen here in the back yard of their Hollywood home.

Below: Yet another leading actress gave birth to a son in 1950, but she was far from Hollywood at the time. Ingrid Bergman had caused a minor scandal in the US in 1949 when she had left her husband for Italian film director Roberto Rossellini. And in June 1952 she had twin daughters Isotta-Ingrid and Isabella, who would become a successful model and film star herself in the 1980s. Here Ingrid is seen with her three children and their governess in Paris where they grew up in the 1950s. This is just one of the vast numbers of photos of Ingrid and her family which were taken at the time when they were regarded as a newsworthy item. In her autobiography she recalls how difficult it was for her to go anywhere with her children without being pursued by the paparazzi.

Left: When Marlene Dietrich's daughter, Maria Riva, gave birth to her first son in 1948, Marlene immediately became known as 'the world's most glamorous grandmother', a role she enjoyed playing from then on. She is seen in this posed 1950s photograph reading through a book of Bible stories with her grandson, but the pose was not faked. She did take a genuine, caring interest in her grandchildren during these years.

Above: It's an all male world – Robert Mitchum and Kirk Douglas photographed with their sons, and not a mother or sister in sight. Whereas both of Mitchum's sons, Jim and Chris, did some acting in the movies, it was Kirk's eldest son Michael who followed most closely in his father's footsteps, developing into an extremely successful actor and film producer in the 1980s and even winning an Oscar for his performance in *Wall Street* (1987). The photo includes Michael's two younger half-brothers, Eric (left), and Peter, with camera. Missing from the shot is the fourth brother, Joel.

Right: Bob Hope and his wife, Dolores, were among the many Hollywood celebrity couples who adopted children in the 1930s and 1940s, including the Cagneys, the Beerys, Burns and Allen – and of course Joan Crawford. Here Bob mugs for the camera, after stepping off the plane with his extended family in the 1950s, including his older son and daughter (Tony and Linda) and a younger pair, Nora and Kelly, all adopted, with Dolores (left).

Many of the leading stars took up photography as a hobby. Top left and right: getting some useful technical advice. On the left, Jane Wyman with cameraman Ted McCord between scenes on *The Lady Takes a Sailor* (1949). Here he demonstrates the use of a light meter – the invention of another Hollywood cameraman, Karl Freund. On the right, two Hollywood veterans: cinematographer Charles Schoenbaum chats with actor Wallace Beery. Beery is seen here near the end of his long career, around the time that he was starring in *A Date with Judy* (1948).

Above left: photographer Tony Curtis clowns around with co-star Rosanna Schiaffino on location for the filming of *Drop Dead Darling* (1966).

Above right: James Bond star Sean Connery snaps his slightly startled actress wife Diane Cilento.

Top: Sophia Loren focuses on co-star Tab Hunter on location in New York for *That Kind of Woman* (1959).

Right: Michael Douglas in the early 1970s, just starting out on a promising acting career.

Far right: a glamorous Norma Shearer enjoying her retirement from films.

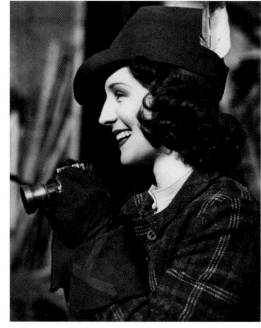

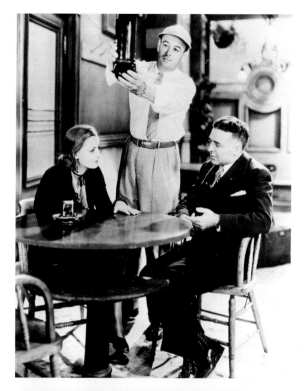

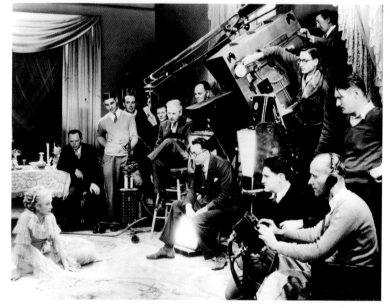

This chapter concludes with a thirty-year behind-the-scenes selection from the 1930s to the 1960s.

The 1930s
Top left: Late in 1929 Greta Garbo began filming her first talkie, *Anna Christie*, based on the play by Eugene O'Neill, with one of her favourite MGM directors, Clarence Brown (right). Here, symbolically, the mike is being positioned to record her very first line of dialogue, 'Gimme a whiskey

with ginger ale on the side... and don't be stingy, baby.' The speech revealed her appealingly deep, husky, contralto voice.

Top right: Vivien Leigh, in the costume which she wears in the Atlanta Civil War sequences chats with Clark Gable and director Victor Fleming on the set of *Gone With the Wind* in 1939. The large Technicolor camera can be seen in the background, mounted on a giant crane which was used to film the spectacular shot of Scarlett

wending her way through the hundreds of Confederate soldiers in the street outside the railroad station at Atlanta. This picture was probably taken by Fred A. Parrish, the film's official stills photographer.

Above left: Boris Karloff takes a lunch break during the filming of *The Bride of Frankenstein* at Universal in 1935. The first, outstanding sequel to the original production four years earlier, it included a few members of the original cast under the same

English director, James Whale.

Above right: A strikingly composed production shot shows a lone woman, the blonde Miriam Hopkins as *Becky Sharp*, seated on the floor wearing a light coloured dress and brightly lit up, faced by an all-male production crew and giant camera, headed by director Rouben Mamoulian (in mid shot), all intently focused on her performance. They are filming the very first Technicolored feature in 1935.

The 1940s

Right: A birds-eye view of Warner Bros' extra-large new 1940s sound stage where filming of the Irving Berlin musical *This is the Army* (1943) is in progress. Two cameras are positioned, one on top of the other on the scaffolding. While the skeleton of two full-scale ships originally constructed for shooting *The Seahawk* (1940) can be seen on the left and the right.

Below left: Although Barbara Stanwyck had previously appeared in DeMille's *Union Pacific*, she only really emerged as a leading Western star in the early 1950s, beginning with *The Furies*. She is seen here in costume in a friendly but very posed-looking shot with director Anthony Mann as they examine a strip of rushes from the film.

Below right: Burt Lancaster's 'injury make-up' gets a bit of retouching from director Robert Siodmak during the filming of *The Killers* at Universal in 1946. Based on the Hemingway story, it was Lancaster's first movie role, as 'the Swede', and the film's great success helped to launch his career.

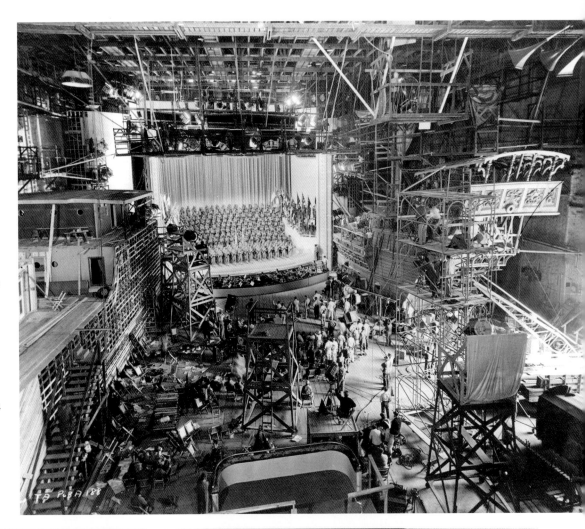

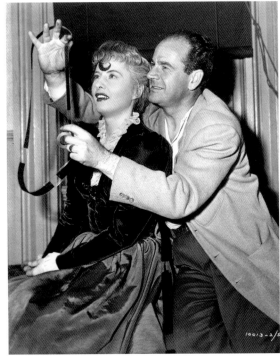

The 1950s

Above: Behind the scenes on the set of *Scaramouche* (1952). English-born star Stewart Granger in costume for the title role is the main centre of interest, but here equipped with his own small 16mm camera, he is filming Eleanor Parker alongside the larger Technicolor one. This posed photo also includes the celebrated cameraman Charles Rosher on the right, with director George Sidney and camera operator John Nickolaus on the left.

Above right: This photo is revealing of the kind of problems which beset RKO in the early and mid-1950s when it was effectively being run down by its eccentric owner Howard Hughes. Jane Russell, engaged in filming *The French Line* on an adjoining set, drops in on Vincent Price for a bit of unscripted clowning. (They had starred together in a couple of films in the early 1950s, *His Kind of Woman* and *The Las Vegas Story*.) Both films were to be shot in 3-D, the latest technical fad in 1953 when this photo was taken, but by the time that *Son of Sinbad* appeared, over one year after *The French Line* in mid-1955, it had been filmed in SuperScope instead!

Left: An assistant holds up a small mirror on location as Marlon Brando applies his own make-up for the violent and dramatic fight scene which comes at the very end of *On the Waterfront* (1954). Without a make-up assistant in sight, this photo suggests that the film was shot on a tight budget and far from Hollywood. As Budd Schulberg, the writer of the film recorded, 'Shooting wasn't easy; twelve, fourteen hours a day on location in Hoboken (New Jersey, across the river from New York), and I have never known such cold...'

Left: Another tough black-and-white movie of the 1950s, also filmed mainly on location on a small budget, was *Paths of Glory* (1957). Even more than the previous shot of Brando, this one captures the feel of the camera-derie of filming under difficult conditions. This group portrait, with its nicely composed, triangular composition, shows an almost unrecognizable Stanley Kubrick (in balaclava and overcoat) with the star and producer of the film, Kirk Douglas, and the actress Suzanne Christian who played a small role in the picture and later became Mrs Kubrick.

Below left: A stunning Audrey Hepburn, dressed for yachting scenes with Humphrey Bogart in *Sabrina* (1954), takes time out to pose for the stills camera with director Billy Wilder (left) and William Wyler. Wyler had directed Hepburn's first American feature *Roman Holiday* the previous year.

The 1960s (Facing page)
Top left: The four Beatles on the set of their first feature, *A Hard Day's Night* (1964), complete with camera and clapper board. Left to right, George Harrison, producer Walter Shenson, Ringo Starr, the 'fifth Beatle' American director Richard Lester, John Lennon and Paul McCartney.

Top right: The talented Sean Connery shows off his athletic skills to co-star Ursula Andress during a break in filming one of the best remembered scenes in the first James Bond movie, *Dr No*, on location in Jamaica early in 1962.

Below right: Clint Eastwood was just another young American actor who had done some film bits and a successful TV series (*Rawhide*) when he went to Italy and grew a beard to star in *A Fistful of Dollars* for director Sergio Leone in 1964. Relaxing with his script, he doesn't look like a man who is about to become the most successful Western star and director of the next 30 years, culminating in *Unforgiven* in 1992.

Below left: Charlton Heston also grew a beard in the 1960s for his role as the human astronaut captured and held captive in *Planet of the Apes*. Here he is seen in his prisoner's garb on the Ape City set at the 20th Century Fox ranch in Malibu, posing for an unknown ape extra in 1967. The film was so original and successful that it spawned four sequels, an imaginative, but short-lived, TV series, an equally short-lived animated TV series, and Tim Burton's 2001 remake.

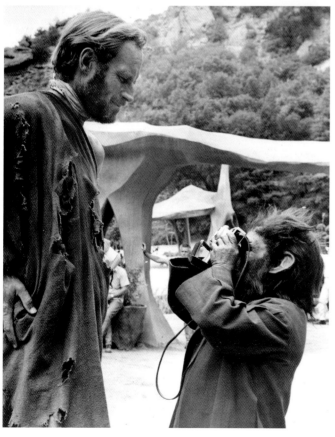

THINGS AIN'T WHAT THEY USED TO BE

New developments in movie stills photography in the 1940s and 1950s reflected the many changes taking place in the film industry in general. The war had a major impact, of course, reducing the market for American films abroad, while many stars and other personnel were lost to the armed services. There were also wartime shortages and a reduction in the number of pictures being produced and released. Yet profits were high and the film companies looked forward to a rapid recovery after the war. But movie attendance continued to fall, and by the late 1940s it became apparent that the studio system itself was in irreversible decline.

Whereas the film studios in Hollywood had been the major centre of film-making ever since the late 1910s this, too, was beginning to change. Most American movies in the 1930s had been filmed entirely in and around Hollywood, making use of the studio back lot and the occasional nearby location for exteriors, with interior scenes shot entirely on the sound stages. But now films were increasingly being filmed on a wide variety of locations all over the US. By the 1950s much American filming was being done abroad, especially in Europe, making use of European studios and technicians.

A severe cutback in studio payrolls meant that many personnel, including the portrait and stills photographers, no longer had long-term contracts, and the budgets of the publicity departments were slashed. At the same time, many of the top stars and directors opted for a more independent or freelance status, forming their own companies to develop suitable projects.

In fact, there was a major change in the position of most of the stars. Since they were no longer signed to long contracts, this meant that they could not depend on the studio bosses to make career decisions for them, and provide them with a regular diet of ready-made star vehicles. Though they now benefitted from a greater freedom in their private lives – which had previously been controlled by the studios – they were now forced to fend more for themselves. Newcomers, for example, were no longer carefully groomed for stardom and given the opportunity to work their way up from bit parts to supporting and then starring roles. With far fewer films being made, and the virtual demise of the 'B movie', even leading stars now appeared in only one or two pictures a year, whereas in the 1930s it was not unusual for the stars to make four or five films every year.

This situation meant much less work for the stills photographers whose fortunes were closely linked to those of the stars they photographed. With less films released and the demise of a number of the movie fan magazines – a natural consequence of the declining movie audiences – and with too few new stars emerging to replace those of the 1930s, there was a fall in demand for movie stills of all types, especially the star portraits and glamour shots. Changes in attitudes to movie stardom and 'glamour' were related to the new styles of film-making, with a more naturalistic approach to movie acting generally, and to portrait photography in particular. Various technical advances (faster film stock, improved lenses and sound recording equipment) now made it easier to shoot on location, with low-key and contrast lighting much in vogue for thrillers and dramatic films in black-and-white, as well as the new type of psychological western.

All these changes posed new problems for the stills photographer used to working within a much more controlled studio environment. He had to be sensitive to the subtleties of the new style of movie photography and overall mood and to the actors' performances, making sure his stills did not look overly posed or over lit. It was more important than ever before for the photographer to inject some spontaneity into his shots, and the feel of a genuinely captured moment of the film.

Unfortunately, many of the photographers were slow to adapt to the new methods, given the fact that the publicity departments continued to prefer stills full of well-lit detail which would reproduce well in newspapers and cheaper magazines. Thus, many of the 1940s scene stills look posed and artificial to us today. This is especially true of some of the interior and dialogue scenes shot in the studio on films which were otherwise known as notable early examples of Hollywood's attraction to location filming such as *The Lost Weekend* (1945) and *The Naked City* (filmed in 1947). Thus, the authentic-looking street exteriors and milieu could have the undesired effect of drawing attention to the artificiality of the (studio) interiors and any weaknesses in dialogue and acting in the films themselves, with the stills merely reflecting this split.

Since the quality of the stills varies so much from film to film and from studio to studio, it is always difficult to generalise. But there is some evidence by the early 1950s (for example, *The Asphalt Jungle*, *Pickup on South Street*)

Making use of 'cheesecake' photos, like this one posed for her first movie, *The Outlaw* in 1940, producer Howard Hughes launched the career of teenage sex bomb Jane Russell. He made sure that her image featured prominently on all the posters and advertising for the film. The censorship disputes and notoriety surrounding Miss Russell and the release of the picture ensured that it would be a big hit at the time. But it is the provocative Jane Russell photos which are still famous today, while the film which spawned them is of little interest and virtually forgotten.

composition which was more effective in a still image.

In the case of Hitchcock, the best-known director specializing in thrillers, some of the most effective stills from his films benefited from just such imaginative or stylized treatment. Whether Hitchcock himself encouraged the stills photographers to come up with original ideas on these films – quite likely, in that he was generally involved in every aspect of his films and their publicity, including the trailers – or whether the films themselves stimulated a special response from the various studio stills departments, the results were often quite striking (see pages 194 - 197).

If the scene stills in the 1940s and 1950s often failed to match up to what was seen on the screen, at least the behind-the-scenes shots and candid views of the stars at home and at work were produced in large numbers and great variety and reflected especially the new trend toward more location filming. The stars, directors, and film units were now more accessible than they had been since the silent era, while the use of small cameras and faster film gave the stills photographer a greater flexibility. There were more genuinely candid shots – Bette Davis almost unrecognizable without make-up, or a rare glimpse of Fred Astaire or Humphrey Bogart without a toupee. And the increase in filming away from the studio, often on unusual or picturesque locations, provided the photographers with many new and different opportunities. We see the stars relaxing or entertaining each other or passing the time in a variety of ways during the breaks in filming; reading their script, having their hair, make-up or costume adjusted, visited on set by friends, family, fans or colleagues. On their days off they might be caught shopping or sightseeing. There were also many more chances now to show the movie units at work and the latest methods of filming, with new cameras and other equipment.

In fact, many of the photographers themselves appreciated the changes which were taking place. Eric Carpenter, for example, recalls how he had become increasingly dissatisfied with his prestigious, though restrictive, position in the MGM portrait gallery: 'Eventually I got fed up just taking portraits and quit.' But when he returned to the same film studio a few years later, he found that there was less gallery work available, and he was offered a less important, unit stills position instead. 'Hell, that was OK with me. I'd been wanting to do unit publicity [ever] since I got there', he later recalled. 'At last I had a chance, and to travel around the world'.

Not only were there important changes in the way that the movies were made, but in the types of films, too. Both the thriller and western genres experienced a new popularity, for example, along with the many musicals filmed in colour. By the 1950s there was a boom in westerns, adventure and costume pictures shot in colour and in the various new widescreen processes – CinemaScope, VistaVision, Todd-AO – while cheaper science fiction and horror movies were turned out by major and minor studios alike. (Even this latter exploitation fare often stimulated a lively response from the studio stills departments who were expected to come up with striking illustrations to accompany the publicity for the new movie

Two good examples here of movie fight sequences. The top photo shows Richard Widmark in action in *Pickup on South Street* (1953). The lighting, composition and slightly blurred result effectively capture the feel of this gritty Cold War thriller directed by Sam Fuller. Similarly, a spectacular battle between Frank Sinatra and Henry Silva takes place midway through *The Manchurian Candidate* (1962). And yes, it really is little Frankie flying through the air in this convincingly staged action shot.

that the stills photographers were succeeding better in capturing the atmosphere of the films in their scene stills.

On the other hand, the poster art and other specially posed shots had always provided the photographers with many opportunities to capture the feel of the film without actually reproducing the image as seen on the screen, using a scene from the movie as the raw material for recreating a

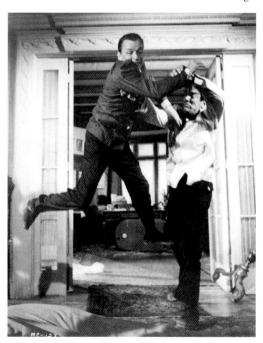

formats, including the short-lived experiments in 3-D.)

Many of the most interesting films were, in fact, directed by a number of important newcomers who had first made their mark in the 1940s and had become even better known and more successful in the 1950s. Thus, not surprisingly, there was now a lot of attention focused on such directors as Elia Kazan, John Huston, Billy Wilder, Fred Zinnemann, Vincente Minnelli and Anthony Mann, along with leading veterans such as Hitchcock, Ford, Hawks, Stevens and Wyler who also experienced some of their greatest successes in the 1950s. This naturally provided the stills photographers with an extra incentive to get good production and behind-the-scenes shots of these men at work and with their stars and leading collaborators such as scriptwriters or cameramen.

At the same time, the decline of the large studios in the 1940s and 1950s led to a cutback in the kind of stylish fashion and glamour photography previously associated with Hollywood's golden age. In fact, the first signs that changes were on the way can be detected as early as the late 1930s when both Mae West and Marlene Dietrich left Paramount, followed by Katharine Hepburn's departure from RKO and Kay Francis from Warner Bros. The retirement of Garbo and Norma Shearer at MGM and Joan Crawford's move to Warners in the early 1940s confirmed this trend, along with the tragic death of Carole Lombard in a plane crash in 1942. (Jean Harlow had died five years earlier.) In addition, these four top studios lost their leading costume designers around the same time, along with a number of the portrait photographers who had played such an important role in creating the glamorous images of the era. (John Engstead and Richee left Paramount, Bert Longworth and Elmer Fryer departed Warners, and George Hurrell went freelance – all in 1941 – while Willinger resigned from MGM shortly after.)

The studios, of course, tried to continue the tradition of glamour photography with varying degrees of success, both in the US and in England, where the Rank Studio had ambitious plans for film production after the war. There was no shortage of attractive newcomers who aspired to take the place of those Hollywood stars who had gone, but few succeeded. Portrait stills played an important role in the rapid rise to stardom of Veronica Lake, Lauren Bacall and especially Jane Russell, boosted by provocatively posed shots from her first picture *The Outlaw*.

Pin-up photography got a great wartime boost as photos of their favourite stars were sent out as morale-boosters to the troops abroad, with Betty Grable and Rita Hayworth gaining a reputation as the GIs' special choices. Among the most memorable images of the decade was the famous over-the-shoulder look of Miss Grable in her white, one-piece bathing suit and Rita in a black strapless evening gown as Gilda.

The similar experiences of Shelley Winters at Columbia (previously mentioned), Ava Gardner at MGM and Marilyn Monroe at 20th Century-Fox suggests that the film companies were slow to change, and they continued to treat their young starlets much as they had in the past. With no prior acting experience, for example, both Ava and Marilyn were forced to spend many years posing for pin-up photos

Bette Davis looks virtually unrecognizable in this candid shot perhaps taken at her home in the 1940s

and doing bit parts on the screen before they got their first chance to play even supporting roles. Ava has recalled her early years in Hollywood with distinctly mixed feelings in her posthumously published autobiography, *Ava: My Story*:

I spent an awful lot of time in what was called the Picture Gallery. But portraits were not what they had in mind for me. My speciality was called 'leg art', publicity stills of the cheesecake variety... I was always a smiling Easter bunny or a roguish lady Father Christmas.

Never seen like this on the movie screen or in the studio publicity stills – a rare shot of the real Humphrey Bogart in the 1940s at the peak of his career as a movie star, without his toupee.

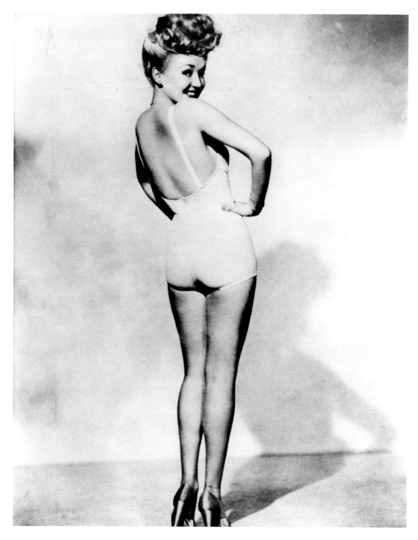

One of the most famous pin-up shots of all time, this photo of Betty Grable, taken at 20th Century-Fox in the early 1940s, contributed to her sweet yet sexy, all-American image at a time when she was at the peak of her popularity as the studio's leading musical star. In an effort to make her appear more wholesome, a garter on her left leg had even been airbrushed out. (Photographed by Frank Powolny.)

relationship of subject to photographer and found the process of being photographed quite enjoyable and stimulating. Top photographer Richard Avedon was impressed by how much she understood about still photography and how 'creative' she could be in front of the camera. According to him, '...she was very, very involved with the meaning of what she was doing', and he even suggested that 'she was more comfortable in front of the camera than away from it'. Similarly, Eve Arnold recalls that 'she knew she was superb at creating still photographs, and she loved doing it. She didn't have to learn lines as in her films (but) could let her imagination range freely...'

In Britain, too, there was a belated effort made to improve the quality of the portrait photography after the war, in imitation of the American pattern, particularly at the Rank studio where a large number of new young stars had been signed to seven-year contracts. As recalled by the studio's leading photographer, Cornel Lucas:

We were all greatly influenced by the move into the international market. British films made in the thirties and forties were moderately English in feeling. Suddenly they were becoming more transatlantic and our pictures had to reflect the same thing. There was, for instance, a great deal more glamour.

Joan Collins, Diana Dors and Dirk Bogarde were among the few real star discoveries, but most of the Rank contract players failed to make much of an impression on the screen, while the studio itself was hit hard by declining movie audiences and found it hard to compete with films from the United States. Thus, its short-lived experiment came to an end.

With the shutting down of many of the studio photographic galleries in the late 1940s and 1950s, and with the stars no longer obligated to attend portrait sessions, the shooting of portraits became more of a hit-or-miss affair than ever before. Often the photographers had to arrange to take their photographs on the set, whenever and wherever the opportunity presented itself. (See the discussion of Cecil Beaton's experience on *My Fair Lady* later in this chapter). At the same time there was a trend toward a more natural, intimate and candid style of portrait photography, in contrast to the older, highly artificial methods of the 1930s.

In spite of the fall in the number of films produced, the interest in Hollywood among the general public had never been greater in the 1940s. There was a new recognition of the importance of the photographers by the Academy of Motion Picture Arts and Sciences which mounted an annual travelling exhibition of the best examples of Hollywood stills photography. Awards were given in various categories ranging from scene stills, fashion and pin-up shots to character portraits and poster art (but these should not be confused with the Academy's better-known annual awards or 'Oscars'). The emphasis here was firmly on the artistically posed and lit photos, the portraits or poster art, generally pin sharp (For example, Ernest Bachrach's photo

Brought up on a farm, the photographers could not believe their luck when Ava told them she could milk a cow, and they eagerly posed her doing just this.

Similarly, in a recent interview Esther Williams recalled her experience as a hard-working and accommodating young MGM star. Not only was she rushed into one film after another, but was also obliged to make herself available for the elaborate post production publicity. As Hollywood's leading aquatic star, this naturally centred on her familiar swim-suited image. 'After each film there was a portrait sitting, a sitting for the poster, a sitting for the fan magazines and a beach sitting for the pin-up photograph. Then it was time to start the next movie. It was a treadmill.'

But undoubtedly the most remarkable photographic subject in the history of the cinema was Marilyn Monroe. Her career as an actress was really made possible by the tremendous amount of exposure she received as a photographic model in the 1940s. Though she was signed to her first movie contract as early as 1946, she was given mainly bit parts for many years. Even after she had attained movie stardom she continued to be more at ease in front of a stills camera than a film camera (and crew). She was obviously happier with the more intimate, one-to-one

of victim Rhonda Fleming reflected in the eye of the serial killer in *The Spiral Staircase* was a First Prize Winner in 1946: see page 152).

The continuing widespread use of movie stills meant that they would not only turn up in newspapers and fan magazines, but in news magazines, too, often accompanied by a story relating to Hollywood or the movie industry. For example, the cover of the 30 December 1946 issue of *Newsweek* featured a slightly cropped still from Frank Capra's *It's a Wonderful Life* sandwiched between the subhead, 'The magazine of news significance' and a caption, 'The Return of Jimmy Stewart'. The accompanying story serves as an interesting example of how movie stills are often used by the media. Shots of Stewart as a young lawmaker crusading against government corruption in *Mr. Smith Goes to Washington* (another Capra film) and in *It's a Wonderful Life*, are included along with a photo of him in uniform as a Colonel in the US Air Force. Thus, there are a whole range of associations here tending to blur the distinction between fact and fiction, between the imaginary heroes played by Stewart on the screen and the real person who had flown many combat missions and was a genuine war hero. (The article makes the point that Stewart had rejected the idea of playing any war roles 'to avoid even the slightest suspicion that he is attempting to cash in on his war record', while conveniently ignoring the fact that relatively few war films were being made in 1946.) An attempt is made to relate Stewart's situation to the general problem faced by soldiers returning to civilian life: 'It is the test of whether he still has the knack of playing before the cameras after more than four years of highly contrasting duty'.

The movie still on the cover, however, shows the Stewart character at home with his movie family, with a Christmas tree seen prominently in the background. Thus, Stewart himself is neatly identified with the traditional American family values represented by this shot, though he was still a bachelor at the time, while the appropriately seasonal setting is no accident either. Clearly, the film's late December release ('Capra's Christmas Carol') has been timed to take advantage of this fact. (The photo itself recalls those many calendar art 'tie-in' stills sent out by the film studios at this time of year to celebrate Christmas and the New Year.) However the attempt to cash in on the Christmas theme did not work, for the film flopped at the box office. Furthermore, it is perhaps appropriate that this old-fashioned, posed-looking still reflects the old-fashioned qualities of the movie itself, a throwback to the kind of movies and formula – taking the ordinary, little 'man in the street' as his hero – that Capra had popularized in the 1930s. Here it is the struggle of Capra's small town 'everyman' to make good, while raising a family and helping his fellow townspeople. At the same time Capra has also opted to return to the artificial-looking and 'generalized' small American town setting constructed on the studio back lot, which featured in so many films of the pre-war years, suited to a movie 'fable' but running counter to the trend toward a more naturalistic style of location filming.

In fact, the theme of servicemen returning to civilian life was the subject of another picture released at the very same

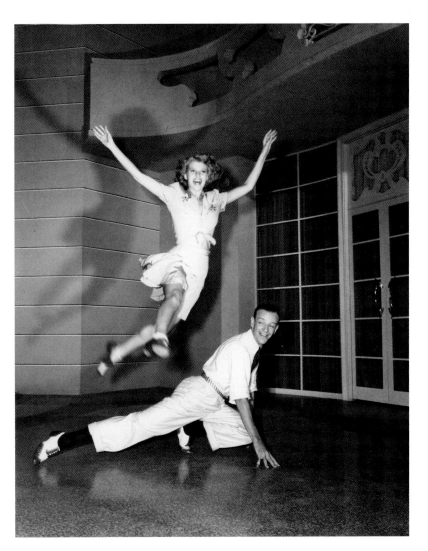

time, *The Best Years of Our Lives*. More 'realistic' and successful, this film reflected the trend toward a more naturalistic style of filming in the mid-1940s. The stills, however, look very posed. Clearly, the approach to still photography in Hollywood was slow to change.

In fact, the use of smaller cameras and available light sources by photo journalists in the 1930s and the popularity of the new picture magazines meant that for many years the public had become familiar with a new and different type of photography, often combined with a short text in the so-called 'picture essay' style. First pioneered by a number of news magazines in Germany, this approach had been adopted and popularized by *Life* and *Look* in the US in the late 1930s.

Life magazine, in particular, had cultivated a special relationship with Hollywood and the movie studios from quite early on. Rather than depending on the stills supplied by the film companies, it sent its own photographers to take photos not only on the movie sets but at the nightclubs, restaurants and homes of the stars. There were special events to cover as well. For example, a 1941 spread was titled 'Life Spends a Day with Sidney Skolsky: Hollywood Columnist Sees Stars from Dawn to Dark'.

A more spontaneous style of photography emerged in the 1940s and 1950s. Here the photographer has succeeded in capturing the delightful vitality and sheer verve in the 'Shorty George' number in *You Were Never Lovelier* (1942). Fred Astaire and Rita Hayworth are just beginning to fall in love at this point in the film and their feelings for each other are conveyed by the dance.

With its appropriately Christmassy theme, this is the very photo that was selected to appear on the December 30th, 1946 cover of *Newsweek* magazine. Left to right, Thomas Mitchell, Donna Reed, James Stewart, Karolyn Grimes, Sara Edwards, Beulah Bondi and Tom Kean. The three children in the foreground are Carol Coomes, Jimmy Hawkins and Larry Simms. (This photo was taken by Gaston Longet.)

The picture essay worked especially well in covering the lives of the stars, combining candid shots at home or out on the town with on-set or off-set views in costume or make-up working on their latest picture. In fact the *Life* photographers soon gained a reputation for observing the Hollywood scene with a fresh eye and generally attacked their subjects with originality and style. Thus, they undoubtedly had a lasting influence on the unit men employed by the studios and on the development of stills photography generally.

Furthermore, in the early 1940s the studio photographers were still subject to the restrictive 'good taste' provisions of the industry's advertising code (already referred to in Chapter Two). Clearly, *Life* and *Look* and the other mass circulation magazines had a very specific impact around this time. For the widespread publication of more candid and revealing types of photos, as well as the 'leg art' and pin-up type shots aimed at the many GIs in the US and abroad, forced a loosening up of the censorship of film stills, in particular.

The *Life* magazine approach also foreshadowed the most important changes which took place from the 1950s on, namely, an increase in the movie photo 'specials'. As the large studios became less involved in actual film-making and continued to cut back on their contract personnel, the tradition of unit stills photography of a high professional standard, which had been established thirty years earlier, gradually came to an end. And the decline in the quality of the unit photography meant that the special photographic assignments became more necessary and important than

ever before.

The way this worked was that a leading photographer or one who specialized in film work would be hired or sent by a photo agency and expected to concentrate on photographing a particular star or focus on some other special aspect of the film. As Arlene Zeichner noted in *Film Comment* magazine, 'The specials try to get a fresh angle on a film, to see something that the unit, tightly bound to the mundane realities of daily shooting, might miss or can't get.' Whether on location or inside the studio, the special photographer concentrates on getting his or her photos quickly and efficiently, within a few weeks at most, unlike the unit photographer who is present throughout most of the filming.

One of the first 'specials', and an unusual example of a major studio employing an outside stills photographer, Bob Willoughby was hired by Warner Bros. to take photos of Judy Garland on the set of *A Star is Born* in 1954 (see page 101). Although specials are now quite common on large budget pictures with top stars, there are a few particularly important ones worth noting. John Engstead was brought in by the producers to take a series of portraits of Marlon Brando on the set of *A Streetcar Named Desire* in 1951. He was careful to photograph Brando in a white T-shirt, rather than the grey one he wears in the film, as it showed up much better against the dark backgrounds. The result was a series of iconic images of the rising young star which have been widely reproduced ever since.

On *My Fair Lady* in 1963 Cecil Beaton was hired to

take portrait and fashion shots, having designed sets and costumes for the film as well (see pages 190 - 193). A few years later Bob Willoughby arrived on the set of *The Graduate* (1967) to try and capture the main theme of the film with its two stars including an attempt at a stylized poster shot which, in fact, was not used. (Anne Bancroft dominates the picture in the foreground as the sophisticated female predator in a leopard skin coat, smoking a cigarette and looking very pleased with herself, while her 'victim' Dustin Hoffman appears as a tiny figure at the end of a long corridor in the far background.)

Terry O'Neill, however, had a better experience with Paul Newman and Lee Marvin on *Pocket Money* (1972). As he later recalled, 'I just stood the two of them up against a wall and took the shots. The film company thought one was so good, they used it for the poster.'

And finally, the production of *The Misfits* serves as a most interesting and exceptional example. As photographer Bruce Davidson later explained: 'Magnum [the celebrated photo agency] had the whole concession. They wanted to document the entire making of the movie.' Aside from Davidson, Ernst Haas, Eve Arnold and other Magnum photographers were present for a few weeks at a time, resulting in a wide variety of candid, off-set and behind the scenes shots of the stars and the rest of the film unit on location in Nevada in 1959-60, including director John Huston and scriptwriter Arthur Miller. (Eve Arnold probably spent the longest time on the picture and benefited from her longstanding friendship with Marilyn Monroe; her many striking photographs of the star are especially well known and highly valued, as this was the last film Marilyn completed before her death in 1962.)

The situation for most of the freelance stills photographers in the film industry is such that they can find themselves hired either as a unit photographer or to do specials. For example, the English photographer David Farrell was signed to do unit photography on the *Pink Panther* movies in the 1970s, but had previously done a location special on the Peter Brook film of *King Lear* in 1970. Here he had concentrated on getting shots of the star, Paul Scofield, while capturing the feel of the bleak, snow-bound settings in Northern Jutland (Denmark) where the film was being made.

Of course, there are obvious advantages for a well-known photographer to appear on the set with the understanding that he or she has a special brief for taking photographs. But there are drawbacks too. A photographer who is not a member of the film crew, no matter how famous, can feel even more of an outsider than the unit stills man and can encounter various problems in getting the photos he or she wishes. (Here again the experience of Cecil Beaton is instructive and will be discussed at greater length toward the end of this chapter.) For the fact remains that the main job in hand is always the shooting of the movie itself, and the taking of still photos can never be allowed to hinder or interfere with the progress of filming.

At the same time, the public's continuing interest in the movies and the movie stars means that the shooting of an important scene in a major film can be turned into a media

event. Press photographers can be invited to join the unit photographers on the set, perhaps on the very first day of shooting, as happened with *My Fair Lady* in 1963, or to meet the stars – Sean Connery with his latest female co-star and bed-mate – or, more recently, with Dustin Hoffman dressed as Dorothy Michaels for the 'fashion shoot' on *Tootsie* (1982).

Most often this would take place on a closed set, but occasionally a location scene could serve just as well – such as the famous uplifted skirt sequence staged with Marilyn Monroe above the Lexington Avenue subway in New York. Although it is rightly remembered as one of the most successful publicity stunts of all time, it was a genuine shoot of an important, if brief, scene for *The Seven Year Itch*. The most eye-catching moment, however, Marilyn's character revelling in the blast of cool air which lifts her skirt on a sultry summer evening, was virtually pre-programmed as the most striking image for selling the movie. As captured by the stills photographer this delightfully erotic shot served as the basis for the film's publicity campaign, including posters, bill-boards and giant size cut-outs. If one shot, of all these taken of her, could sum up her tremendous sex appeal in the 1950s, this one is it. (Aside from the one, best-known pose, a large number of other photos were taken of this same scene

By the early 1940s Frank Powolny, Fox's leading stills photographer was making use of a smaller, more flexible camera (as already noted on p.125). Here we see him in action with his favourite Speed-Graphic photographing Gene Tierney from an unusual high angle — around the time that she was starring in *The Razor's Edge* (1946). The unknown photographer who took this shot even managed to turn it into a nicely composed photo on its own.

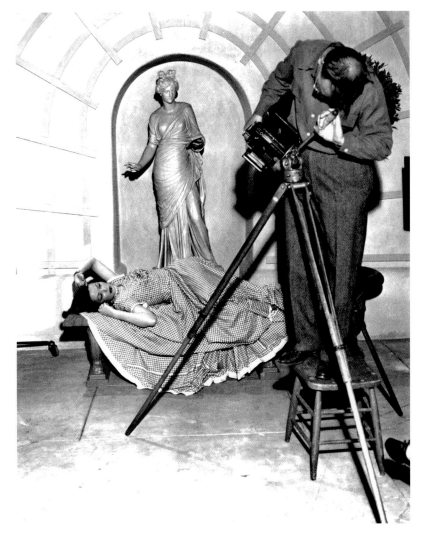

A genuinely candid Hollywood shot caught by a 20th Century-Fox photographer at the première of *The Snows of Kilimanjaro* in 1952 – when actress Dawn Addams, soon to be cast in a small role in Fox's *The Robe*, suddenly fainted outside Grauman's Chinese Theatre.

by the many magazine and press photographers present, along with a thousand or so onlookers including her husband at the time, Joe DiMaggio, who left in a huff quite early on: see pages 204 - 205).

Sadly, the 1950s stands as the last decade of high standard stills, and during the 1980s and 1990s there was a marked decline in the quality of the black-and-white prints sent out by the film companies, reflecting the wish to cut costs, or the use of poor dupe negatives or of printing from colour rather than black-and-white originals which produces less good results. Digital distribution of images has now all but replaced the traditional method of sending out prints, but the compression software used to reduce images to a manageable size means that the results often appear as compromised as their soft and grainy forebears.

And occasionally the distribution company has simply made a poor choice of stills to print up for use in publicizing the film. Perhaps the important task of selecting the photos has been entrusted to some young or inexperienced member of the publicity department who has made the choice quickly and badly, selecting photos which represent particular scenes or stars and not for their quality as photos, thus failing to do justice to the film and reflecting badly on the stills photographer.

Since the main stills tradition has been closely identified with black-and-white photography on large-size negatives – especially 8 x 10 or 4 x 5, and occasionally 2 1/4" square (see page 194) – the changeover to colour filming in the 1960s and a greater demand for colour material by magazines and newspapers has led to a widespread adoption of 35mm equipment by the stills photographers as most suitable for both black-and-white and colour. Thus, Ralph Nelson Jr. (son of the late movie director) described the equipment he uses in the book *Working in Hollywood*. Aside from two Polaroid 5X-70s which he depends on for the continuity stills, used only for reference purposes, most of his photos are

shot on 35mm. He alternates between a Leica Range Finder and the Canon single-lens reflex, while his thirty-odd lenses range from 15mm to 300mm, many of them duplicates so he can shoot colour and black-and-white simultaneously. He also uses a camera 'blimp' – a sound-proof casing which allows him to work silently on the film set without distracting anyone. When asked to supply portraits as well, he takes advantage of the opportunity to make use of the larger format camera, either 8 x 10 or a Mamiya medium format 6 x 8.

Clearly, the general quality of the film stills has become much more unpredictable ever since the early 1960s when the main tradition of Hollywood studio stills photography was reaching an end. The cutback in film production by the leading companies and in their contract personnel meant that many of the leading photographers retired or gave up doing film work around this time. No longer given the option (or required) to work their way up within a studio stills department, newcomers now sought work on a largely freelance basis. And the work was not getting any easier. Not only was the photographer expected to take photos in both colour and black-and-white, but the work conditions varied tremendously from film to film. Even if the producer and director recognize the value of good quality stills, the photographer needs the co-operation of many others actually involved in the making of the film in order to carry out his job most effectively. The attitude of the first and second assistant directors, for example, may well be crucial as they play such an important role in organizing the shooting of the film on the set or on location. And of course the stars too must be helpful and make themselves available – hopefully recognizing that good quality portraits and stills will be of benefit to their career, if widely circulated and published. But they can, however, make life difficult for the photographer. In his obituary for the actor Geoffrey Kendal, director James Ivory tells an amusing story of how, during the filming of *Shakespeare Wallah* in 1964 '... Kendal chased the stills photographer all around the set, threatening to smash his camera, because he had dared to take a picture of him while he was cat-napping.'

On a technical level, the faster modern film stock means that light levels on the set are often reduced to the point where this has become a major problem for the taking of stills, as Daniel Meadows has pointed out in his book, *Set Pieces*. He further notes that it continues to be the case today (as it has always been) that the stills photographer must work hard to get the job done: 'If you want to shoot stills these days you have got to learn to do it around everyone else and in spite of everyone else, and only intervene to beg a setup when all else has failed'.

The most common complaint among the photographers is that their job is unappreciated and made especially difficult due to the pressures of time and an unsympathetic attitude on the part of the film crew. Budget economies often mean that producers try to spend as little as possible on stills. Yet this is a false economy which may lead to problems in publicizing the film when it is released. Quality stills can easily be justified on purely commercial grounds alone, and this has nothing to do with the actual

size of the film. In fact, a low budget picture can benefit disproportionately: if there are lots of dramatic and interesting stills, this may help to gain a larger slice of coverage and more free publicity, aside from the fact that the stills can always make the film appear more appealing and interesting than it actually is.

Photographers today are forced to concentrate on the most exploitable aspects of the production. Of course, elaborate and imaginative sets and costumes, and picturesque locations, provide greater opportunities for the photographer than obtain on a cheap production. But it is also important for him to be given an opportunity to take portrait and poster shots in addition to the scene stills. But this requires the co-operation of the stars as well as special provision in the film's budget and shooting schedule.

In retrospect it is not really surprising to discover that the general stills quality deteriorated in the 1960s, since there were many problems experienced by the film industry during these years. It was a difficult decade when many veteran film-makers were coming to the end of their careers, and the decline in the quality of their films was often matched by a falling off in the standard of the stills. Perhaps the older directors were used to the responsibility for stills being taken by the film companies, and they had little interest in taking this on themselves. And there is a sense here that the stills serve as a sensitive indicator of the (decline in) quality of production generally.

In the case of Alfred Hitchcock, for example, the standard of stills from his films of the 1950s is so high that one can easily detect a falling off in the early 1960s from *Psycho* and *The Birds* to *Marnie* (filmed in 1963). And by the time of *Torn Curtain* (1966) and *Topaz* (1969), Hitchcock's decline as a film-maker is reflected not only in the films but in the poor stills too.

The films of the 1960s ranged from glossy-looking comedies in colour, at one extreme, to low-keyed dramas and thrillers filmed in black-and-white, neither of which was well represented by the stills of the period. And the newer, younger generation of directors were not well served by the stills photographers either. Or rather, the quality of the stills could vary widely from film to film. In the case of Arthur Penn, for example, the standards were far higher for the mainstream (Warner Bros.) productions such as *The Miracle Worker* (1963) and *Bonnie and Clyde* (1967) in contrast to his independent, low-keyed productions of the period – *Mickey One* (1965) and *The Chase* (1965).

Similarly, with Stanley Kubrick there is a good selection of stills from *Lolita* and *Dr Strangelove* in the early 1960s, but by the time of *2001* the still photos are less interesting: shots of astronauts or scientists in space-suits and space ships, while no photos at all appear to have been taken of the ape sequence prologue. Kubrick was proud of what he had accomplished here, but a bit disappointed at the lack of recognition, in contrast to the far more widely publicized *Planet of the Apes* around the same time. It is, of course, quite possible that the failure to have any stills made may have contributed to this neglect, an example of how the taking of still photos and their widespread publication can draw attention to aspects of a film which might otherwise

be neglected. According to John Jay, the unit stills photographer assigned to *2001*, Kubrick became so annoyed by the click of the stills camera on the set that he had the carpenter build a kind of mobile, sound-proof box in which to enclose the stills man. (An echo here of the kind of cubicle used to enclose the noisy camera and cameraman in the early years of the sound era, and similarly, it was stiflingly hot inside.) When a fan was installed in the box, this then made too much noise. The end result was that, in spite of the long period of over a year that the film was in production, in six months Jay was never able to shoot more than a relatively small number of usable still photos.

Clearly, the publicity for *2001* could have benefited from imaginative sets of poster or collage stills to supplement the dull scene stills. But Kubrick, functioning as producer and director, does not appear to have been much interested, in spite of the fact that he himself had once worked as a professional photographer and had taken photos himself on some of his early films. And he became even less interested in having stills made on his subsequent films, dispensing almost entirely with the services of a unit stills photographer. (Wishing to maintain complete control over the images relating to his films, he preferred to make use of grainy frame enlargements which he felt more accurately showed the scenes exactly as seen in the film, in spite of their inferior quality as stills.)

To conclude this chapter it is useful to compare the experiences of two different photographers, on *My Fair Lady* in 1963 and the *Pink Panther* movies in the mid-1970s. These latter, written, produced and directed by Blake Edwards, were among the most popular and successful independent productions of the decade, co-produced and distributed by United Artists. The experience of English photographer David Farrell on these films suggest that it is still possible, during the 'post-studio era', for the stills man to be taken on for the entire production period and given the opportunity to take a wide range of photos.

In fact, Farrell had first met the star, Peter Sellers, a few years earlier while on location in North Africa for the Moustapha Akkad movie *Mohammed, Messenger of God*. Sellers was on holiday and had visited the set with his current girlfriend. A photography enthusiast himself, Sellers had brought with him his latest acquisition, a new slimline Polaroid camera which had just come on the market. Farrell was able to spend some time with the star, sharing his ideas on photography, and even took a few photos of Sellers with the new camera as well.

When Sellers, who had the final say on selection of the stills photographer, decided that he did not like the stills man who had worked on the first of the new *Pink Panther* movies, *The Return of the Pink Panther* (1975), and David Farrell's name was mentioned as a replacement, he readily agreed.

Farrell's success on *The Pink Panther Strikes Again* (1976) and *Revenge of the Pink Panther* which followed depended on his maintaining a good working relationship with the film's star. In fact, he spent about three months on each of these films, beginning a few weeks before the start of the actual shooting, by making reference stills on the sets

David Farrell's camera has caught a spontaneous reaction from Peter Sellers, dressed in a Toulouse-Lautrec disguise, when a stunt has gone slightly wrong. In one of the early scenes in *Revenge of the Pink Panther* (1978) a trick bomb that has exploded has produced too much smoke. Note the camera positioned on the left and the assistant in the right background just rushing over to make some adjustments on the set before the next take.

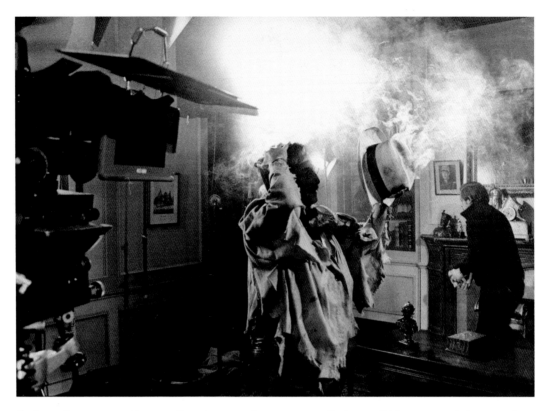

for the art department, and he was still on the movie after filming was completed, selecting and sorting through photos with the unit publicist on the film.

As with most modern films, shooting combined location and studio filming – this latter was especially important since the kind of comical or violent physical gags often involved unusual stunts and camera angles and the destruction of walls, ceilings or furniture, requiring the kind of control only possible on studio-built sets. Since these action scenes called for a lot of careful preparation and rehearsal with props and special effects, Farrell was able to take advantage of the many interesting photo opportunities which presented themselves. In fact, he was generally encouraged to take many behind-the-scenes shots showing stunts being prepared and executed, and occasionally going wrong, in addition to the usual scene stills. Such photos were rightly considered to be useful in publicizing these films. For example, a large selection from *Revenge of the Pink Panther* were featured in a special *Pink Panther* issue of the *American Cinematographer* magazine in July 1978 and in the paperback version of the script published at the same time. Aside from showing some of the stunts, action sequences and picturesque locations, these photos also reflect the star Peter Sellers' enjoyment at dressing up and posing for photos in a variety of funny costumes – as a hunchback, a Mafia godfather or Toulouse-Lautrec. But, like most stars, he could be difficult to handle if he did not feel in the mood to pose for photos.

In contrast to Farrell's experience on the *Pink Panther* films, *My Fair Lady* in 1963 represented a rare 1960s example of a lavish and totally studio-bound production. Yet here the stills photographer's job was not made any

easier at all. One would have expected that on such an expensive film, an effort would be made to accommodate the photographers and make sure that the best possible stills would be made to help in publicizing the film. Not at all. In contrast to the informality on set which had allowed Farrell to function so well, there was a lot of tension on the set throughout the filming of *My Fair Lady* on the Warner Bros. sound stages. As Cecil Beaton cynically noted at one point in his detailed diary of the making of the film, 'Of course [still] photographs are not even an important detail of a $17 million project', while unit photographer Mel Traxel was of the opinion that 'conditions were much less favourable than on any other picture he ever worked'.

As an expert on the Edwardian era who had been responsible for the costumes of the original show, Beaton was hired by producer Jack Warner to do the costumes, collaborate on the set design, hair styles, make-up and other aspects of the film as well as to take still photos in black-and-white and colour. Thus, he was present during much of the filming in various capacities. (Though it is not unusual for a well-known photographer to be hired to take photos on a major film, for him to be involved in other ways, too, is quite rare.)

As Beaton noted quite early on in his diary, his attempts to take photographs on the set led to friction with the director, George Cukor, even before the shooting of the film had begun. And whereas the two men had started out friends, the strains which developed between them while working on this picture, led to a permanent rift that would never be repaired. Unfortunately, it appears that little or no provision was made in advance to take account of the unique position that Beaton would occupy during the shooting. A director, such as Cukor, was generally under

tremendous pressure when making a major feature film, while the taking of still photographs was regarded as subsidiary to the main task of completing the film. But in this case it could be argued that Beaton's taking of photos was also an important creative activity in its own right and should have been allowed for in the shooting schedule.

A continuing theme which runs through the diary concerns Beaton's efforts to take the kind of photographs he wished without upsetting the director or interfering with the progress of filming in any way. Yet he was eager to make a photographic record of many aspects of the production, including many of his own special contributions in particular. As he expressed it,

It is only natural that I should wish to record, in my own way, the work that I have done, particularly upon the exquisite leading lady for every infinitesimal detail of whose appearance I am responsible.

As is the usual practice on a feature film, the wardrobe tests took place many weeks before the beginning of filming when the stills photographers are required to make reference shots of all the costumes. Beaton, too, was on hand and took some photos of Audrey Hepburn with his Rolleiflex. But he was furious when he was asked not to take any more shots of Audrey during her tests 'as it made Mr Cukor nervous'. This was especially unfortunate, and unexpected, since, on many films, the pre-production period provides the best opportunity to take photographs without interfering with the filming. A few weeks later Beaton noted in his diary that 64 photographers, from all over the world, were invited onto the set to record the first shot of the first scene – 13 August 1963.

Beaton was, of course, sympathetic to the problems experienced by the two unit stills men Bob Willoughby and Mel Traxel.

It is a long and soul-destroying assignment. They are not allowed to photograph during rehearsals, and for most of the time try to hide themselves in dark corners. 'I wear this black suit,' Mel continued, 'just not to be seen; of course, if I were invisible, it would make my job easier, but it's been an uphill struggle just to get the most ordinary shots, let alone anything interesting!'

Beaton concluded his remarks by noting that,

If conditions are hard for these acceptable photographers, imagine the courage it takes to brazen out my presence when I appear wearing flamboyantly light-coloured clothes and a planter's straw hat, with my Rolleiflex in my hand and my pockets bulging with film.

The major problem for Beaton continued to be the unavailability of the two stars during most of the filming, though he kept himself in readiness for any other chances

that might come his way. Thus, he notes at one point that he was allowed on the set: 'Even though the principals were not on hand, the extras provided me with many opportunities for interesting compositions ...'. Similarly, he was allowed to take photos in the gallery with three models and was provided with lighting assistants, too. However, these men were used to working on the usual, brightly-lit and sharply-focused, but generally uninteresting type of movie still. The electricians kept adding fill-in lights to obliterate the shadows, and it was difficult for Beaton to get them to accept his methods which involved a blend of light and shadow to achieve a more artistic result.

Finally, at a relatively late stage in the filming Beaton got permission to take photographs on the embassy staircase set under the same conditions as the other stills men. There was a great deal of tension during the rehearsal which, as he noted, had nothing to do with the stills photography, and quite revealingly concluded that,

I feel like a trespasser on the sets that I have designed. When the scene had been shot six times the 'still' men were given only a few seconds in which to register the past event.

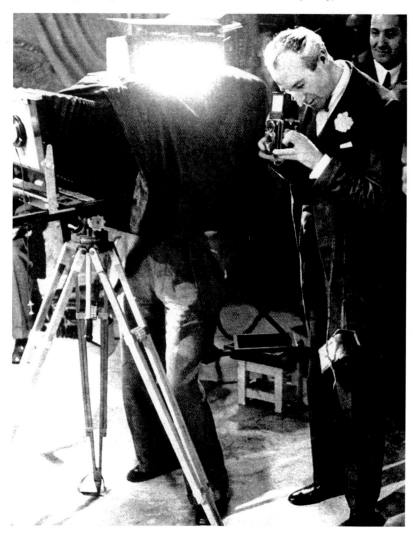

Sixteen years before *My Fair Lady*, Cecil Beaton was hired by the producer-director Alexander Korda to collaborate on the set and costume designs for his production of Oscar Wilde's *An Ideal Husband*. And he naturally brought his camera with him on the movie set. Here we see him in action with his favourite Rolleiflex, while the official stills photographer beside him is still operating a large plate camera on a tripod with only his legs to be seen. (Photo credited to George Konig.)

Though Audrey Hepburn was a delightful and willing subject for Beaton's camera, she was rarely available since she was required for filming on virtually every day of the shooting schedule, and Beaton had been refused permission to take pictures of her during the breaks in filming or during rehearsals. In addition, she was aware of the frictions which had developed between him and the director and was concerned not to upset Cukor, while Rex Harrison was just plain difficult.

It was only after a month of filming had gone by that Beaton was given his first photo session with Hepburn. He was tremendously pleased, as he recorded in his diary, 'Today [10 September] she was through her scenes early, so was able to give me twenty precious, long-awaited minutes...' In the gallery she not only donned her own costumes, but also posed in some of the most striking outfits and Ascot hats that Beaton had designed for the many extras. However, Beaton never gave up visiting the sets, and occasionally his persistence was rewarded. Thus, at one point during the filming of the ballroom scene,

'Audrey was very friendly and, daring displeasure from higher quarters, even looked into my camera lens from the vantage point of her chair rest.' He was less successful, of course, with the temperamental Harrison. Since film stars, ever since the 1960s, have generally been signed up for a single film, (and are not under contract to a studio), there is little that the publicity department can do if a star is uncooperative. Beaton was only able to arrange one brief session with Harrison during the main filming period when he was able to snatch a few shots: as he noted, 'luck was on my side; I caught Rex at the right moment. In ten minutes we took a remarkable number of pictures of the old boy, and he was delighted' – before giving a weak excuse to cut the session short and hurry back to the set. Then on the following day, 2 October, Beaton had his only opportunity to photograph both of the stars. But Harrison proved so awkward about posing with Miss Hepburn that Beaton never did manage to get any good shots of the two of them together.

It was late in November, toward the end of filming, and

Cecil Beaton in a pensive mood, flanked by one of his costume designs for *My Fair Lady*.

of Beaton's involvement in the production, that he had his only full photo session with the elusive Harrison, which had proved impossible to arrange previously. As Beaton noted, 'Rex finally submitted to being photographed, yet for weeks the publicity department had tried in vain to make appointments.' Apparently Harrison felt more able to relax in front of the stills camera once filming was completed – yet another example of how much the work of the photographer depends on the good-will of the stars, some of whom find it more difficult to pose for stills than to act for the movie camera.

Even allowing for some exaggeration on Beaton's part, his diary provides a fascinating insight into the job of movie stills photography, and the problems experienced by him were not all that different from those encountered by the unit stills men on the film. One can only imagine their problems, having to 'work around him' as it were. What they had in common was that their activities were considered marginal to the main task of film-making. Watchful and observant when they were allowed on set, which was not often, and ready to take advantage of photo opportunities whenever they presented themselves, they were equally ready to fade into the background when their presence was not welcomed.

Finally, one is left with an impression of the absurd situation that existed on the film, of such a famous and distinguished photographer as Cecil Beaton, banned from the sets he helped to design and having to resort to a variety of strategies and subterfuges to get the photos he had been hired by the producers to take.

Unfortunately, the experience of Beaton and the other photographers on *My Fair Lady*, rather than that of David Farrell on the *Pink Panther* films, may be more typical of the problems experienced by stills men in recent years when the contribution they make is apt to be undervalued and underappreciated. If this book appears to end on a downbeat note, this is perhaps inevitable. As the great tradition of movie stills photography recedes further into the past, and is unlikely to be revived in the future, one can only pay tribute to the photographers who made it happen, many of them unknown or forgotten today. By giving recognition to the major contribution made by the stills photographers, it is hoped that this book may contribute to a better understanding and recognition of the role that the photographers continue to play today and a much needed upgrading of their position on today's films.

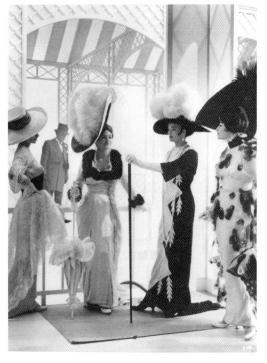

Some of the many fashion photos supplied by the film studio as publicity for the film of *My Fair Lady*.

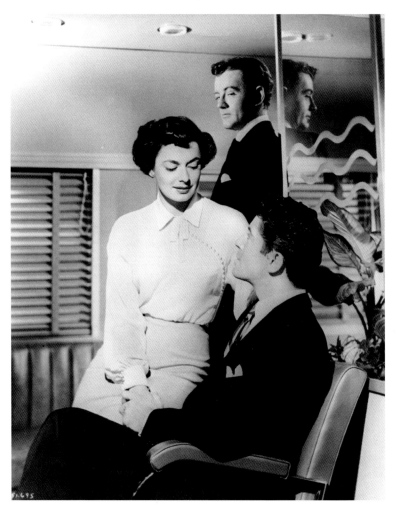

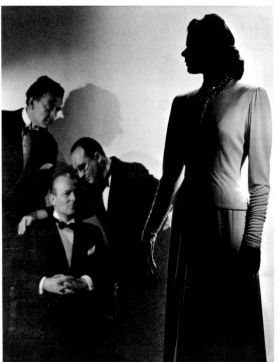

The thriller or film noir often inspired the photographers to come up with imaginative photo ideas, especially for the films of Alfred Hitchcock, the 'master of suspense'.

For example, Gaston Longet's poster photo of Ingrid Bergman in *Notorious* (left) suggests the atmosphere of paranoia and fear in the house where she is kept prisoner and is being slowly poisoned, here observed by a group of her husband's slightly sinister associates.

In *Strangers on a Train* (1951), Ruth Roman and Farley Granger are the happy couple menaced by the suave-looking Robert Walker. In this posed scene (above), unlike anything seen in the film, the mirror image draws attention to Walker's two-faced quality – seemingly friendly and witty, but with nasty psychotic qualities hidden beneath the surface.

Of course, Hitchcock himself often appears prominently in the stills, posters and other publicity material for his films – such as this jokey face in a crystal ball from *Family Plot* (1976), his last movie (above left).

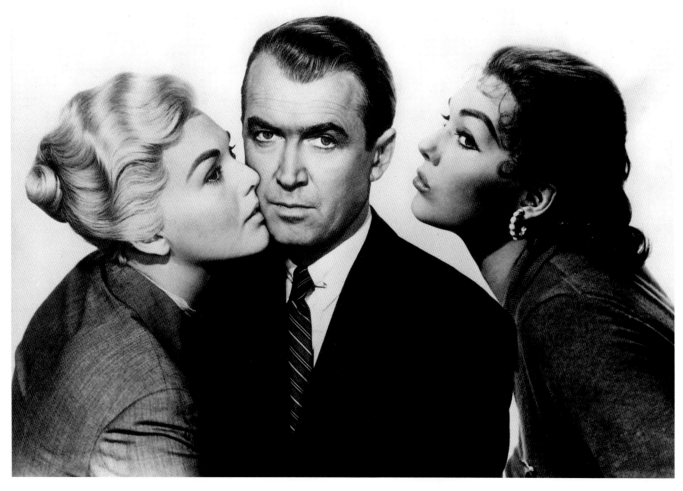

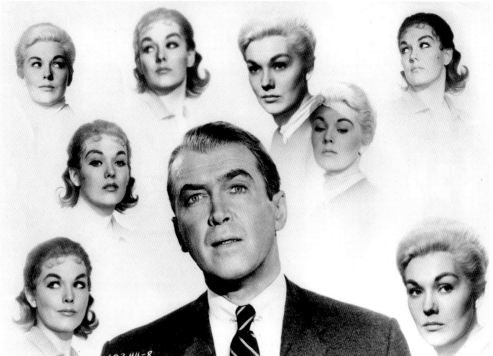

The James Stewart character in *Vertigo* is haunted by the image of one woman, or is it two women?, both played by Kim Novak. The publicity still showing him between them could deceive many movie-goers into thinking that there really are two different ladies who just happen to look very much alike – the kind of trick which would appeal to Hitchcock with his offbeat sense of humour.

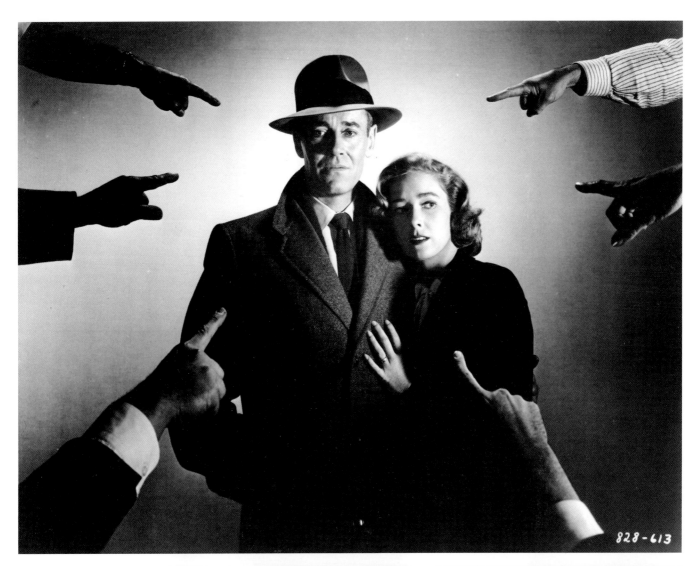

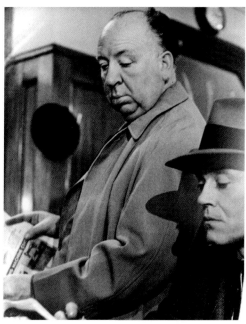

The happy marriage of Henry Fonda and Vera Miles in *The Wrong Man* (1956) is threatened by a total stranger. Here and on the facing page, a series of poster art representations show the falsely accused hero and his frightened, insecure wife, an ordinary couple caught up in a nightmarish situation. Making use of a simple but striking, graphic style, the image above in particular reinforces the sense of the hero as a kind of Kafkaesque victim, forced to appear in a police line-up and to re-enact the events of his alleged crimes, a bland every-man, an anonymous face in the crowd whose very ordinariness and lack of distinguishing characteristics cause him to be mistaken for the real criminal. The still (left) showing Hitchcock with Fonda at the opening of the film proves that he did shoot one of his familiar cameos, though he later cut it as unsuitable for inclusion in such a downbeat film based on a true story. (He decided to appear in a brief spoken prologue instead.)

When the film companies turned to new technical gimmicks to help halt the decline in movie audiences in the early 1950s, the stills photographers were naturally expected to play their part and come up with new photo ideas for publicizing the new technology. Photo montage or collage effects appear to have been most popular at the time. For example, this well-known still for *This is Cinerama* (right) suggests that, as the caption says, 'audiences are brought right into the onscreen action' with the thrilling filmed version of a roller coaster ride. Taking advantage of the exploitation nature of many of the 3-D subjects, the photographers (and copy writers) had some fun with the idea of audiences being attacked, assaulted, bombarded or frightened by people or objects coming at them from the screen. A typical 1953 example here: Van Heflin and Julie Adams in action in *Wings of the Hawk* (below).

However, a more tasteful example of simulating the 3-D experience was devised for the Rita Hayworth version of *Miss Sadie Thompson* (or *Rain*) and shows how well a collage effect could convey a three dimensional quality. It is interesting, for comparison to see a still of the original scene of Rita entertaining the troops and discover how naturally the composition lends itself to being adapted in this way.

MISS SADIE THOMPSON, (RITA HAYWORTH) NIGHTCLUB SINGER FROM HONOLULU HOT-SPOTS, is stranded on a tropical island when her ship is quarantined. The women-hungry Marines stationed on the island led by Sergeant Phil O'Hara (ALDO RAY) welcome Sadie and the island rings with revelry. Wealthy plantation owner, Davidson (JOSE FERRER), a fanatical reformer knowing Sadie's reputation, becomes incensed at her behavior and begins a personal vendetta against her, accusing her of being sinful and promiscuous, a charge which Sadie angrily denies. She falls in love with O'Hara who wants to marry her. The conflicting emotions which follow make the story of "Miss Sadie Thompson" one of the all-time greats of modern romantic fiction.
(Use this space for local theatre imprint and playdate.)

In recognition of the new status of the leading directors in the 1950s, the stills men were encouraged to photograph them at work with their actors and take advantage of the many photo opportunities which presented themselves during the course of a production and especially during rehearsals on the set. Of course, some directors were more interesting subjects for the camera, liked being photographed and generally encouraged this more than others. Since the director and stars could be very involved in working out the details of a particular scene and even forget about the presence of the photographer lurking nearby, these photos often have a genuinely spontaneous or candid feel to them. Aside from their amusing or entertaining qualities or interest as photos of famous personalities, these shots could provide a unique photographic record of the film-makers at work, serving to document important aspects of the creative process. In general, this type of photo became more readily available in the 1950s than ever before, quite different in style from the typical shot of the director posed with his stars of earlier years.

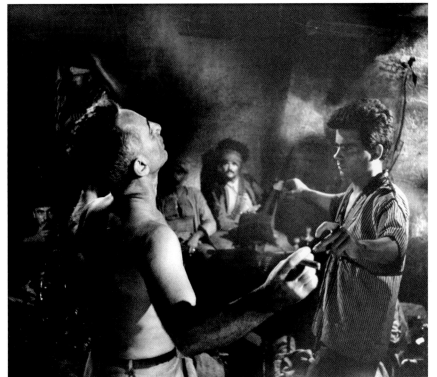

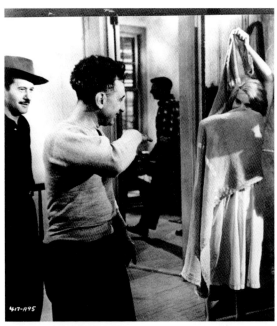

These pages show director Elia Kazan at work during the 1950s and early 1960s. He was especially known for his close working relationship with his young actors. A former actor himself, Kazan would often develop an intense and close rapport on the set, as reflected in his remarkable collaboration with the young Marion Brando on *A Streetcar Named Desire* (below) or the youthful Stathis Giallelis. He played the role of Kazan's own uncle as a young man, struggling to make it to the United States as an immigrant in the late 19th century in *America, America* (1963) based on Kazan's story and script (facing page bottom).

Facing page top: Kazan demonstrating a dance for Barbara Loden in *Splendour in the Grass* (1961). Kazan can be seen at the extreme right of the second still observing how the actors are following his instructions.

Left: Kazan directing Eli Wallach and Carroll Baker in *Baby Doll*.

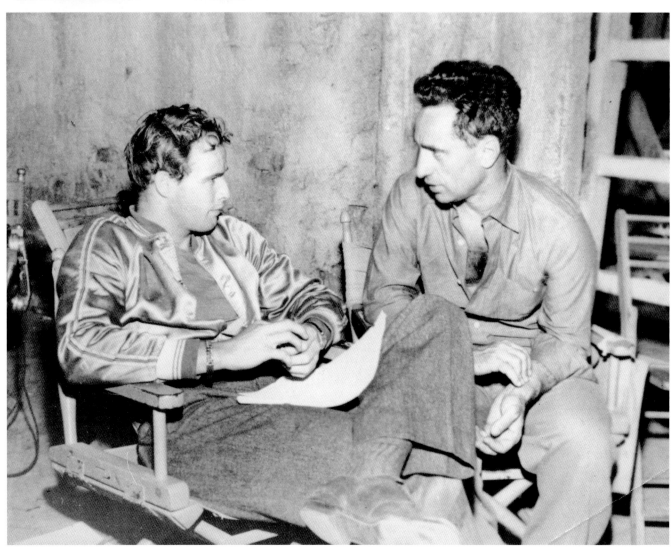

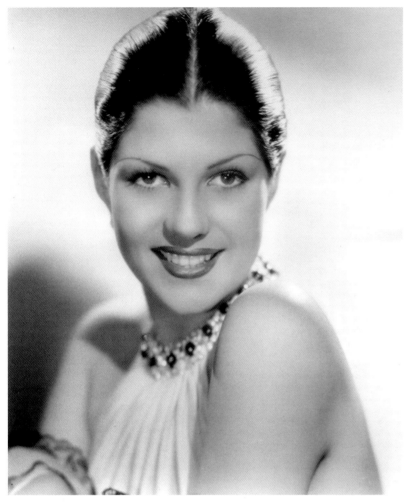

RITA CANSINO 20th CENTURY FOX PLAYER

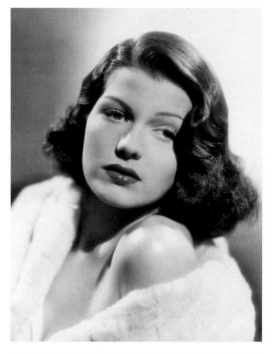

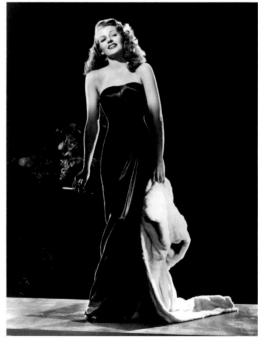

Though it could not match the peak studio years of the 1930s, the tradition of Hollywood glamour photography continued strongly in the 1940s and helped advance the careers of a number of attractive new stars in particular. Perhaps most remarkable of all was the gradual transformation and maturing of Rita Hayworth at the small Columbia studio. She had formerly been under contract at Fox as long ago as 1935 under her real name, Rita Cansino, with a very Spanish-looking appearance to match (above). A nose job and painful electrolysis to lift her hairline, with other touches to face and hair served to eradicate all trace of her ethnic background and transform her into the ultimate all-American girl and a favourite war-time pin-up of the GIs, much photographed at the time and seen here (above right) in *The Lady in Question* (1940) and finally as the sophisticated and alluring *Gilda* (right) in 1945. In fact, this classic still image comes from a film which is quite remarkable in its own right. Her perfectly formed, mask-like face and white shoulders gleam out of a simple black strapless gown by Jean Louis. She is a modern American version of the *femme fatale*, more like a statue on a pedestal than a real woman, with fur stole in one hand and a lighted cigarette in the other – producing the only spontaneous element in the photo – a swirling puff of smoke outlined against the dark background, to complete the picture.

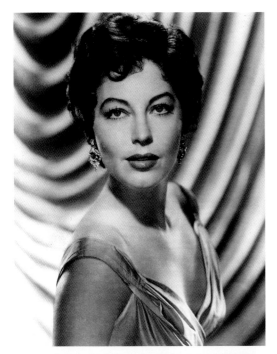

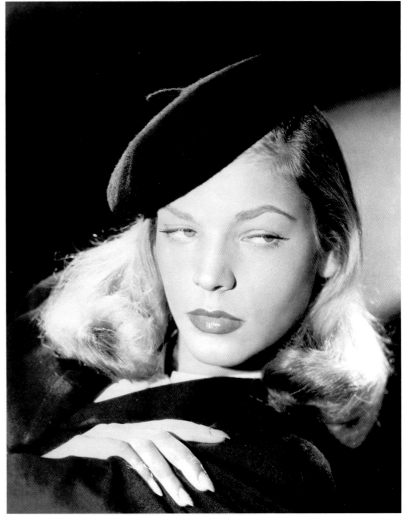

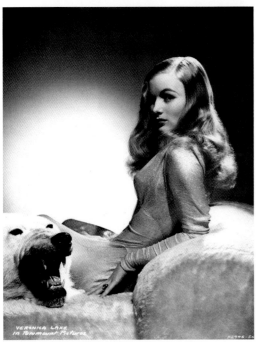

A number of new young stars benefited from being photographed extensively at the various studios. The petite Veronica Lake (far left) suddenly shot to stardom at Paramount in the early 1940s with her 'peek-a-boo' hair style, while Ava Gardner (above left) spent far more time being photographed than acting at MGM in the 1940s. Lauren Bacall (above), a former model, became an overnight sensation at Warner Bros, after starring opposite Humphrey Bogart in her very first movie, *To Have and Have Not* in 1944. Then too, there was a young Marilyn Monroe, just starting out as a model and bit part actress. This pin-up photo of her (left) in costume is actually a publicity still for her second movie, a cheap Columbia musical called *Ladies of the Chorus* (1948) in which she landed her first starring role. She was put under contract at Fox soon after and emerged as the studio's biggest star of the 1950s.

A tremendous number of photos were taken of Marilyn Monroe when she was filming this scene for *The Seven Year Itch* in New York City in 1954, and some of the photographers present recorded it as the photo event which it undoubtedly was, showing other photographers snapping away in the background. A few of the best scene stills were then selected at Fox to be turned into cut-outs and blown up into giant size images for use on cinema marquees and posters for advertising the film all over the world. Many of the still photos, such as those shown here, were far more sexy and provocative than the same scene in the final film – yet another notable example of the way in which the still image often takes on a life of its own and acquires a popularity and familiarity that goes far beyond the relatively brief and simple scene in the movie which originally sparked it off.

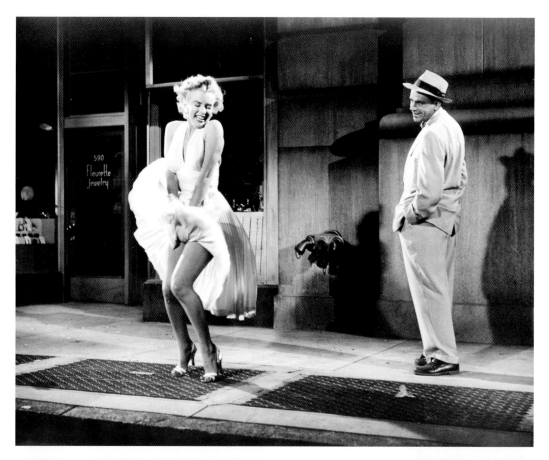

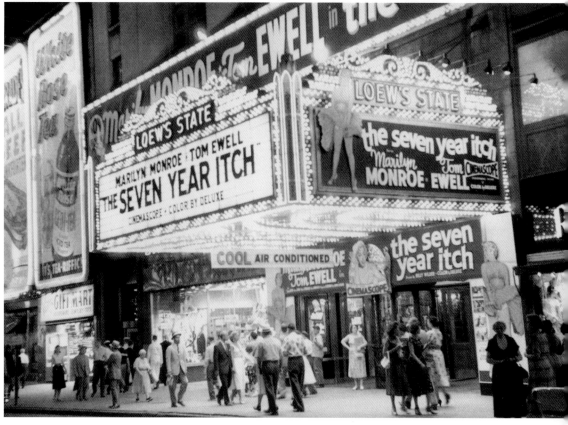

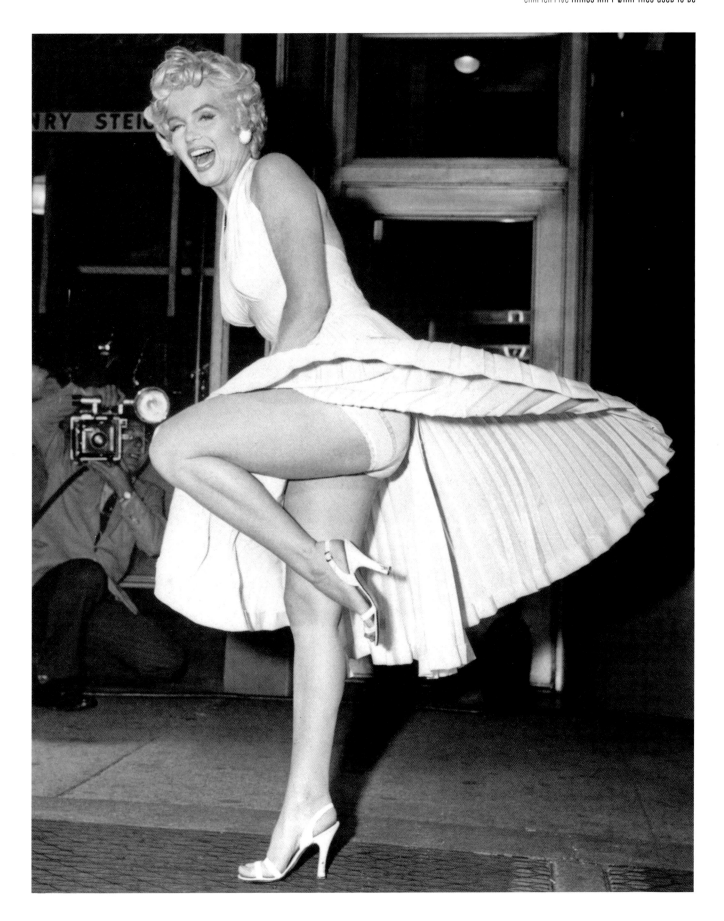

With the new emphasis on location filming during the post-war years which has continued ever since, there were many more opportunities for the stills photographer to take a variety of production shots. And with the presence of more than one photographer on special location shoots, it was more likely that one of the stills men would also be caught in shot with the rest of the film unit.

In addition to perfectly capturing the feel of the film unit at work on location, this still also reflects the boredom associated with much of the film-making process – lots of people spend a lot of time standing about, waiting for the camera to be put in postion, for the lights to be adjusted, for the director to finish rehearsing the cast, for the sun to come out, etc. At least the stills photographer can keep taking pictures like this one. The setting is small town America and the film is *The Goddess* (1958), written by Paddy Chayefsky. Kim Stanley is the star about to descend the stairs, while director John Cromwell gives her some last minute instructions.

By the mid-1950s American film companies were shooting many of their costume epics abroad, and especially in Europe. This photo gives some idea of the elaborate preparations which go into the filming of a large scale battle sequence. A rough-looking location in the Guadarrama Sierras in Spain has been selected for staging the battle of Cheronea for *Alexander the Great*, starring Richard Burton in 1955. Camera-man Robert Krasker, on the far left, is just preparing an elaborate tracking shot, while the camera crew and camera have already been positioned on a prepared surface in the centre of the picture along with an impressive array of arc lights. Everyone appears to be waiting for the sun to come out. A few actors in costume can be glimpsed among the technical crew. Director Robert Rossen and actor Stanley Baker, who plays General Attalus, are seated prominently on the right, while the 4 x 5 stills camera on its tripod in the right foreground is positioned, ready to take a photo of the action which will be taking place to the left of the picture. (This photo was taken by Swedish photographer Per Olow.)

Irving Lippman, a leading stills photographer at Columbia, joined the film unit on location at the secluded Hawaiian beach where one of the most memorable sequences in *From Here to Eternity* was filmed in 1953. He can be seen in the centre of this photo wearing a white tee shirt, outlined against the dark edge of the cliff just behind him, positioned discreetly in the background with his camera on its tripod aimed at director Fred Zinnemann (in white short-sleeve shirt) and his two stars. Lippman's widely reproduced photos of Burt Lancaster and Deborah Kerr embracing passionately on the beach, as they are engulfed by the sea, were originally banned and only the "dry" version, as shown here, was allowed by the censor.

The camera crew in the rigging of the *Pequod* during the filming of Moby Dick includes camera operator Arthur Ibbetson, lighting cameraman Ossie Morris (below left), a disgruntled looking director (John Huston wearing a flat cap and smoking a cigarette) and leading Elstree studio stills photographer George Higgins with his 5 x 4 Speed Graphic. It is important for the stills man to go where the movie camera goes and be accepted by the film unit, as is clearly the case here.

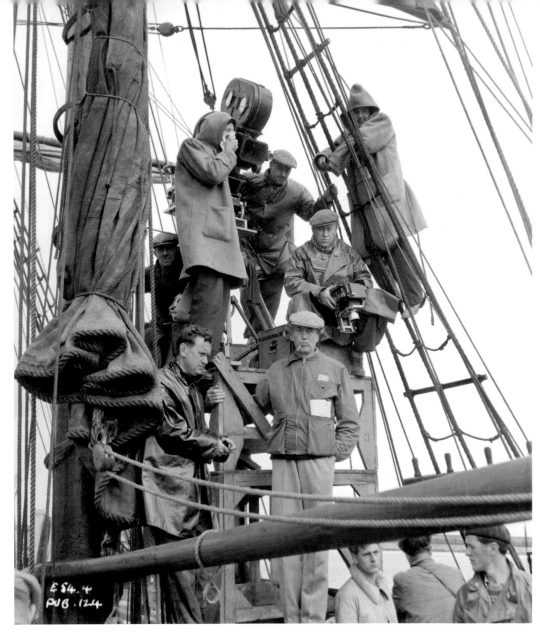

A photographer has been specially positioned high up on the set to get this superb view of the entire *Spartacus* film unit in action, while the main stills photographer (in the lower right corner) with a small, hand held camera, is intent on capturing the action from as close as possible. This dramatic duel takes place at the gladiator school relatively early in the film between Kirk Douglas and Woody Strode (who gets a bit of help with his net from a handy prop assistant positioned out of shot). Director Stanley Kubrick looks very relaxed observing the action, seated well back, wearing dark trousers, his head partly hidden. To his right is chief cameraman Russell Metty wearing a white shirt, no hat, while operator George Dye kneels beside the large Technirama camera.

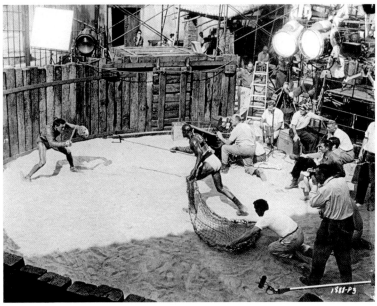

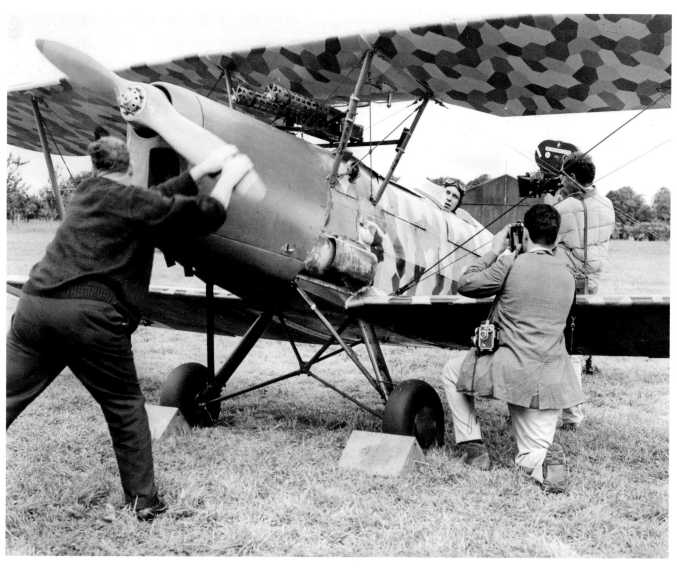

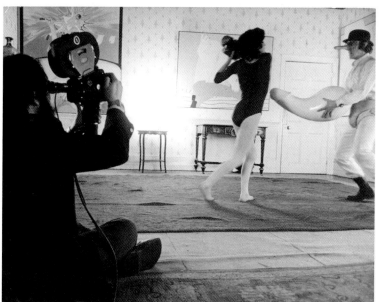

Above: An excellent example of how, under the most favourable conditions, the stills photographer may be allowed or even encouraged to work in partnership with the movie cameraman. Here he positions himself at a discreet distance from the star George Peppard, taking a shot with his Nikon, while the Rolleiflex hangs over his shoulder. (The cameraman is holding an Arriflex for hand-held filming). The film is *The Blue Max* (1966).

Left: In her recently published autobiography *Some Sort of Life*, Miriam Karlin has described the extraordinary sequence in *A Clockwork Orange* (1971) when Alex (Malcolm McDowell) tries to kill her with a giant phallus sculpture. As she recalls it, 'shooting this scene went on for hours in a fairly small room. Stanley ran around with a hand-held camera and we went on and on and improvised the entire thing, over and over... ' The surprise here, as the still shows, in a neatly composed composition, is that Kubrick functioned as his own cameraman. It looks more like the filming of a low cost, independent production than a mainstream high budget feature.

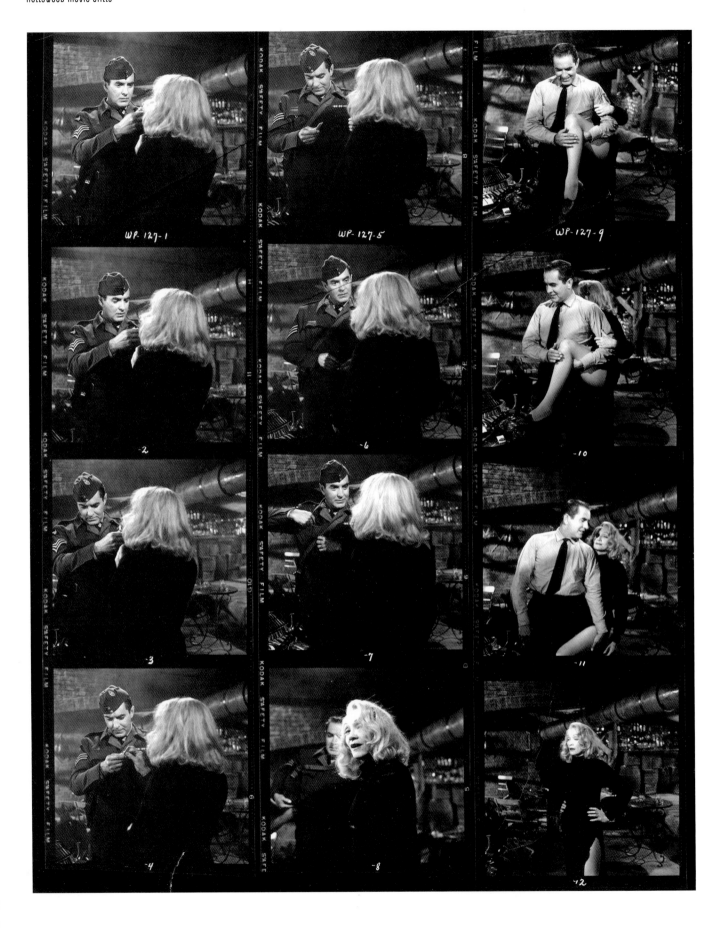

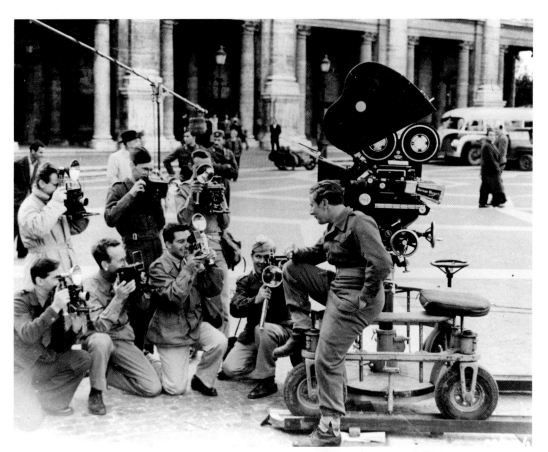

Peter Ustinov in uniform finds himself besieged by photographers, on location in Italy for his role as *Private Angelo* (1949), which he also produced, directed and co-scripted.

Below: Here an unidentified photographer tries to grab an informal shot of Tony Curtis and Janet Leigh with their baby daughter, Kelly, in 1957 around the time that they were signed up to co-star with Kirk Douglas in *The Vikings*.

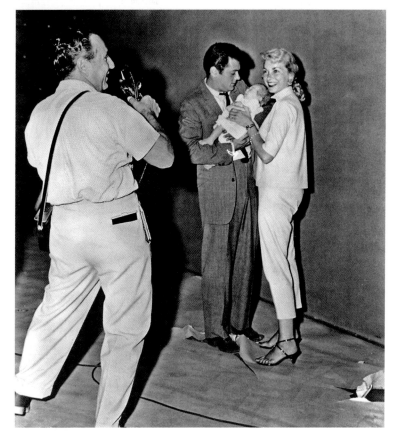

Facing page: A rare example here of one photographer's unmarked contact sheets from which publicity stills will be chosen. It depicts the crucial flash-back sequence in *Witness for the Prosecution* (1957) showing the first meeting and seduction scene between American GI Tyrone Power and the sexy German woman of dubious background played by Marlene Dietrich. (An obvious echo here of director Billy Wilder's earlier film, *A Foreign Affair*, also starring Marlene Dietrich in black-and-white.) (See photo on page 146.)

The contact sheet presents a numbered series of images beginning in the upper left-hand corner, the first of three columns. Power is seen here offering chewing gum and lighting her cigarette. Probably photographed during a rehearsal, the eight shot sequence ends as Dietrich turns to face the camera. Here we get a brief, candid and unglamourized view of her, very different from the more usual, carefully posed and lit photos of her, as seen, for example in number 12 (the last of the series, in the lower right corner.) In fact, the four images in the right hand column show the two stars clowning about during a break in filming later in the same scene when Power has removed his jacket.

The complete roll of 12 2^1/$_4$x 2^1/$_4$ inch (60mm x 60mm) images was taken with a twin reflex lens camera of a type which was popular during the 1950s. This was the kind of camera which produced high quality images which could easily be blown up to the standard 8 x 10 still size, but was more flexible and easy to handle than the larger earlier cameras.

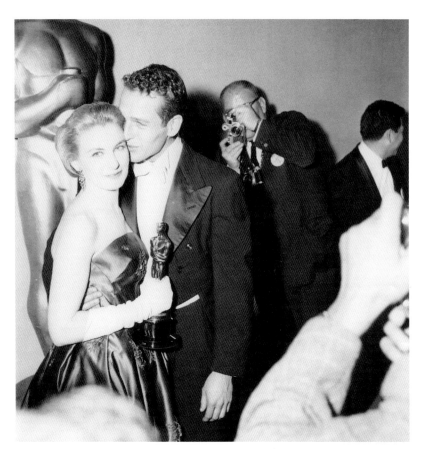

Oscar night always brings out the Hollywood photographers. Here Joanne Woodward is congratulated by her husband, Paul Newman, after winning the award for best actress for her performance in *The Three Faces of Eve* in 1957, while an unknown photographer snaps away in the background.
(Oscar image copyright AMPAS.)

Marilyn Monroe always loved to pose for photographers, both amateur and professional. Here she chats with a group of GI shutterbugs on a visit to Korea in the early 1950s.

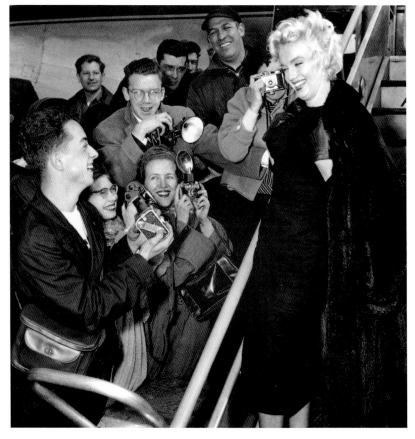

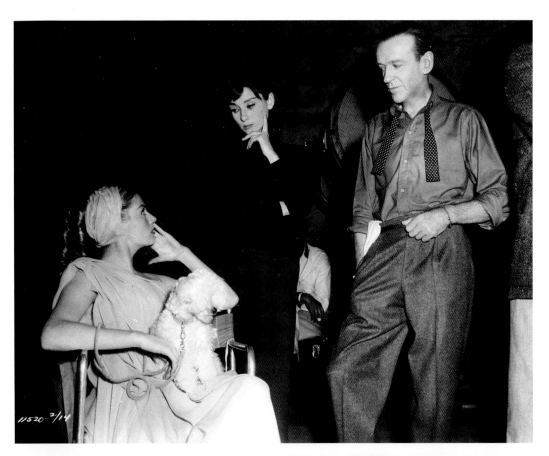

A popular type of behind-the-scene shot which became more familar in the 1950s and 1960s was the photo showing an informal visit to the set or location by family, friends or associates of the movie stars. These could look like star versions of family snapshots and often appear amusing or incongruous, with the actors in make-up or period costume, with their visitors in modern dress, while various props or bits of set or pieces of film equipment in the background often complete the picture.

Left: When Anita Ekberg visits Audrey Hepburn and Fred Astaire during a break in filming *Funny Face* in 1956, they pose awkwardly for the stills man.

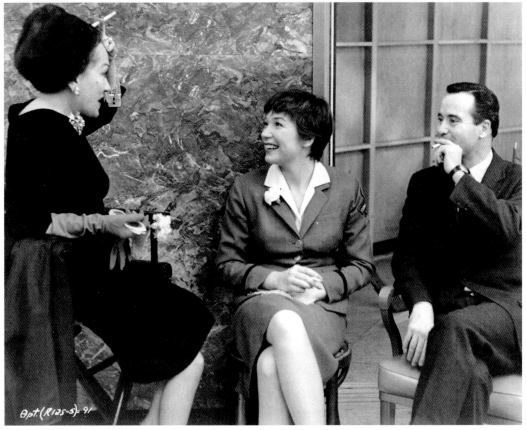

In a far more natural looking encounter, Gloria Swanson, who had previously starred for Billy Wilder in *Sunset Boulevard* (1950), chats with Shirley MacLaine and Jack Lemmon on the set of *The Apartment* (1960).

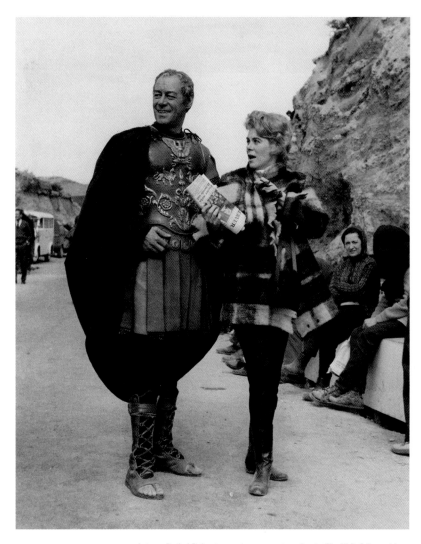

Actress Rachel Roberts carrying her *Observer* visits husband Rex Harrison, in costume for his role as Julius Caesar in *Cleopatra* on location in Almeria in south eastern Spain in March 1963 (above). He and Rachel Roberts had married during an early stage in the filming, many months before. But their personal life was overshadowed by the tremendous publicity given to the complicated marital and extra-marital relations of Elizabeth Taylor. Her husband, Eddie Fisher, had continued to visit the *Cleopatra* set (above right) in spite of her well publicized affair with co-star Richard Burton. She and Burton then appeared together in *The V.I.Ps* followed by *Becket* in which Burton was set to play the title role opposite Peter O'Toole. Liz became a regular, daily visitor to the set and was even given a labelled chair of her own (right). She, Burton and O'Toole did a lot of heavy drinking together and it was quite clear by this time, late in 1963, that her marriage to Eddie Fisher was finished. As with *Cleopatra*, the film company was happy to benefit from all the publicity surrounding their relationship, with the stills photographers encouraged to get lots of shots of the couple, of which this is a good example.

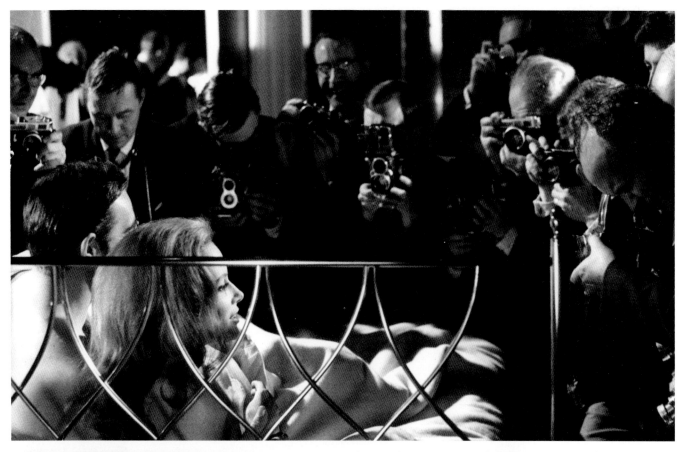

A standard publicity stunt for the James Bond films in the 1960s was for the press photographers to be invited onto the set at Pinewood studio to join with the stills photographer in taking shots of Sean Connery in bed with his latest female co-star. Here she is the Italian actress Luciana Paluzzi. The film is *Thunderball* (1965), and at this point in the movie she bites his shoulder provocatively and jokes about being frightened: 'This bed feels like a cage ... those bars ... do you think I'll be safe?' The widespread publication of such photos long before filming was completed would announce to the world that another, new James Bond film was on the way.

These photos were taken by David Farrell during the filming of *Revenge of the Pink Panther* in 1978.

Right: Producer-director-writer Blake Edwards adopts a reclining position on the floor as he devises a low angle shot for one of the comical stunt fights which take place between Inspector Clouseau (Peter Sellers) and his Chinese man-servant Cato. Sellers (right) and the technicians look rather bored, as if they are used to seeing Edwards clambering over the set or crawling on the floor as he plans out the next sequence to be filmed.

Below: Shooting on location on Kowloon Peninsula, across the harbour from Hong Kong Island, Sellers and Burt Kwouk speed along in a golf cart which is veering out of control, while stunt-man Malcolm Weaver completes a spectacular crash and leap as the stand-in for Kwouk.

APPENDIX
AN A TO Z OF MOVIE STILLS PHOTOGRAPHY

AMPAS
In the 1940s, the Academy of Motion Picture Arts and Sciences mounted an annual series of exhibitions of the best examples of Hollywood movie stills photography. Awards were presented to a number of leading photographers including Clarence Sinclair Bull and Ernest Bachrach (see page 152).

Bara, Theda (1885-1955)
Her sudden and spectacular rise to fame in 1914-5 presents a notable early example of the important role that still photography could play in creating the image of a new star (see pages 24 - 25).

Bull, Clarence Sinclair (1896-1979)
Garbo's favourite photographer in the 1930s, he headed the MGM stills department for over 20 years up to the 1950s (see page 41).

censorship (see X-certificate)
During the 1930s and 1940s in particular, Hollywood publicity stills, like the films themselves, were closely vetted by the newly-created Advertising Advisory Council, an offshoot of the Hays Office. There were

Hélène Chatelain in *La Jetée* (1962).

strict rules: no cleavage, navels or inside of thigh shots, for example, while male chest hair was generally airbrushed out (see pages 62 - 63).

DeMille, Cecil B. (1881-1959)
One of the first Hollywood directors to recognize the value of, and encourage the taking of, stills on his sets to publicize his movies. He employed a number of leading photographers for this purpose such as Karl Struss and Edward Curtiss in the silent era.

'eight by ten' (8 x 10)
The most common size of publicity photo or print sent out by the movie companies to publicize their pictures measured eight inches by ten inches.

Fraker, William A. 'Bud' (b. 1923-2010)
One of the few stills photographers who became a leading director of photography (in the late 1960s) and then a director, i.e. *Monte Walsh* (1970). He received his first screen credit on *The Pleasure of His Company* in 1961 for the photographs of the cast which appear behind the film's opening credit titles.

Freulich, Jack (1880-1936) and Roman (1898-1974)
These Polish-born brothers emigrated to the US with their family and became the leading stills photographers at Universal in the early 1920s. Jack headed the stills department for many years, up to 1935, while his younger brother Roman continued at Universal up to the mid-1940s when he was hired by Republic.

gallery
The small photographic studio located on the production lot of all the movie studios, mainly used for taking portraits and fashion shots of the stars.

Hurrell, George (1904-1992)
One of the most celebrated of the Hollywood portrait photographers during the golden age of the 1930s and 1940s (see page 50).

Intolerance (1916)
One of the most spectacular and memorable still

Davos Hanich in *La Jetée*, directed by Chris Marker (1963).

images of the silent era was the aerial view of the Babylon set taken by James G. Woodbury, D.W. Griffith's leading stills man at the time.

La Jetée (1962)

A remarkable short fiction film made up entirely of still photos, conceived and directed by Chris Marker in France in 1962.

'kill rights'

Leading stars often had the right to reject or 'kill' those portrait photographs of themselves which they disliked and did not want printed or used for publicity.

King Kong (1933)

For this film, which relied heavily on special effects, montage and double exposure techniques were used to create many memorable stills (see pages 148 - 149).

Louise, Ruth Harriet (1903-1940)

The most famous and successful woman photographer in Hollywood during the peak years – in a profession so dominated by men that the stills photographer was often referred to as the 'stills man'. She is best remembered as Garbo's favourite portrait photographer at MGM in the late 1920s.

My Fair Lady (1964)

The stills photography on this film included a special contribution from Cecil Beaton who published a diary on the making of this picture. His own experiences included a famous dispute with the director, George Cukor, over the taking of photographs on the set.

La Nuit Américaine (1973)

The leading character in this film, played by Jean-Pierre Léaud, dreams that, as a young boy, he had stolen movie stills of *Citizen Kane* from outside the cinema – as director François Truffaut had done in his youth.

The Outlaw (1943)

A series of provocative pin-up shots of a young Jane Russell in the hay and starring in her first movie launched her career as a Hollywood sex symbol in the early 1940s, though screening of the film itself was held up by a dispute with the Hays Office.

Powell, Michael (1905-1990)

Probably the most famous director who got his start in the movies as a unit stills photographer. He shot the stills on two Hitchcock pictures in the late 1920s, *Champagne* (1928) and *The Manxman* (1929).

production shot

A still photograph taken on the set or location during the course of filming, showing members of the cast, director and/or film unit at work.

Les Quatre Cents Coups (1959)

Antoine Doinel, the teenage hero and alter ego of director Francois Truffaut, plays hookey from school to go to the movies and pinches movie stills from the front of the cinema, as the director himself had done.

Richee, Eugene Robert (1896 - 1972)

The leading photographer at Paramount for many years, where he was also in charge of the main portrait gallery for a time and was responsible for some of the most memorable photos of the studio's stars ranging from the silent era (Clara Bow, Gloria Swanson) through to the 1930s (Marlene Dietrich, Gary Cooper, Carole Lombard and others).

scene stills

The most widely used type of publicity photo, these shots, taken on the set by the unit photographer, represent the various scenes in the movie more or less as they will be seen in the completed film. Sent out by the film companies in large numbers at the time of the picture's initial release, they used to be displayed prominently outside the cinemas to give the public a sample of what to expect inside. They also appear in books, newspapers and magazines to accompany reviews or articles about the movies.

still

This term for a movie photograph probably originated in the early days of the cinema before 'still photographs', and especially 'scene stills', were taken regularly on the film set. Thus, the 'still' or 'still image' was an individual frame selected from the film itself which was then enlarged and printed up as a photograph for use on a poster, for example. However, according to John Kobal, the long exposure time required by the early still cameras meant that everyone had to 'freeze' while a photo was being taken: hence the term 'still'.

The Trail of '98 (1928)

The remarkable location shots taken on this film (by James Manatt) reflect the kind of hardship endured by some of the early stills photographers with their bulky equipment as they struggled to get the photos they needed.

unit stills photographer

The person hired by the movie company to shoot publicity and reference stills during the course of a film's production.

Vitagraph

This leading early American film company was one of the first to promote its pictures using still photographs rather than frame enlargements. It also began advertising its stars through the use of photo portrait postcards from about 1912.

Willinger, Laszlo (1909-1989)

A leading photographer in the 1930s, he arrived in the US in 1937 as a Jewish refugee from Europe and soon established himself as one of the best portrait photographers in Hollywood, employed by MGM up to 1944.

X-certificate photography

Still photographs survive from censored scenes in many films. Best-known examples include the orgy scenes in Erich von Stroheim's *The Merry Widow* (1925) and *The Wedding March* (1928). But most notorious of all was the dancing shot of Carmen Miranda which caught her in mid leap as her skirt flew up and revealed that she was not wearing any undies. Though the negative was immediately destroyed by the studio, pirated copies of the shot probably hurt her career and almost cost the photographer, Frank Powolny, his job. The photo most recently turned up as a featured image in *Hustler* magazine's 'Porn from the Past' (vol. 3 no.7) and in Kenneth Anger's book *Hollywood Babylon II*.

youthful beginnings

Karl Brown started out as a thirteen year old stills photographer on *The Spoilers* (1913), then went on to work as a camera assistant and stills photographer for D.W. Griffith. As a teenaged office assistant at Paramount in the 1920s, John Engstead began his long and distinguished career as a photographer by arranging a memorable sitting with Clara Bow, the studio's major star.

Zelig (1983)

This black-and-white Woody Allen film is memorable for its ingenious use of doctored stills as part of the recreation on screen of the world of the fictional title character, played by Woody himself.

As they leave the cinema, Jean-Pierre Léaud (left) and his friend, played by René Bigey, run off with a publicity still of Harriet Anderson from the Bergman film, *Summer with Monika*. A scene from Truffaut's *Les Quatre Cents Coups*.

BIBLIOGRAPHY

Arnold, Eve, *In Retrospect*, Sinclair-Stevenson, London, 1996

Arnold, Eve, *Film Journal*, Bloomsbury, London, 2002

Avery, Sid, *Hollywood at Home*, Crown, New York, 1990

Bernard, Susan, *Bernard of Hollywood: The Ultimate Pin-up Book*, Taschen, 2002

Bridges, Jeff, *Pictures*, Power House, London, 2003

Brouwer, Alexandra and Wright, Thomas Lee, *Working in Hollywood*, Crown, New York, 1991, pp. 495-500 on the 'still photographer'

Brown, Karl, *Adventures with D.W. Griffith*, Secker & Warburg, London, 1973

Bull, Clarence Sinclair and Lee, Raymond, *The Faces of Hollywood*, A.S. Barnes, South Brunswick, N.J., 1968

Champlin, Charles and Derrick Tseng, *Woody Allen at Work: The Photographs of Brian Hamill*, Harry N. Abrams, New York, 1995

Clavieres, Guillaume, *On Set and Off Guard*, Thames & Hudson, London, 2002

Dallinger, Nat, *Unforgettable Hollywood*, Bonanza Books, New York, 1982

Dance, Robert, 'The Hollywood Studio Photographers' in *Glamour of the Gods*, pp.21-35

Davidson, Bruce, *Portraits*, Aperture, London, 1999

Engstead, John, *Star Shots*, Dutton, New York, 1978

Fahey, David and Rich, Linda, *Masters of Starlight: Photographers in Hollywood*, Los Angeles County Museum of Art, 1987/Columbus Books, London, 1988

Film Stills: Emotion Made in Hollywood, Museum für Gestaltung, Zurich/Edition Cantz, 1993 (exhibition catalogue)

Finler, Joel W., *The Hollywood Story*, Octopus Books, London/Crown, New York, 1988. 3rd edition: Wallflower Press, London and New York, 2003

Finler, Joel W., *The Movie Directors Story*, Octopus Books, London, 1985

Finler, Joel W., *Stroheim*, Studio Vista, London, 1967/University of California Press, Berkeley, 1968

Freulich, Roman and Abramson, Joan, *Forty Years in Hollywood: Portraits of a Golden Age*, A.S. Barnes, South Brunswick, N.J., 1971

Garrett, Murray, *Hollywood Candid: A Photographer Remembers*, Abrams, New York, 2000

Glamour of the Gods, (Photographs from the John Kobal Foundation), Steidl, 2008/National Portrait Gallery, London, 2011

Haralovich, Mary Beth, 'Mandates of Good Taste: The Self-Regulation of Film Advertising in the Thirties', in *Wide Angle*, vol 6 no 2, 1984

Harvith, Susan and John, *Karl Struss: Man with a Camera*, Cranbrook Academy of Art and Museum, 1976 (exhibition catalogue)

Hayes, Suzanne Lloyd ed., *3-D Hollywood: Photographs by Harold Lloyd*, Simon & Schuster, New York, 1992

Higgens, Steven, *Still Moving: The Film and Media Collections of the Museum of Modern Art*, MOMA, New York, 2006

Hopper, Dennis, *Photographs 1961 - 1967*, Taschen, 2011

Horak, Jan-Christopher, 'Using Hollywood Stills as Historical Documents', *Historical Journal of Film, Radio and Television*, vol.10 no.1 (1990)

In the Picture: Production Stills from the TCM [Turner Classic Movies] *Archive*, Chronicle Books, San Francisco, 2004

International Photographer magazine, Los Angeles, 1929-1954

Kobal, John, *The Art of the Great Hollywood Portrait Photographers 1925-1940*, Michael Joseph, London/Knopf, New York, 1980

Kobal, John ed., *Hollywood Glamor Portraits: 145 Photos of the Stars, 1926-1949*, Dover, New York, 1976

Kobal, John ed. and introduction, *Film Star Portraits of the Fifties*, Dover, New York, 1980

Kobal, John, *People Will Talk*, Knopf, New York, 1985/Aurum, London 1986
(includes interviews with some of the leading Hollywood photographers)

Lester, Gene (with Laufer, Peter), *When Hollywood was Fun! Snapshots of an Era*, Robert Hale, London, 1994

Lester, Gene (with Laufer, Peter), 'Snapping the Stars' in *International Photographer*, November 1941

Life Goes to the Movies, Time-Life, New York, 1975

Lloyd, Suzanne, *Harold Lloyd's Hollywood Nudes in 3-D*, Black Dog, London, 2004

Longworth, Bert, *Hold Still Hollywood*, (privately printed), 1937

Lucas, Cornel, *Heads & Tails*, Lennard Publishing, Luton, Bedfordshire, 1988

Magnum Cinema: Photographs from 50 Years of Movie-Making, Phaidon, London/New York, 1995

Mark, Mary Ellen, *Seen Behind The Scene: 40 Years of Shooting On Set*, Phaidon, New York & London, 2008

Meadows, Daniel, *Set Pieces: Being About Film Stills*, Mostly, BFI, London, 1993

Molt, Cynthia Narylee, *Gone with the Wind on Film: A Complete Reference*, McFarland, Jefferson, N.C., 1990
(includes an annotated list of all the printed and numbered stills taken by the official stills photographers. Fred A. Parrish shot 25,000 8 x 10s and 4,000 4 x 5s, not all of which were printed, while Bull and Willinger shot additional 'publicity photos'.)

Pepper, Terence and Kobal, John, *The Man Who Shot Garbo: The Hollywood Photographs of Clarence Sinclair Bull*, Simon & Schuster, New York, 1989

Pictures by Jeff Bridges, Power House, London, 2003

Pizzello, Chris, 'Framing Film History', *American Cinematographer*, Jan. 1998

Rotha, Paul, 'Old Film Stills', in *Rotha on Film*, Faber & Faber, London, 1958

Schickel, Richard and Willoughby, Bob, *Lights! Camera! Action! Hollywood Its Platinum Years*, Random House, New York, 1974

Schifferli, Christoph (compiler-editor) and Campany, David (introduction), *Paper Dreams: The Lost Art of Hollywood Still Photography*, Steidl/7L, Paris and Göttingen, 2007

Stackpole, Peter, *Life in Hollywood 1936-1952*, Mainstream, Edinburgh and London, 1993

Stallings, Penny with Mandelbaum, Howard, *Flesh and Fantasy*, Macdonald & Jane's, London, 1979

Starr, Steve, *Picture Perfect: Deco Photo Frames 1926-1946*, Rizzoli, New York, 1991

Stern, Phil, *Hollywood: Photographs, 1940-1979*, Knopf, New York, 1993

Stine, Whitney, *50 Years of Photographing Hollywood: The Hurrell Style*, John Day, New York, 1976

Thomson, David, 'The Lost (or at Least Buried) Art of the Movie Still', in the *New York Times*, April 21, 2002 (Arts & Leisure Section)

Trent, Paul, *The Image Makers: 60 Years of Hollywood Glamour*, McGraw-Hill, New York, 1972

Vieira, Mark, *Hollywood Portraits: Classic Scene Stills 1920-41*, Bison, London, 1988

Vieira, Mark, *Hurrell's Hollywood Portraits*, Abrams, New York, 1997

Weinberg, Herman ed., *The Complete Greed of Erich von Stroheim: A Reconstruction of the Film in 348 Still Photographs*, Dutton, New York, 1972

Willoughby, Bob, *Hollywood, A Journey Through the Stars: A Photographic Autobiography*, Assouline, New York, 2001

Willoughby, Bob, *The Starmakers: On Set with Hollywood's Greatest Directors*, Merrell, 2003

Wolfe, Charles, 'The Return of Jimmy Stewart: The Publicity Photograph as Text' in *Wide Angle*, vol. 6 no. 4. Reprinted in Gladhill, Christine ed., *Stardom: Industry of Desire*, Routledge, London and New York, 1991

Woods, Edward, 'The Still Cameraman', in Oswell Blakeston ed., *Working for the Films*, Focal Press, London and New York, 1947

Worth Exposing Hollywood, Cinemage, 2002

Yul Brynner: Photographer, Abrams, New York, 1996

Zeichner, Arlene, 'Still Lives' in *Film Comment*, April 1984

Index

Index of Movie Titles

DATE			